LANDSCAPE

PHOTOGRAPHER OF THE YEAR

COLLECTION 7

Editor: Donna Wood
Designer: Nick Johnston
Image retouching and colour repro: Ian Little

Produced by AA Publishing
© AA Media Limited 2013
Reprinted October 2014

Published by AA Publishing (a trading name of AA Media Limited,
whose registered office is Fanum House, Basing View, Basingstoke RG21 4EA;
registered number 06112600).

A05296

ISBN: 978-0-7495-7516-8

A CIP catalogue record for this book is available from the British Library.

Printed and bound in Italy by Printer Trento SRL.

theAA.com/shop

GRAEME PEACOCK ⋯⟩

Gateshead Millennium Bridge
Gateshead, Tyne and Wear, England

There is a superbly designed kink in the Gateshead quayside metal fence which echoes perfectly the reflection of the Millennium Bridge in the Tyne. For this image to succeed, Mother Nature needs to oblige with a) a calm evening with wind speeds less than 5mph, b) a clear evening (ideally in autumn/winter when air particles are minimised) just after sunset, whereby ambient light matches the intensity of street lighting and c) a high tide with no discernible current running. No wonder then, that it took me 10 visits over a period of two years to achieve the desired result. Who says that landscape photographers don't have patience?!

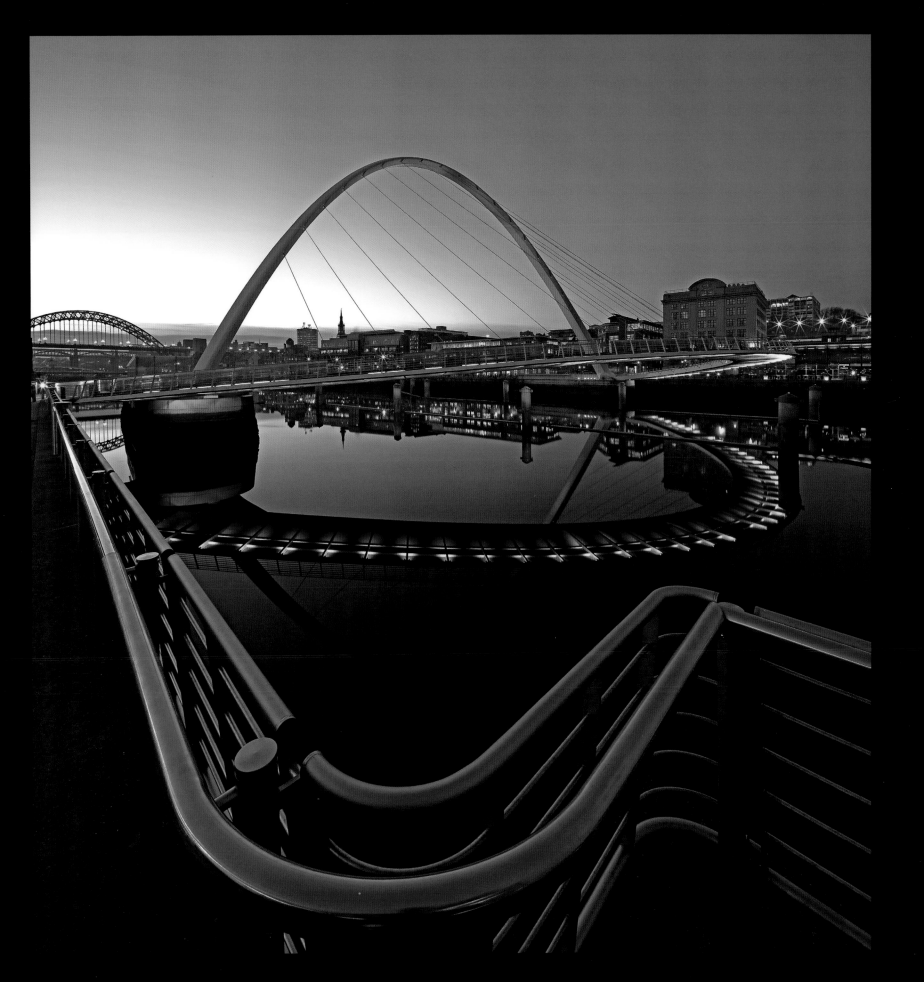

CONTENTS

ANDREW MIDGLEY ···>

King's College
Cambridge, England

I went out to take this picture looking towards King's College Chapel at dawn, to avoid the crowds of tourists. It was a beautiful morning with light cloud and soft sunlight hitting the chapel.

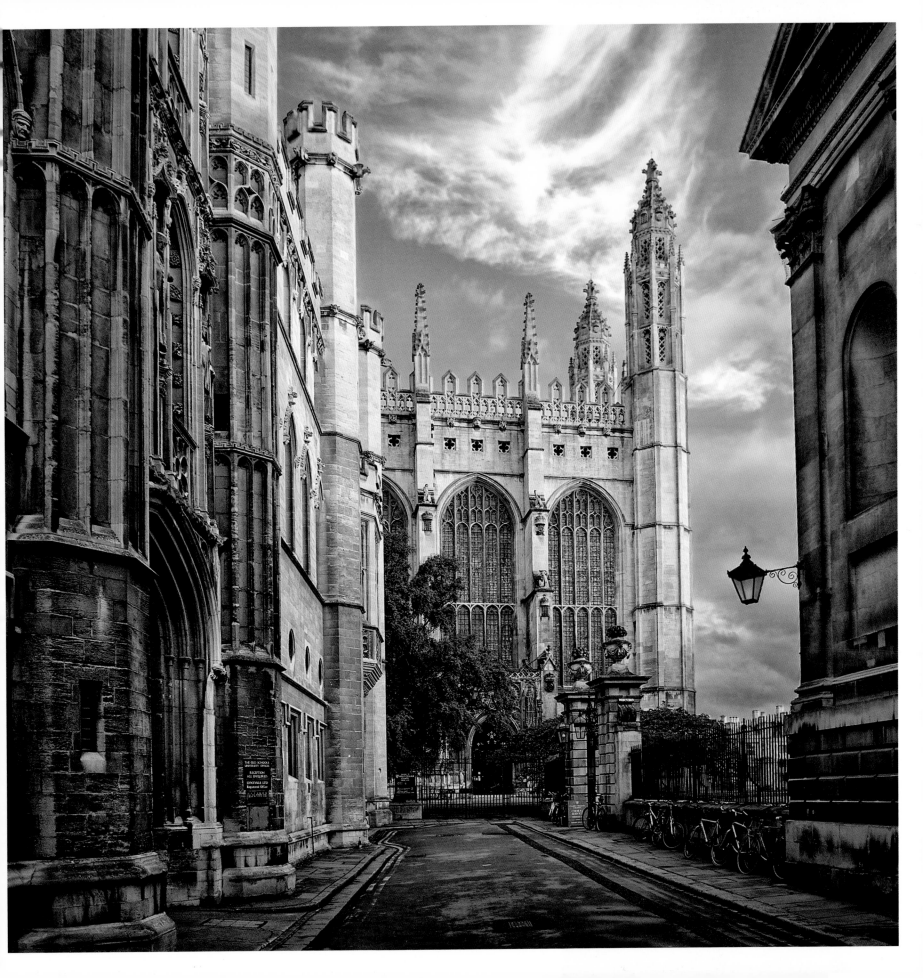

INTRODUCTION

THE COMPETITION

Take a view, the Landscape Photographer of the Year Award, is the idea of Charlie Waite, one of today's most respected landscape photographers. In this, its seventh year, the high standard of entries again proves that the Awards are the perfect platform to showcase the very best photography of the British landscape. This year's Award would not have been possible without the invaluable help and support of Network Rail.

Open to images of the United Kingdom, Isle of Man and the Channel Islands, Take a view is divided into two main sections, the Landscape Photographer of the Year Award and the Young Landscape Photographer of the Year Award. With a prize fund worth a total of £20,000 and an exhibition of winning and commended entries at the National Theatre in London, Take a view has become a desirable annual competition for photographers of all ages.

All images within this book were judged by the panel as Commended or above, a high accolade and a very small percentage of the total entry.

www.landscapephotographeroftheyear.co.uk
www.take-a-view.co.uk

THE CATEGORIES

Classic view

For images that capture the beauty and variety of the UK landscape. Iconic views, from waves crashing on a Cornish beach or views from the top of a Lakeland Fell to lone trees and mystical woodland; all showing the drama of our seasons. Recognisable and memorable – these are true classics.

Living the view

Featuring images of people interacting with the outdoors – working or playing in the UK landscape. From quad-biking in the snow to a man walking his dog, these images illustrate the many ways in which we connect with our outdoor environment.

Urban view

Statistics suggest that up to 80% of the UK population lives in towns or cities. That's a huge number and this category highlights the surroundings that many of us live in every day. Contemporary buildings, such as London's Shard, vie for attention with the traditional architecture of King's College in Cambridge and show that all landscapes matter.

Your view

What does the UK landscape mean to you? Sometimes intensely personal and often very conceptual, the parameters of this category are far-reaching, with images showing a whole range of emotions and perspectives. More digital manipulation is allowed in this category and images may not be precise representations of the physical landscape in every case. Details can be found in the technical information for each image.

KEY SUPPORTERS

www.networkrail.co.uk

WITH THANKS TO

The Sunday Times Magazine

AA Publishing
Natural England
VisitEngland
Epson
Light & Land
Amateur Photographer
Bayeux
Environment Films Ltd
Campaign to Protect Rural England
Outdoor Photography
Fujifilm
Páramo Directional Clothing Systems
What Digital Camera
Cooltide Interactive

SPECIAL PRIZES

The Network Rail 'Lines in the Landscape' Award

This Award is for the one photographer who best captures the spirit of today's rail network as it relates to the landscape around it. Entries had to be of the operational national rail network anywhere in Great Britain (excluding Northern Ireland).

The VisitBritain 'You're Invited' Award

Introduced for the first time this year, the VisitBritain 'You're Invited' Award is presented to the image judged to be the best submitted by an entrant living outside Great Britain, the Isle of Man and the Channel Islands.

The Calumet Photographic 'This is Britain' Award

This Award is for the image that, for Calumet, sums up the spirit and landscape of Britain in 2013. They were looking for something just a bit different; something that triggers an emotional response relevant to the times we live in today.

The Sunday Times Magazine Choice

As media supporter of the Take a view Awards, *The Sunday Times Magazine* has always been the first to announce the results and to feature successful images from each year's competition. To celebrate this relationship, now in its seventh year, there is an Award for the favourite image of *The Sunday Times Magazine*.

FOREWORD

BY DAVID HIGGINS,
CHIEF EXECUTIVE, NETWORK RAIL

After the excitement of the Olympics and the Jubilee, I'm sure that I'm not the only one who wondered if 2013 could be as memorable as 2012 but, for many reasons, it already is. The reassuring thing about British life is that something new always comes along to please, excite and inspire you and, of course, provide many opportunities to capture the moment.

This summer, to extend our partnership with Landscape Photographer of the Year, we held a series of exhibitions of previous entries at five of our biggest stations across the country. Not only did this allow us and Take a view to share some amazing photography with the millions that pass through our stations but also I hope it inspired people to go out and take their own photographs of all the amazing places that can be reached by rail.

What was unique about these exhibitions was that the images changed at each station to include places that could be reached by the city's railway and details of how to do this were provided alongside each photograph. As I passed through King's Cross station near my office, I could see people admiring the photographs on display and wondered if they would be moved to pick up their own cameras and maybe, next year, their image might be the one that everyone stops to see.

Once again, the standard of images entered this year to the Network Rail 'Lines in the Landscape' award has been extremely high. The railway continues to elicit a great sense of romance about the British landscape, of which it is a major part. For me, the images commended this year illustrate a wonderful combination of the beauty of the historic architecture, which Network Rail has the responsibility and honour of maintaining, and the speed and connectivity of the modern network, which continues to grow as rail travel becomes more popular than ever. Well done to everyone involved for another amazing year of photography.

COMMENT

BY AWARDS FOUNDER,
CHARLIE WAITE

Everybody is photographing. With nearly 40 million people in the UK carrying a mobile phone camera with them most of the time, the impulse to want to photograph is quickly satisfied. Quite what happens to that image thereafter will always be a mystery to me and perhaps to the photographer as well.

In this age of digital photography, with 64GB SD cards and easily affordable 1TB external hard drives, images of every imaginable content are being made and more often than not being offloaded, sometimes in an 'unedited' state, onto huge capacity external drives where they may remain perhaps for perpetuity, or for as long as they may still be retrieved, if indeed they ever are.

In the late 19th century, my great grandparents approached their landscape and holiday photography with a great degree of care and as much skill as they could muster. The subsequent compiling of the album commemorating each event was prepared with loving hands and every image would carry with it a caption and a date, often written in white ink. There was nothing reckless about their photography and the album would be shown with pride to all; no finger flicking at speed across a tablet; each image was examined, discussed and thought precious. Cost was a factor and every image made was treated as a production of consequence and magnitude, even if it was of the nanny cuddling the dachshund. Photographing the landscape was also immensely popular.

To a large degree, we have now said farewell to dyes and silver halide crystals. So many hundreds of billions of images would have been taken over the many years that film prevailed and now perhaps thousands of billions of images are taken in less than a tenth of that time; everybody is photographing.

Yet throughout our wonderful photographic fraternity is to be found a group of photographers who have an unerring passion for landscape photography. Their business is and will always be to produce an image that evokes what they saw, what they felt and what they needed to say. Casual lines such as 'I hope it may come out' are phrases that do not exist in their vocabulary.

The images in this book, the seventh *Landscape Photographer of the Year* collection, testify once again that every photographer, whether they be keen beginners, enthusiasts or professionals, will have devoted themselves so wholeheartedly to the making of their images that their skill and devotion to their subject is apparent as we turn the pages of 'their' book.

My gratitude extends to all landscape photographers for their ability and often tenacious determination to deliver distinctive and emotionally charged images of our much loved United Kingdom that continue to remind us what we have and what we hold so dear to our hearts.

THE JUDGES

Damien Demolder
Editor
Amateur Photographer magazine

Damien Demolder is the editor of *Amateur Photographer* magazine, the world's oldest weekly magazine for photography enthusiasts, and a very keen photographer too. He started his photographic professional life at the age of 18, but since taking up the editorship of the magazine he has been able to return to his amateur status – shooting what he likes, for his own pleasure.

With interests in all areas of photography, Damien does not have a favourite subject, only subjects he is currently concentrating on. At the moment his efforts are going into landscapes and social documentary. When judging photography competitions Damien looks for signs of genuine talent or hard work. Originality is important, as is demonstrating a real understanding of the subject and an ability to capture it in a realistic manner. He says 'Drama is always eye-catching, but often it is the subtle, calm and intelligent images that are more pleasing and enduring.'

Charlie Waite
Landscape Photographer and
Awards Founder

Charlie Waite is firmly established as one of the world's most celebrated landscape photographers. He has published over 30 books on photography and there have been many solo exhibitions of his work across Europe, the USA, Japan and Australia, including three very successful exhibitions in the gallery at the OXO Tower in London.

His company, Light & Land, runs courses, tours and workshops worldwide that are dedicated to inspiring photographers and improving their photography. This is achieved with the help of a select team of specialist photographic leaders.

He is the man behind the Landscape Photographer of the Year Awards and they tie in perfectly with his desire to share his passion and appreciation of the beauty of our world.

Monica Allende
Picture Editor
The Sunday Times Magazine

Monica started her career in publishing commissioning travel photography, where sourcing idyllic landscapes was the main objective. For the last 12 years she has been Picture Editor for *The Sunday Times Magazine*.

Although she works with images every day of her life, Monica still gets excited about the variety and creativity of photography and likes to champion up-and-coming photographers. She is interested in the increasing accessibility of photography and the changing attitudes of young people towards the art.

She likes extreme landscapes; raw nature that gives a feeling of infinity and appears unchanged by the human hand. Her favourite element is water and so the coastal landscape, particularly of North Devon and Cornwall, has provided her with unforgettable visual images, but as an urbanite born and bred among concrete, the urban landscape speaks to her in a familiar language.

David Watchus
Head of AA Media

David is responsible for the online and offline delivery of AA Media's extensive content across its core areas of UK travel, lifestyle, maps and atlases and driving titles; areas in which the AA has many market-leading titles.

His involvement in the Landscape Photographer of the Year competition dates back to its original conception and the AA's sponsorship of the first-ever competition. Stunning imagery of the British landscape is a key element of AA Media's future publishing strategy as it delivers a greater variety of engaging and informative content across an ever-growing number of diverse platforms, from books to apps and ebooks to online.

Jasmine Teer
VisitBritain
Photographic Manager

Jasmine Teer provides shoot management for VisitBritain, the UK's National Tourism Agency, and manages their online collection of over 50,000 images. She has produced and art directed hundreds of shoots throughout England, Wales, Scotland, Northern Ireland and the Channel Islands, working with some of the best photographers in the UK.

Jasmine previously curated the Britain on View exhibition and is currently a mentor for the Young Photographers' Alliance.

John Langley
Director
National Theatre

John Langley is the Director of External Relationships at the National Theatre, on London's South Bank. Alongside its three stages, summer outdoor events programme and early evening platform performances, the National has become renowned for its full and varied free exhibitions programme. Held regularly in two bespoke spaces, these exhibitions are an important ongoing part of London's art and photographic scene. John is responsible for these shows and has organised over 300 exhibitions and played a significant role in presenting innovative and exciting photography to a wide and discerning audience.

When escaping from the urban bustle of the capital, John particularly loves the coastal scenery of the United Kingdom, with the Pembrokeshire coast and Purbeck in Dorset being particular favourites.

Rupert Grey
Photographer and Practising
Copyright Lawyer

Rupert has balanced life in the law courts with long periods in the wild places of the earth and creating, with his wife Jan and three daughters, a thriving and happy family life in their remote cottage in the South Downs.

As an outdoorsman and photographer he has travelled on foot, by boat, dog sledge, camel and Land Rover in many different countries, including Papua New Guinea, Alaska and the Orient.

Rupert serves on the board of a number of front line charities in the fields of performing arts, education, photography and conservation. His photographs have been exhibited in several countries including Bangladesh. He is now one of the leading solicitors in photographic law.

Photo: Ray Mears

Colin Prior
Landscape and Advertising
Photographer

Colin Prior is known as one of the world's most respected landscape photographers. Born in Glasgow, his proximity to the Scottish Highlands shaped his passion for the outdoors and fostered his interest in photography. His photographs capture sublime moments of light and land, which are the result of meticulous planning and preparation and often take years to achieve. Colin is a photographer who seeks out patterns in the landscape and the hidden links between reality and the imagination.

Commissioned by British Airways for four years, he has travelled to over 40 countries throughout the world and lived alone for extended periods of time in the wild just to understand his subject. His six books include *The World's Wild Places*, which was published internationally. He is currently working on a 25-year retrospective and is about to begin a four-year project in the Karakoram Mountains in the western Himalayas. He is a Fellow of the Royal Photographic Society and a founding member of the International League of Conservation Photographers.

PRE-JUDGING AND INTERIM JUDGING PANELS

The pre-judging and interim judging panels have had the difficult task of selecting the best images to go through to the final shortlist. Every image entered into the competition was viewed and carefully assessed before the resulting list was put through to face the final judging team.

Trevor Parr, Parr-Joyce Partnership

Trevor's lifelong love of photography started at art college. He was a fashion photographers' assistant before setting up on his own in a Covent Garden studio. He then moved to the stock/agency business, seeking new photography and acting as art director on a number of shoots. In the late 1980s, he started the Parr-Joyce Partnership with Christopher Joyce and also owned a specialist landscape library that was later sold to a larger agency. He now concentrates on running Parr-Joyce from his base in the south of England and sources conceptual, landscape and fine art photography for poster, card and original print markets.

Pete Bridgwood, Photographer

Pete Bridgwood is a photographer and writer from Nottingham. He is fascinated by the creative foundations of photography and passionate about emotional elements of the art. He developed an infatuation with photography in the pre-digital era and learnt the craft using manual cameras, doing his own processing and printing in a traditional wet-process darkroom; he now works entirely digitally. Pete specialises in fine-art landscape photography and writes a monthly column in *Outdoor Photography* magazine.

Tim Parkin, Director, *On Landscape*

Tim Parkin runs the world's only dedicated landscape photography magazine, *On Landscape*, which represents a diverse range of genres and styles from the classic sublime through to experimental contemporary photography. He draws from his previous engineering background and PhD study in computational mathematics to give an in-depth understanding of digital imaging systems from camera through post-processing to printing. He also runs a fine art film and artwork scanning service and shoots with 4 x 5 and 10 x 8 film cameras for his personal photographic work.

Robin Bernard, Director, Bayeux

Robin founded Bayeux, the London West End pro-photo lab, 12 years ago and it is still going strong today. He is involved in every aspect of photographic post-production, for every genre of photographer. He has been heavily involved in digital imaging since the early days in the 1990s but still enjoys getting his hands wet in the darkroom, hand-printing the black-and-white fibre prints that remain popular. Robin admires images that reflect the tranquil peace of the British landscape but is inspired by technical excellence regardless of location.

Antony Spencer, Landscape Photographer

Antony Spencer is a photographer who captures the landscape in the best available light wherever and whenever possible. The beautiful Dorset coast is right on his doorstep and he takes advantage of that whenever he can. In 2010, Antony was the UK's Landscape Photographer of the Year, being the overall winner of the fourth 'Take a view' Landscape Photographer of the Year competition. Always interested in photography, Antony started taking the art more seriously in 2007 with the purchase of his first digital SLR. He now specialises in Aurora Borealis and UK landscape photography.

Awards Founder: Charlie Waite

Awards Director: Diana Leppard

IAN CAMERON ···⫶

Kaleidoscape
Loch Achtriochtan, Glencoe, Scotland

The shallow water and windless conditions, in combination with the dappled sunlight of a cloud-flecked autumnal afternoon, gave rise to an outstanding mirror reflection of the slopes of Aonach Eagach on the opposite shore; a kaleidoscope of colour and light.

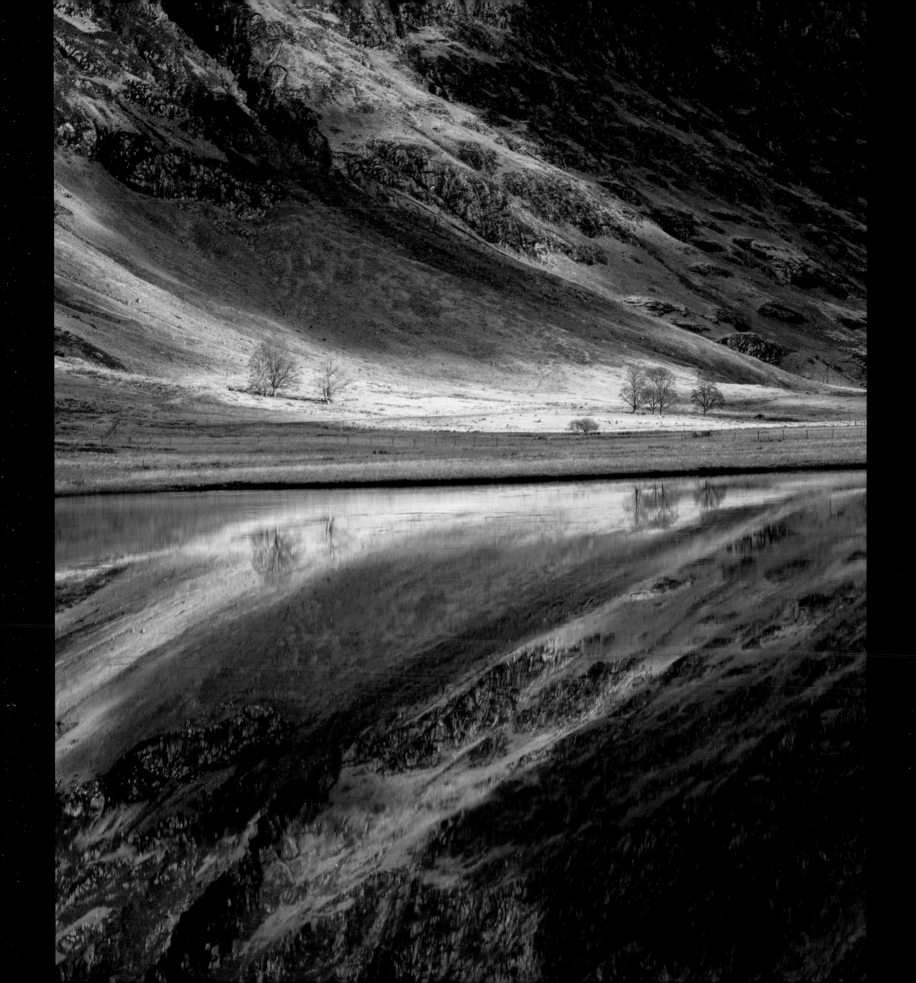

LANDSCAPE
PHOTOGRAPHER OF THE YEAR

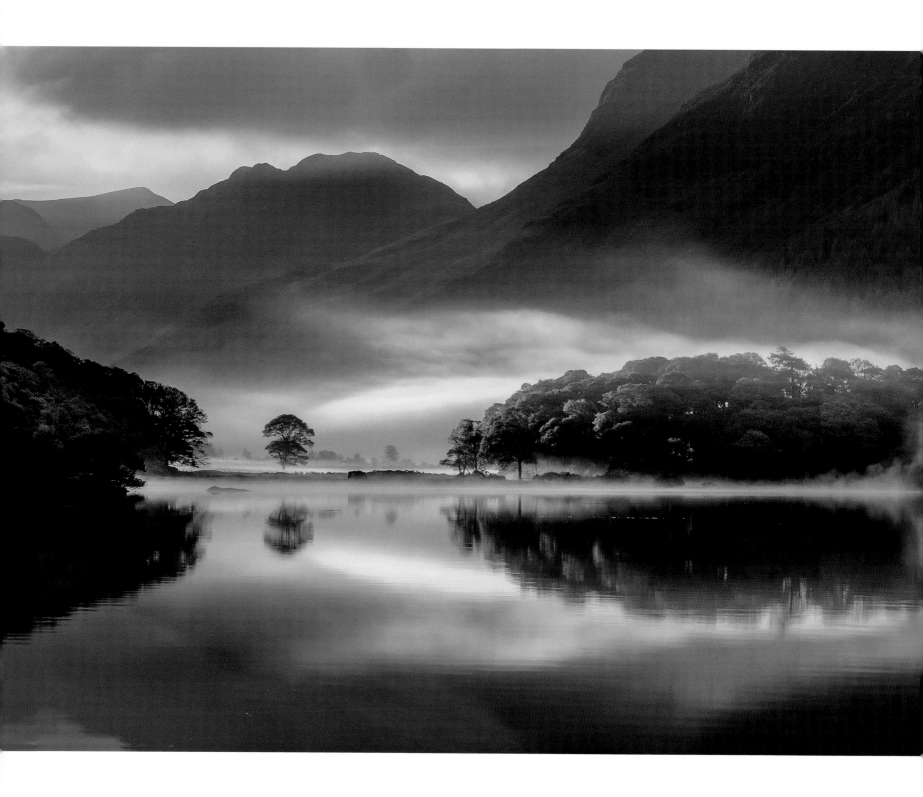

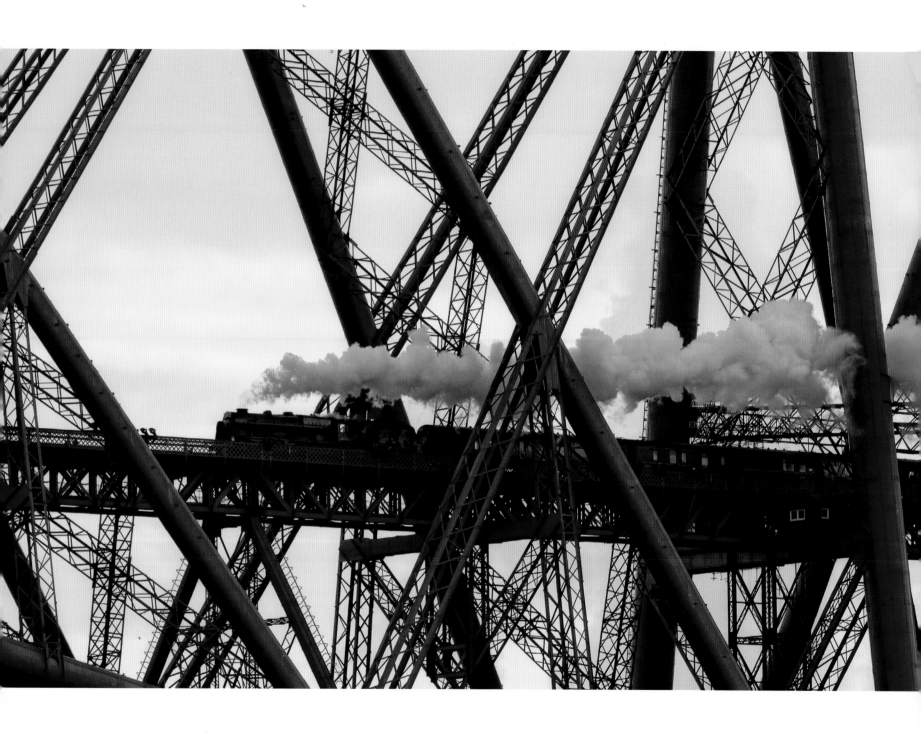

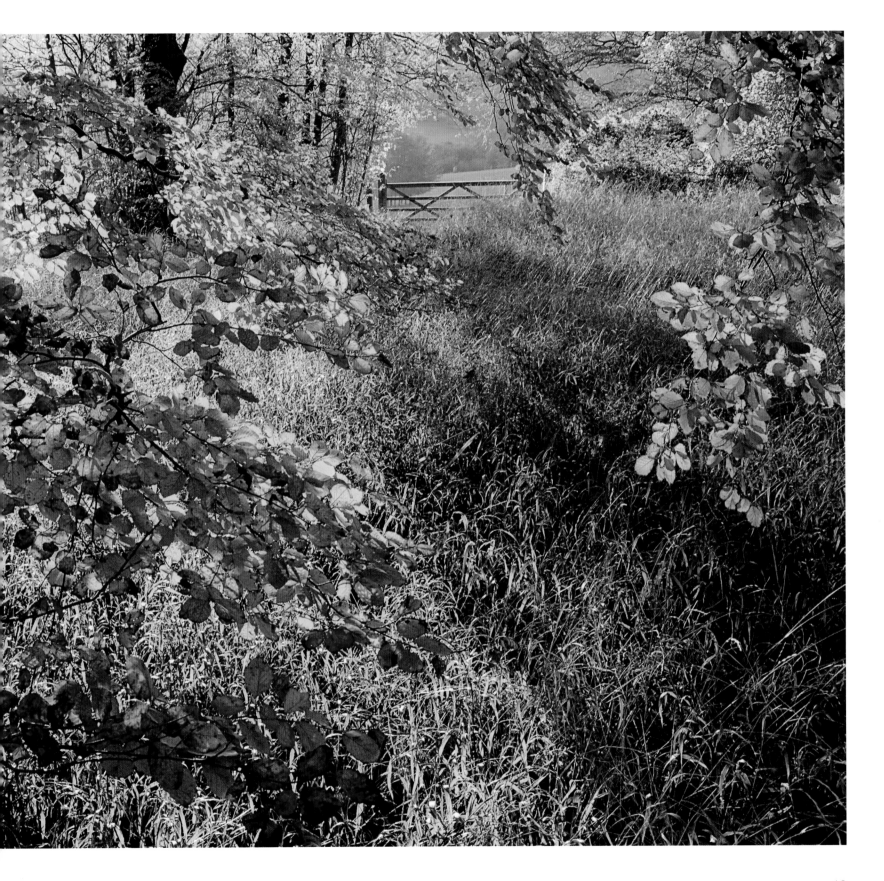

YOUNG LANDSCAPE PHOTOGRAPHER OF THE YEAR 2013

OVERALL WINNER

CHRISTOPHER PAGE

Autumn Colour at Polesden Lacey
Surrey, England

The colour of the autumn leaves was pitch-perfect and the low, golden light created a blaze of colour. All that was needed now was a focal point to ground the composition and luckily the hard lines of the gate perfectly complemented the golden leaves.

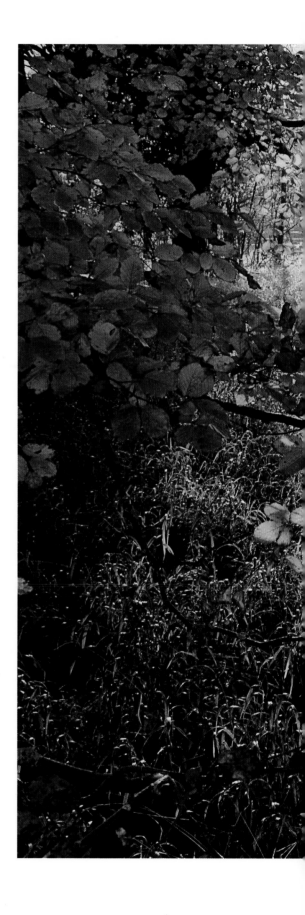

LANDSCAPE PHOTOGRAPHER OF THE YEAR 2013

OVERALL WINNER

TONY BENNETT

Mist and Reflections
Crummock Water, Cumbria, England

This photograph was taken during those magical minutes of an autumn dawn when the rising sun began striking the tops of trees and breaking through to the surface of the lake. Every second the scene was changing, creating a hundred memorable images, but this moment particularly caught my attention. The still night mist began rolling and tumbling, as if in protest, as the heat of the sun vaporised and dispersed it forever. Within a minute it was over; a moment in time, never to be repeated but always remembered.

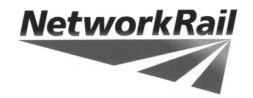

NETWORK RAIL
'LINES IN THE
LANDSCAPE' AWARD

THE NETWORK RAIL WINNER

←··· **DAVID CATION**

Caught in a Web of Iron
North Queensferry, Fife, Scotland

The Forth Rail Bridge had recently been repainted and I timed this visit to North Queensferry to coincide with the crossing of a steam train. This was the scene as the LMS Royal Scot Class 6115 *Scots Guardsman* hauled its carriages north over the bridge early one morning. I was drawn to the finesse of the details within the massive structure and chose the gap in the bracing to frame the locomotive.

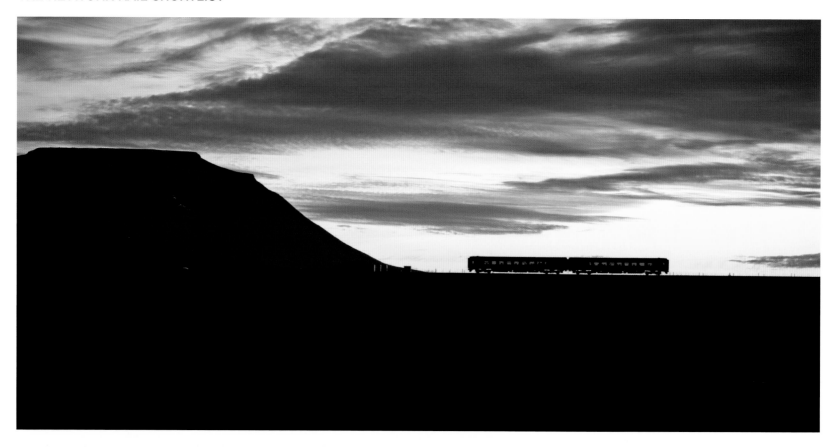

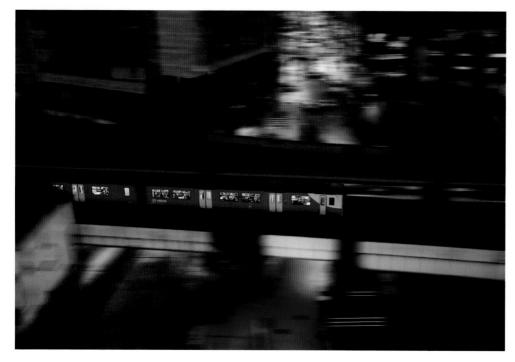

⋯ **ROBIN COOMBES**

Going Home
Cardiff, Wales

Commuters head home on a local Welsh Valley service from Cardiff Central Station, with the city's St Mary Street behind, on a wet Friday evening in March. This is a panned shot, taken from my sixth-floor office, before I packed up and headed home too. It captures the busy modern railway playing its key role in people's lives; mostly taken for granted.

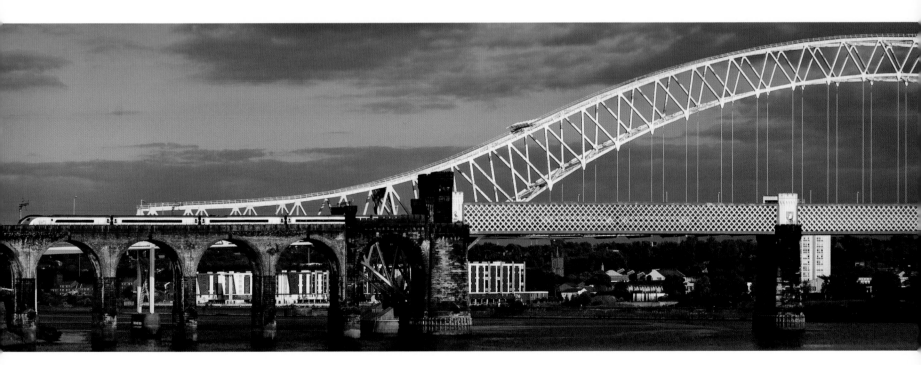

ROBERT FRANCE

Heading for the Viaduct
North Yorkshire, England

A Northern Rail Sprinter train passes Ingleborough and heads towards Ribblehead Viaduct at sunset in late November. I had the afternoon off work and had been in the area since lunchtime. I'd intended to take some silhouettes of the viaduct but, as I was setting up my tripod, the train approached and I took a few shots of it running towards the viaduct. It was not the shot I had originally intended but it is much better than the rest.

DAVID LONGSTAFFE

Elements of Travel
Runcorn Bridge, Cheshire, England

It has always intrigued me to think how famous this relatively unknown bridge would be if it had been erected just several miles down the River Mersey to link the Wirral Peninsular with Liverpool. The dark clouds behind the low sun illuminated the blend of stone, iron and steel to lift the shape and lines away from the industrial landscape and slowly flowing river. It almost depicts how all the elements work together as one to ensure safe passage. Runcorn is never going to be the Riviera of the North but I hope that the image collates all of the elements of the bridge and its local area that make its purpose essential for modern travel and movement of freight.

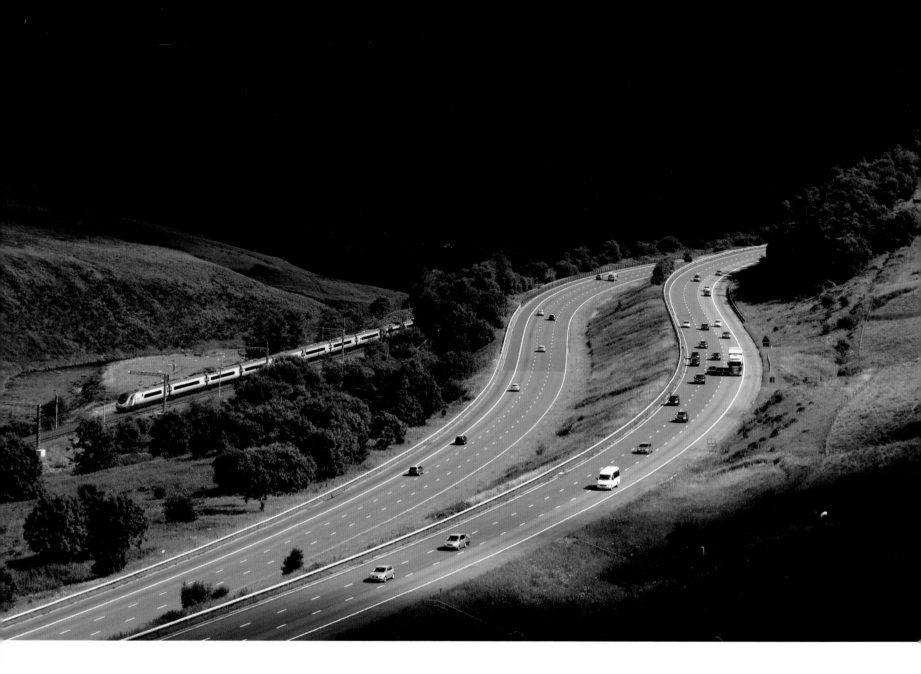

🕈 **ROBIN COOMBES**

Road and Rail
Lune Gorge, Cumbria, England

The Lune Gorge is one of my favourite locations. The railway first arrived in 1846, when the engineer Joseph Locke proposed the inland route between Lancaster and Carlisle as an alternative to the coast route of George Stephenson. The railway is now part of the West Coast main line and the approach to the fierce climb to Shap Summit. Locke's course through the Lune Gorge would be used again by the engineers of the 1960s for the construction of the M6 motorway which runs in a split level cutting above the railway. The two are seen running in parallel, with a modern Pendolino train, Saturday traffic on the M6 and an approaching thunderstorm.

STUART LOW ⋯⋟

The East Coast Lines
Seafield Cliffs, Kirkcaldy, Fife, Scotland

I travel to London on the East Coast Express and I see a lot of fantastic views on the way.
This part of the journey is on the coast near where I live and is part of a heritage trail that
runs along the top of nearby cliffs, overlooking the Forth Estuary towards Edinburgh.
I saw lots of classic lead-in lines so I chose to complement these with light trails from the
passing express train. It was a challenge trying to keep things sharp due to the vibration
from the trains as they passed.

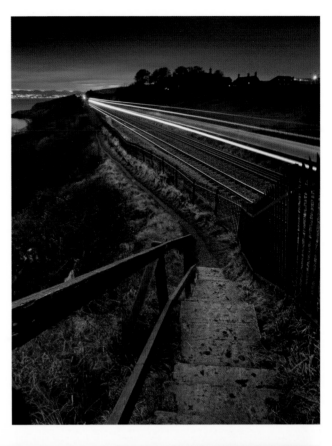

RORY TRAPPE ⋮

Barmouth Bridge
North Wales

I went to take a few photographs at the Cregennen Lakes above Dolgellau. The sun had
gone behind a few large clouds that were looming around the summit of Cader Idris, so to
kill a bit of time I decided to climb a small hill to get a view of the sea. Luckily, I had a long
lens with me and just after setting the camera up on the tripod a train popped into view. As
it was taken in midwinter the sun was quite low, which added so much more to the scene.

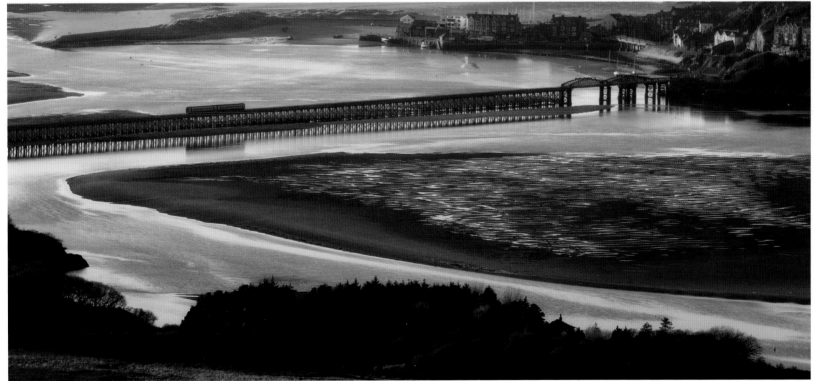

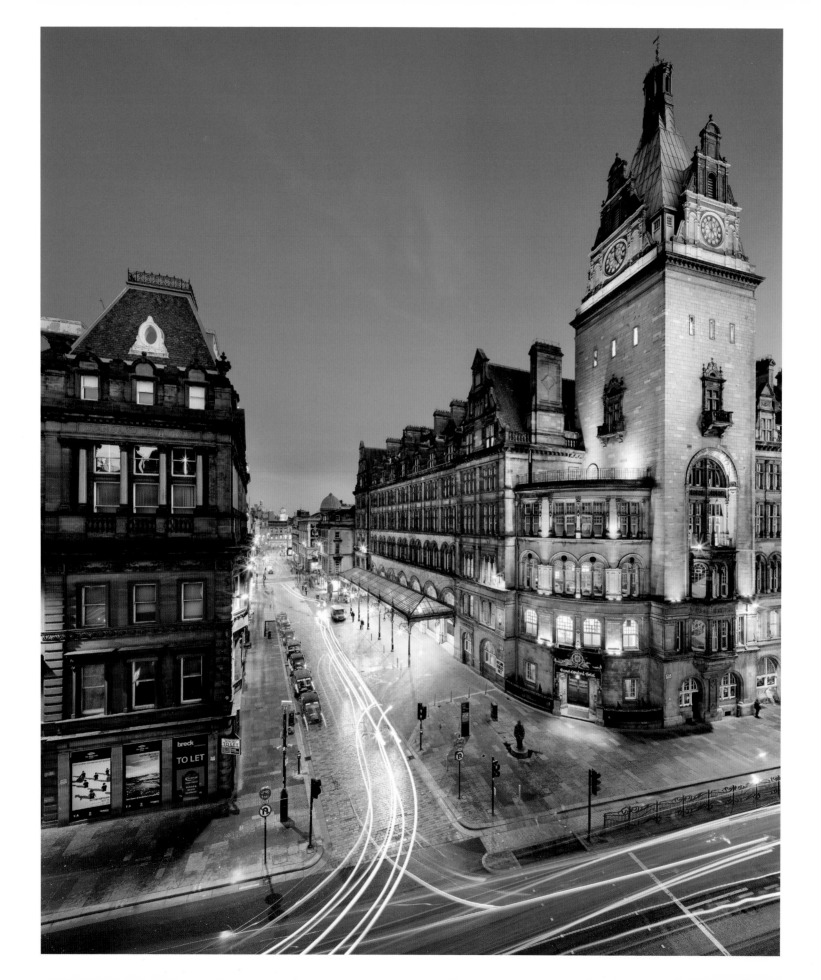

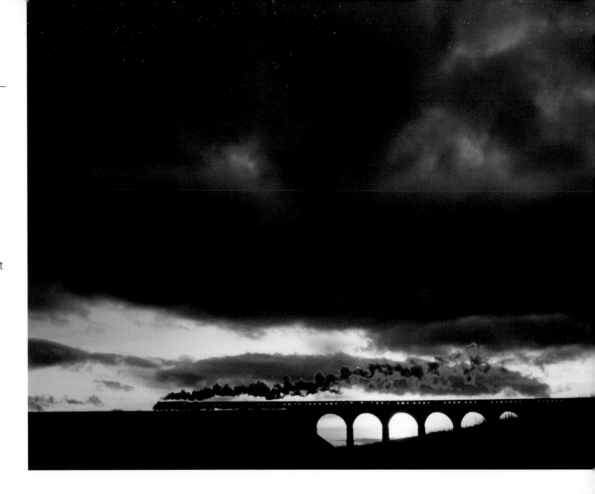

NEALE SMITH

Central Station at Night
Glasgow, Scotland

I've always been fascinated by the cathedral to worship the iron horses. This is, arguably, one of the finest examples of Victorian architecture in the great city of Glasgow; its sheer size and grandeur has drawn my attention again and again. If I'm ever in the city, I simply have to take a path through the station, just to be in the place. It's such an immense feat of engineering, built in a way that will never be repeated again. I've always loved the front facade, and I finally got to take the shot I'd been thinking about for a long time.

DAFYDD WHYLES ···>

Classic Train and Classic Architecture
Ribblehead Viaduct, North Yorkshire, England

The iconic Ribblehead Viaduct on the Settle to Carlisle railway line is crossed by an A4 class steam loco on a charter but the entire scene is dwarfed by the massive sky at sunset.

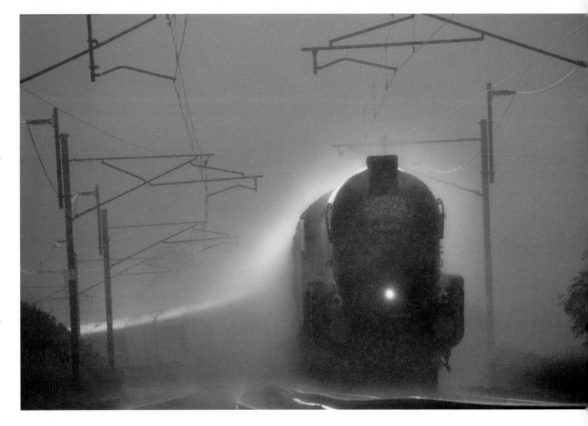

ROBIN COOMBES ···>

Perfect Storm
Lune Gorge, Cumbria, England

This was my chance to shoot the A4 Pacific 60009 *Union of South Africa* on the Cumbria Mountain Express at full speed in torrential rain during a thunderstorm. Rain was falling so hard I did not even see the train come around the curve, so it was one chance to lift camera, shoot and hope for the best. The camera survived the soaking, so well done Nikon. It is one of my all-time favourite shots and shows that railways continue to run in all winds and weathers regardless of motive power or age.

Also Alan Courtney **Early Morning Steam at Parkstone**, page 166

CLASSIC VIEW
adult class

CLASSIC VIEW ADULT CLASS WINNER

DAVID BREEN ···⟩

Ghost of Rannoch Moor
Scotland

Enveloped in a veil of white hoar frost, the well-known 'island tree' of Rannoch Moor
stands as a ghostly reminder of what is no longer present. A perfect, freezing morning
with clearing skies and no-one else around made this day feel very special.

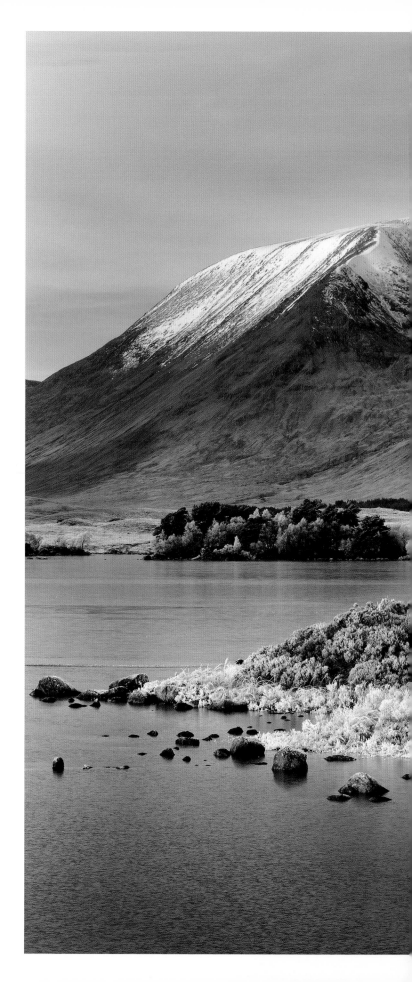

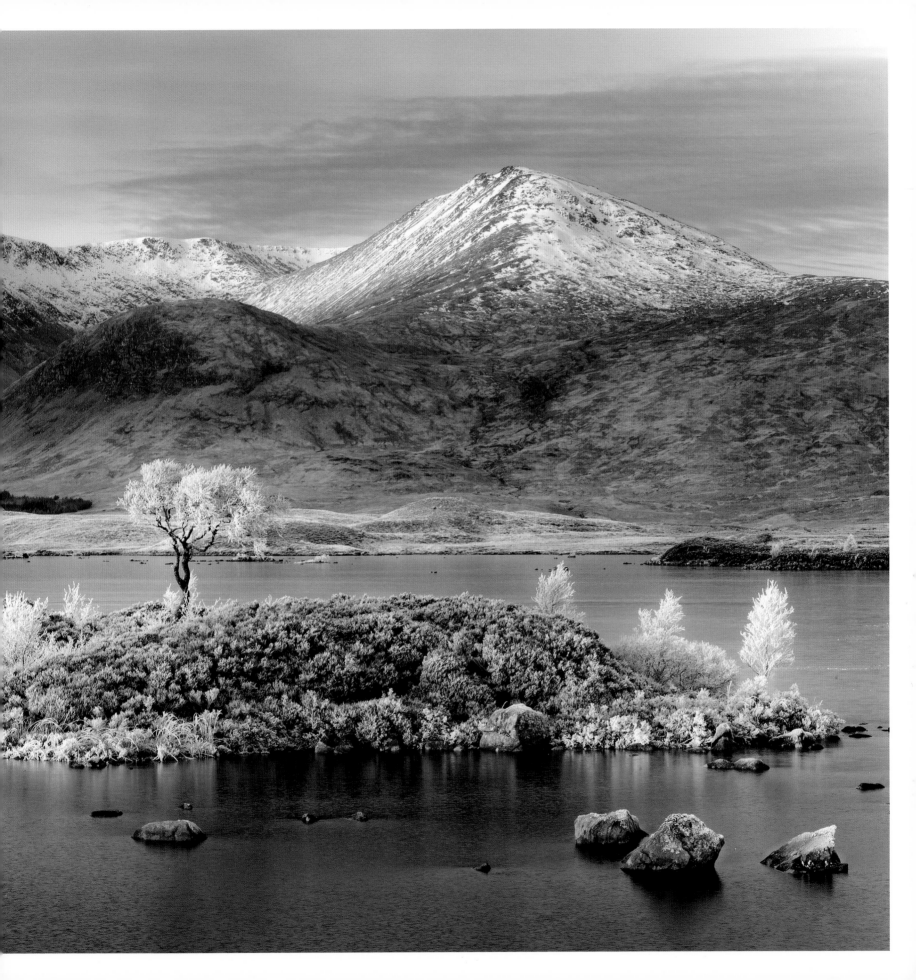

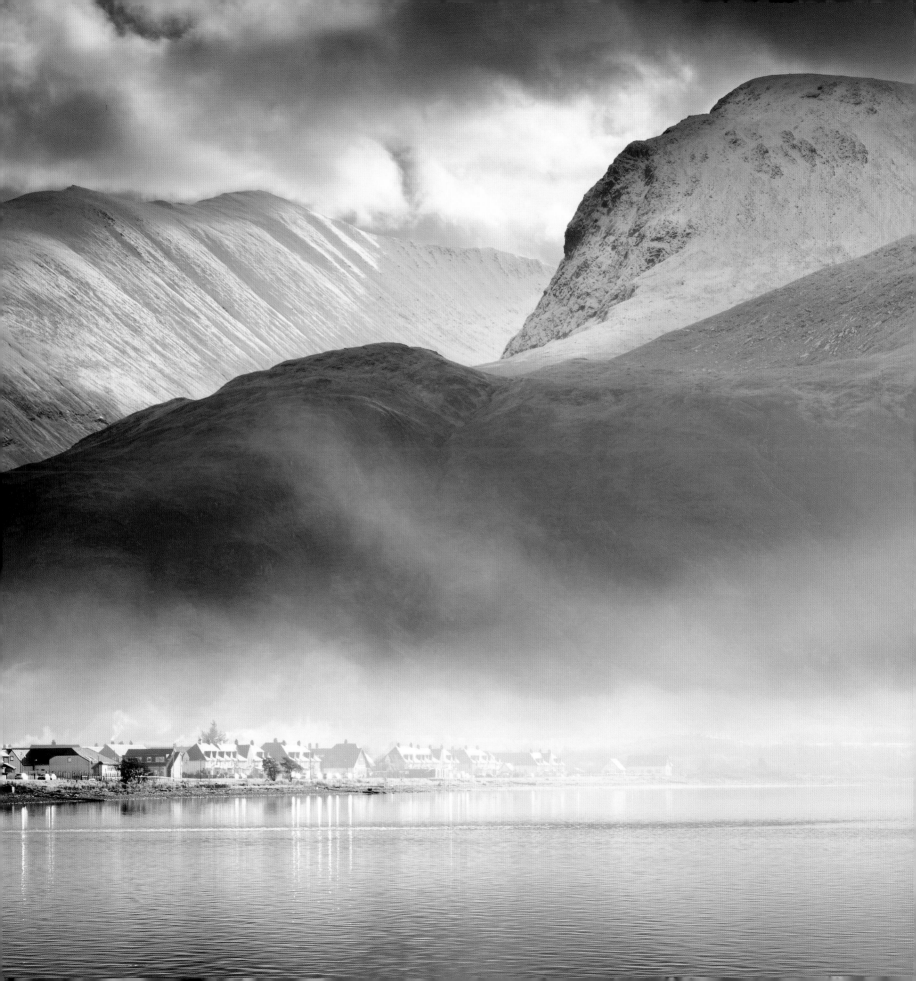

⟵ ROBERT BIRKBY

Bill & Ben
Fort William, Scotland

Driving home from an autumn trip to the Highlands, I couldn't resist stopping at Corpach. Sunlight was illuminating the morning mist rising from Loch Linnhe, creating a most impressive scene. Houses on the outskirts of Fort William, or 'Bill' as it is affectionately known, set the scale, with the snow-covered bulk of Ben Nevis towering above to the right. Getting the exposure correct was tricky and took experimentation with graduated filters and a few frames. It's a long drive back to Yorkshire but I managed to spare a few minutes to get it right.

Judge's choice Damien Demolder

HIGHLY COMMENDED

Corfe Castle
Dorset, England

Ever since I saw Corfe Castle for the first time, I knew exactly the picture I wanted to capture there. It took several attempts until I found the right conditions. Each time I returned home empty-handed, I wondered whether it would ever be possible to get my envisioned frame, as I live a good two-hour drive away and can only devote Sundays to my hobby. But I stayed motivated and kept on coming back until finally I caught the desired conditions. It just shows that if you remain determined and keep on trying you will eventually find what you have been looking for.

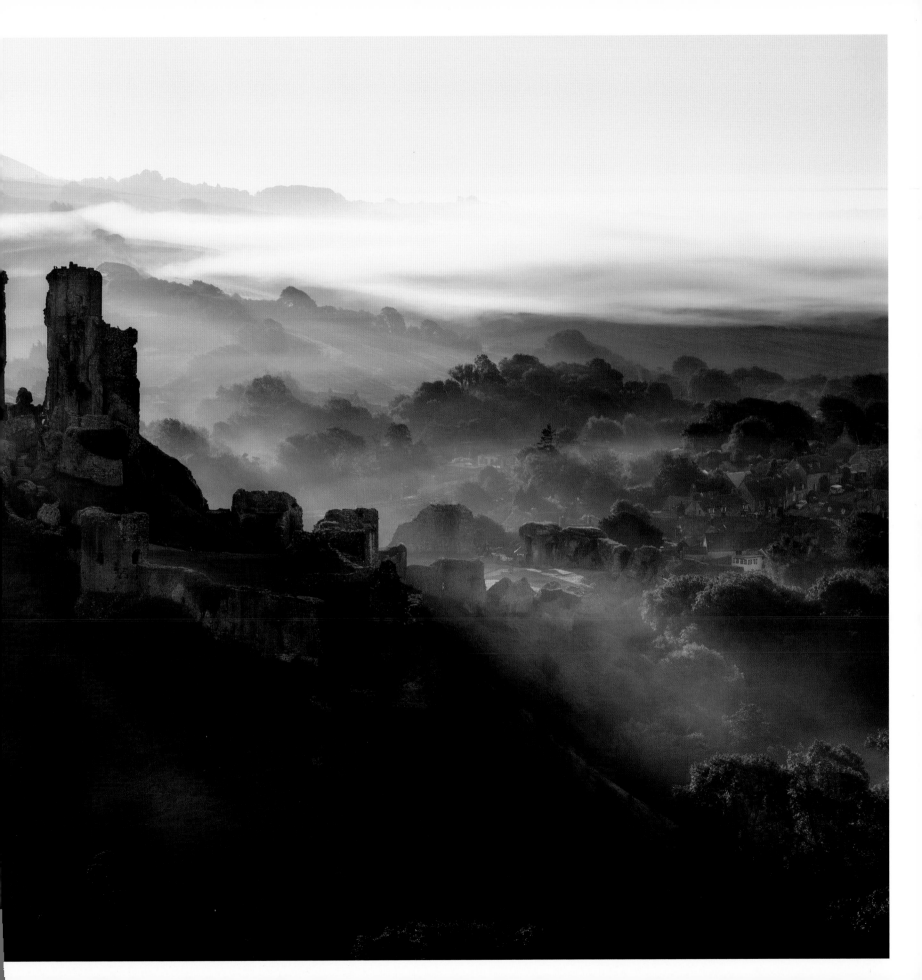

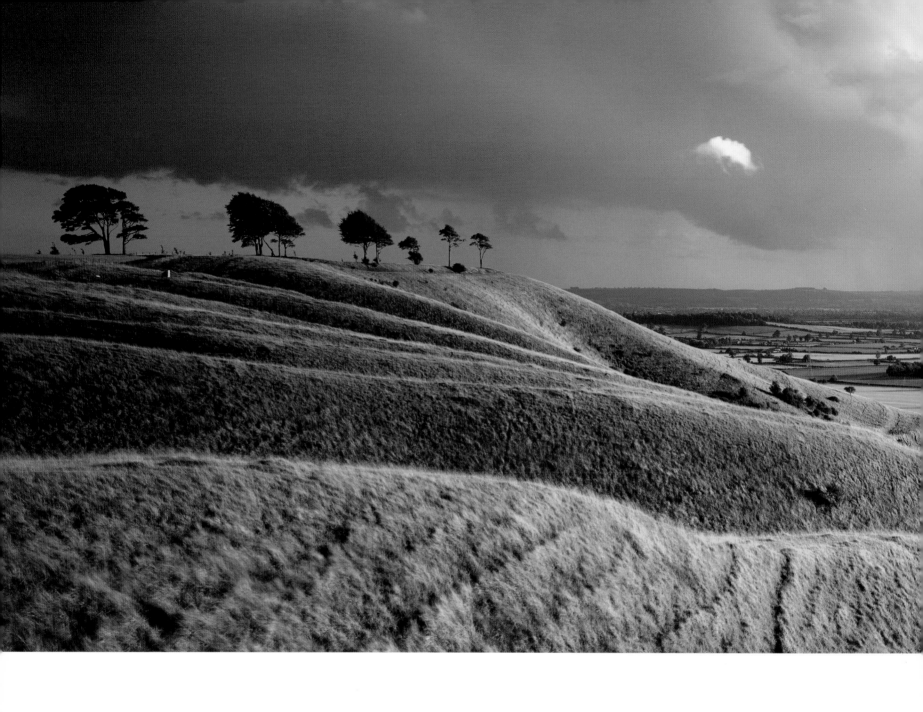

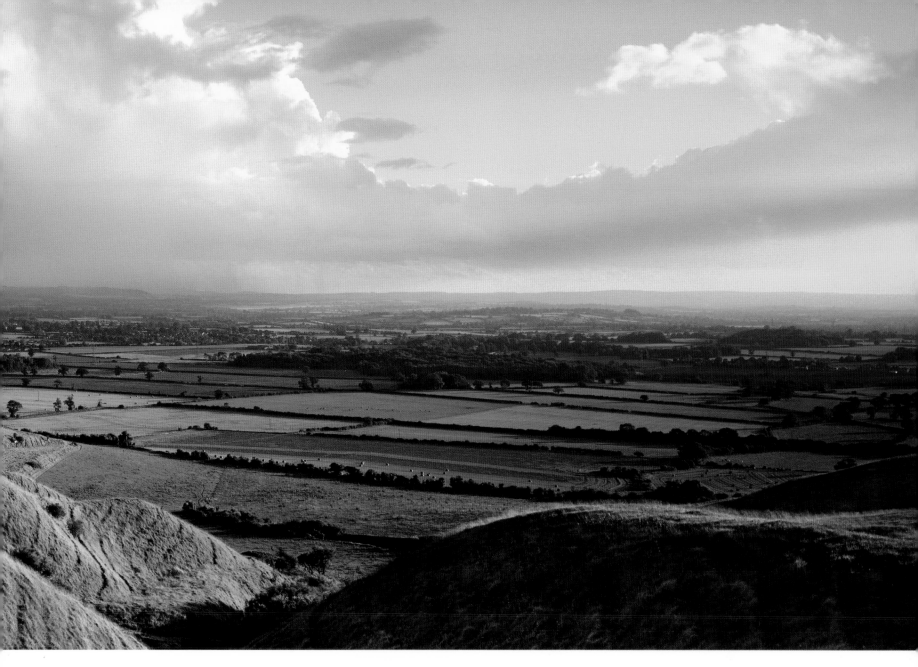

✝ JAMES HOURD HIGHLY COMMENDED

Roundway Hill
Wiltshire, England

I had visited this location a number of times previously but, on this occasion, dark storm clouds hung overhead with heavy showers in the distance. The edge of the weather front was clearly visible on the horizon and a strong wind made the lighting unpredictable. As the sun slowly dipped, a break in the clouds illuminated the hillside, which shone golden from long grass waving in the breeze. This was an impressive contrast to the dark, ominous sky above. I only had a few exhilarating minutes to record the scene before the sun finally dropped behind a ridge.

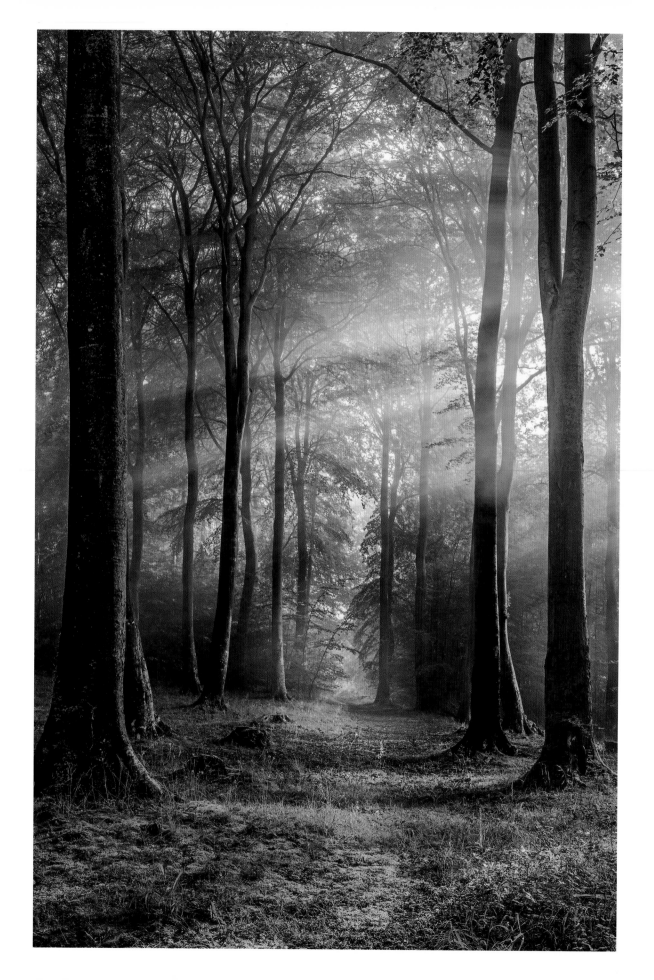

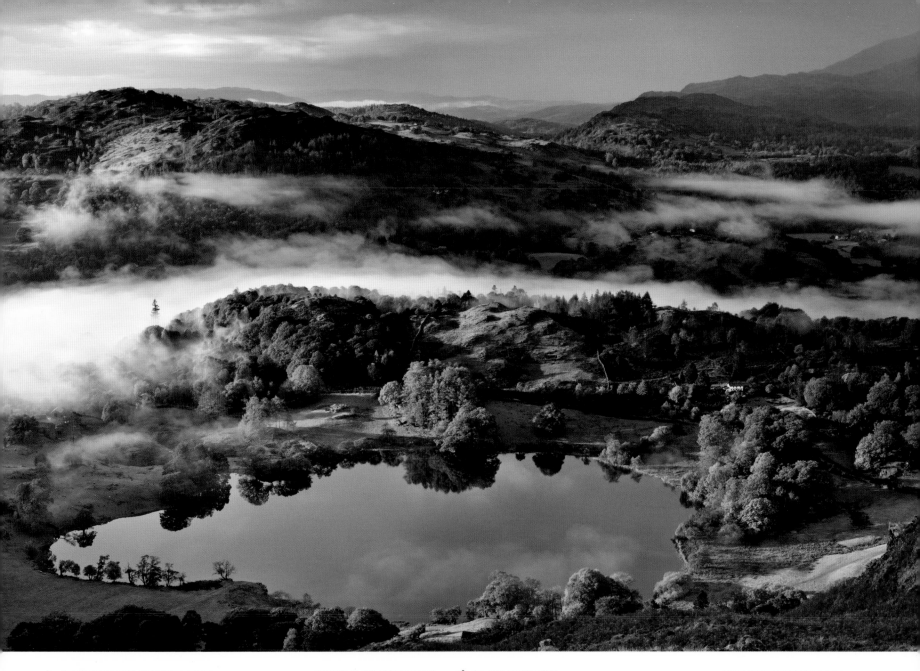

◄··· ROBERT WOLSTENHOLME

Buckholt Wood
Cranham, Gloucestershire, England

A path leads through the Cotswold Commons and Beechwoods National Nature Reserve, woodland which is in the care of a sympathetic private owner and Natural England. It's an ancient woodland, with records going back to the time of the Domesday Book. I work mainly around the Gloucestershire Cotswolds and, if there's a forecast for early mist clearing to sunshine, there's a good chance I'll be out for dawn. This was an especially beautiful morning, with just the right kind of mist.

⊤ ADAM BURTON

View from Afar
Lake District, Cumbria, England

For several years my family have visited the Lakes during autumn. We usually stay near this tarn, so I have photographed it often, never particularly well. But this morning was going to be different. I was actually photographing on the other side of the fell, but with the misty conditions and the possibility of morning sunshine breaking through I raced over to get a view in this direction. I knew the tarn was on this side, but didn't know what to expect. Upon arriving, my eyes nearly popped out as the view opened out before me. I was puffing so heavily from my hurried trip up that I genuinely struggled to change lens. Fortunately I attached my lens in time to catch the sun lighting up the tarn before the mist blew away.

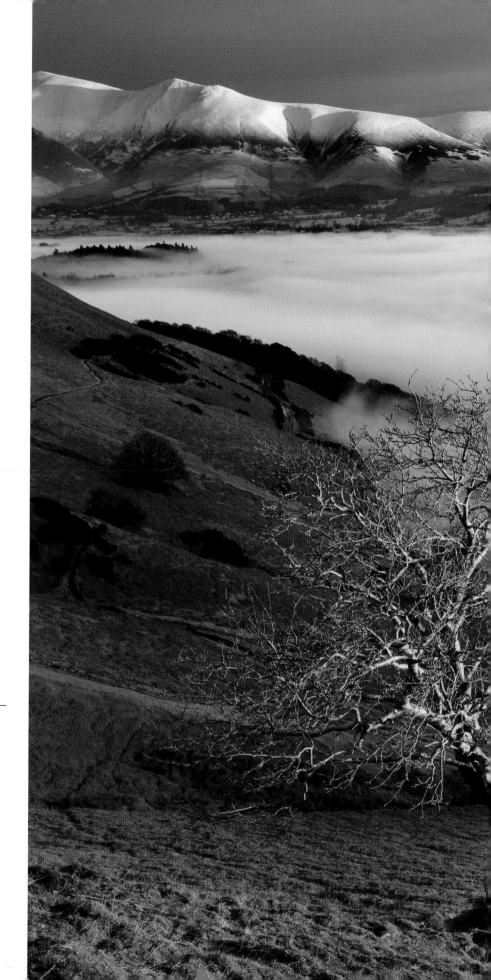

MANI PUTHERAN ····⟩
HIGHLY COMMENDED

Winter Sunrise from Catbells Ridge
Cumbria, England

I had been planning this picture for some years, as I wanted snow on the peaks and the slopes. This was taken in January after five attempts. The interesting thing I realised was that when the sun comes over the peaks in the east, there should not be any cloud. Even a small amount of cloud means you don't get the required intensity of light. The intense colour and light on the tree lasted for about a minute.

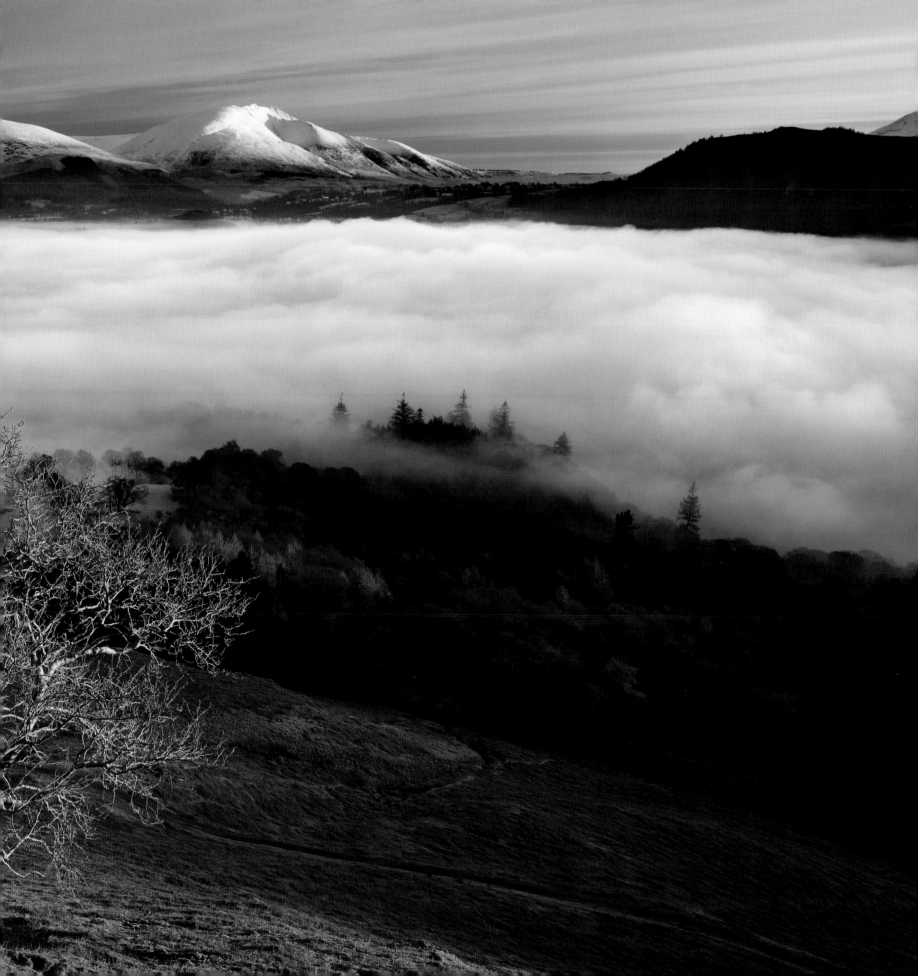

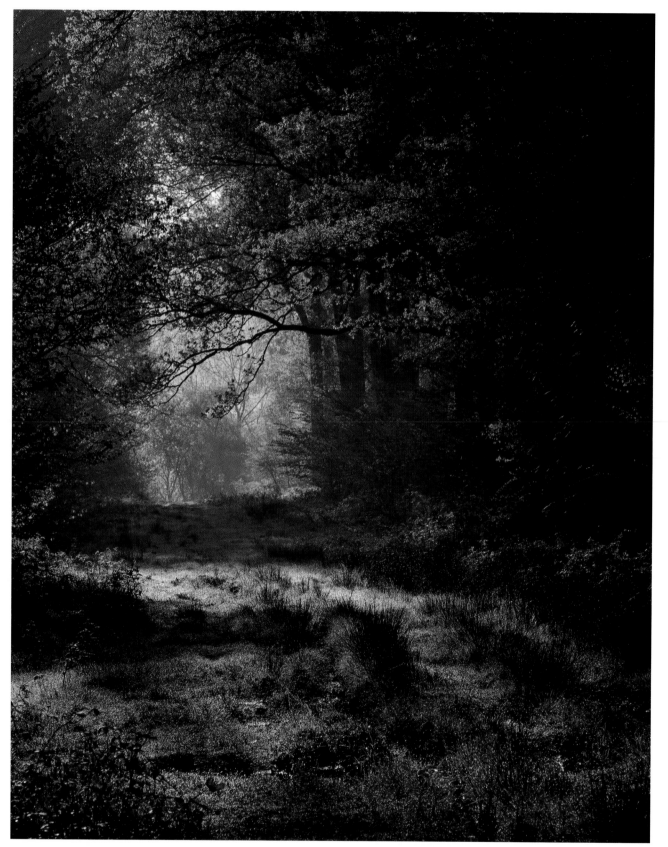

The Sunday Times Magazine

THE SUNDAY TIMES MAGAZINE CHOICE

◄··· PAUL MITCHELL
HIGHLY COMMENDED

Micheldever Woods
Hampshire, England

We are so fortunate in the UK to have many beautiful bluebell woods and Micheldever in Hampshire is certainly one of them. Arriving before dawn, I was not surprised to have four or five other photographers for company. As the sun rose higher and started to flood the woodland with harsh light it became clear that it was time to return to the car. It was during the trek back to the car park that I paused at one of the many tracks leading off the main path. The sun seemed to be finding its way through a gap in the trees and forming a pool of light on a patch of dew-laden grass. Being predominately green, this is an image with a limited colour palette but, for me, far more rewarding than a carpet of bluebells.

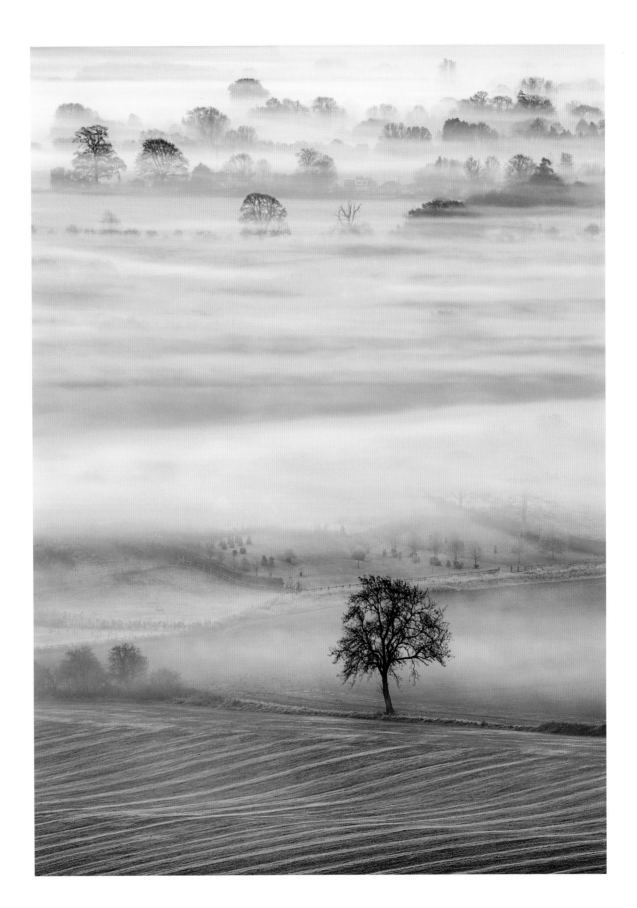

JOHN HODDINOTT ···≯
HIGHLY COMMENDED

Vale of Mist
Clench, Vale of Pewsey,
Wiltshire, England

Another early morning and another climb
to the top of Martinsell Hill. Its incredible
mist-laden views of the vale encouraged
me to push beyond my normal limits so
that I could reach the summit before the
dawn light spread across the landscape.
This was my third successive visit to
this location and each time I had been
overwhelmed at seeing rivers of low-lying
mist snaking over farmland and through
the trees, gently fading to soft ribbons as
the sun slowly peeked above the horizon.
As the mist softened, I was immediately
drawn to the lines of the farmer's field,
which in turn drew my eye to the lone tree
in the near foreground and so it was that I
captured in this very satisfying image.

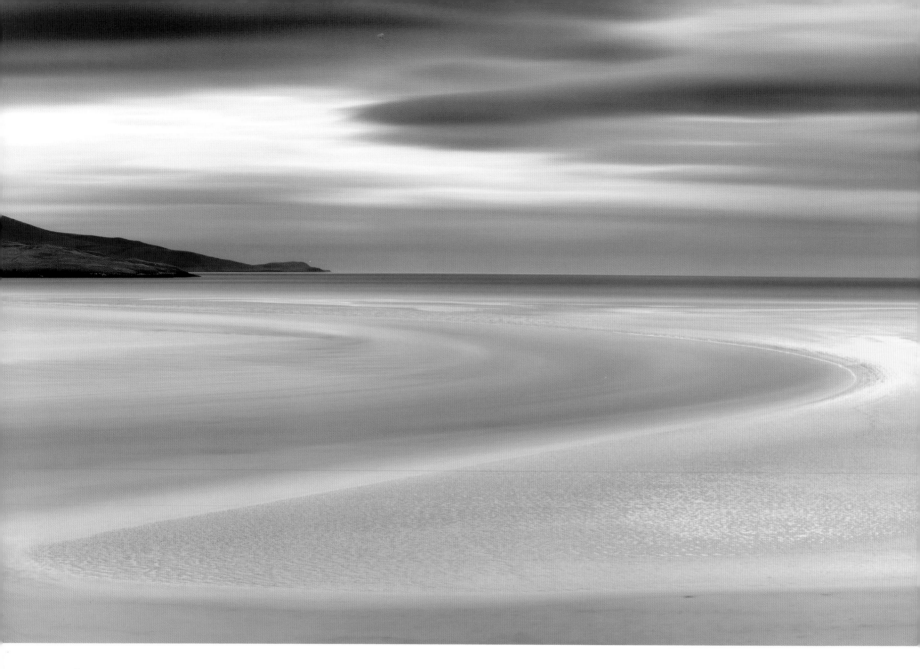

🕇 ROBERT BIRKBY

Curves
Luskentyre, Isle of Harris, Scotland

The light was fading but I was determined to catch a shot of the sweeping
sands whilst the tide was at optimal position. The first couple of frames
showed promise, with the stunning pastel tones of the water and sand,
but the sky looked slightly less impressive. I fitted a neutral density filter
to dramatically increase the exposure time and smooth out the whole
scene. There was just enough movement in the clouds and the resulting
shapes in the sky seemed to complement the curves in the sand below.

IAN CAMERON ⋯⟩

Fiddler on the Roof
Sgurr An Fhidhleir, Inverpolly, Scotland

The dusting of snow on the summit of 'The Fiddler' proved extremely
useful in helping to separate the foreground elements of wind-eroded
rock from the distant view over the roof of the Inverpolly reserve. The
dappled lighting created visual depth for this world-class scenic view.

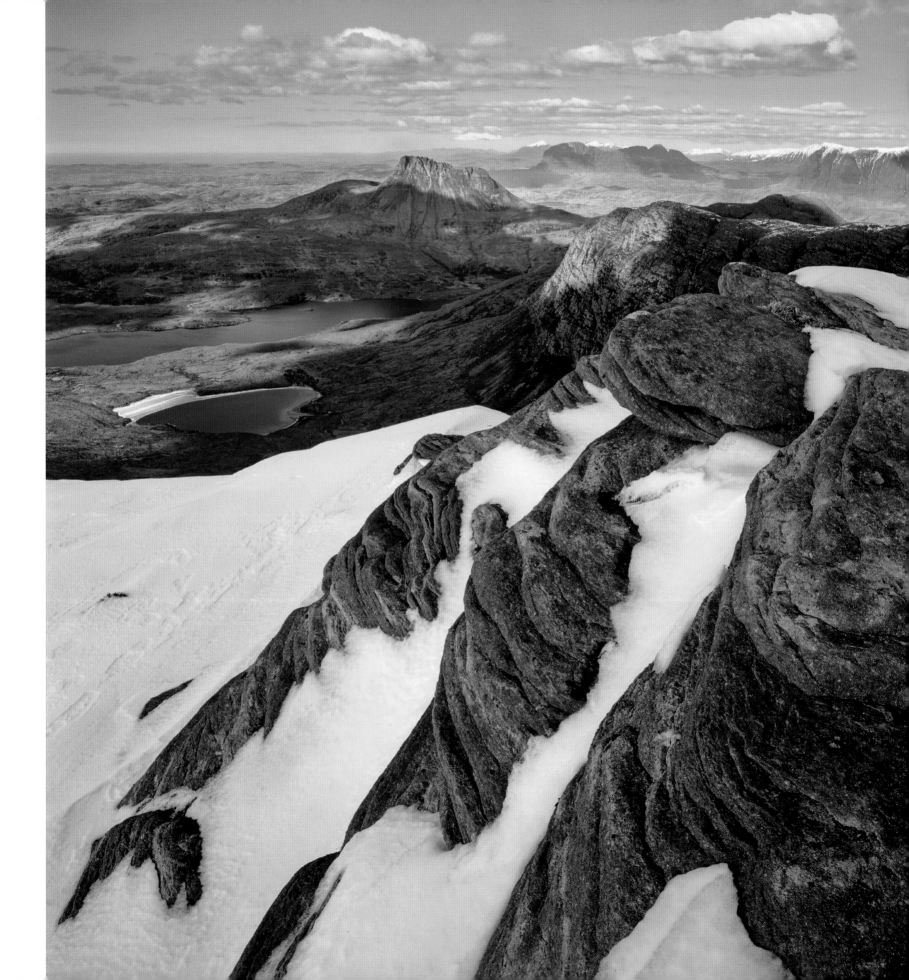

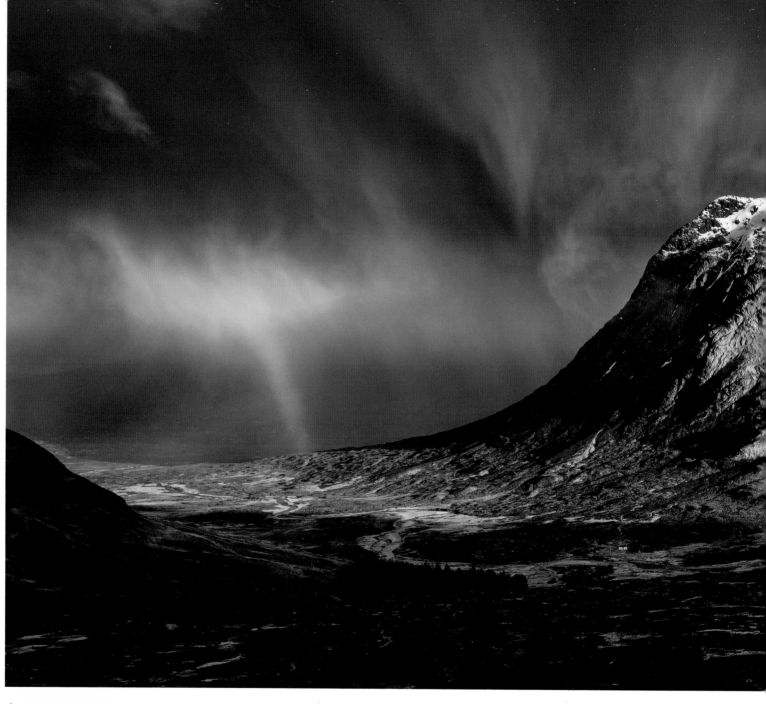

⚜ SCOTT ROBERTSON

Moody Buachaille in Late Spring
Glencoe, Scotland

On this particular night I wanted to photograph the mountain from a lesser seen angle so I took a wander up The Devil's Staircase. I approached the top and could see further down the glen; it didn't look inviting. A black wall of low, fast-moving cloud was heading my way. As the sleet began to fall I took cover. The sleet soon passed and the Buachaille came into view. What unfolded before me was something I'd never seen on the mountain before: light, wispy clouds rising quickly from the sun-soaked slopes, offset by a slate-grey storm cloud in the background. The cherry on top was the sudden and brief appearance of a small rainbow further down the glen. After making a few exposures I made my way down, a little wet, a little cold but with a smile on my face from what I'd just witnessed.

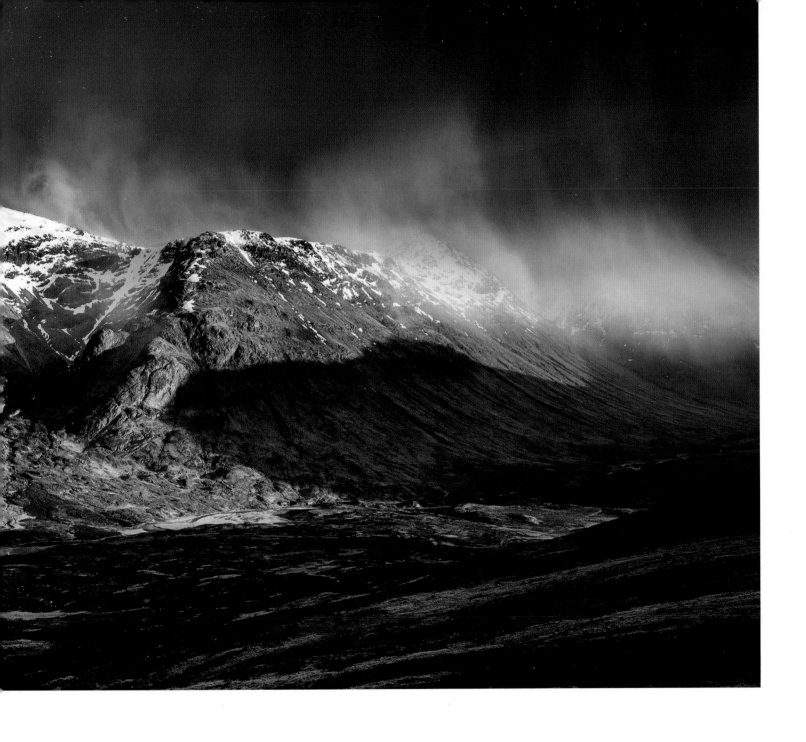

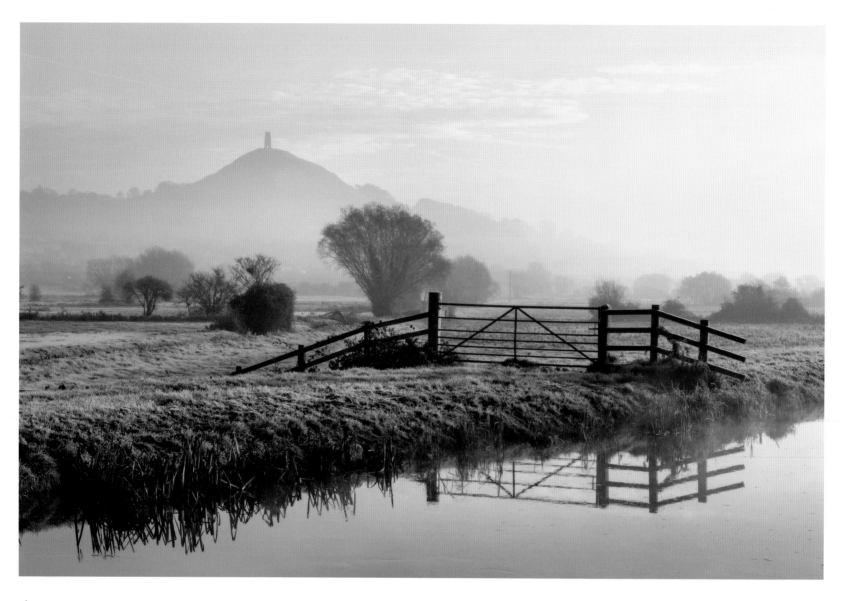

GRAHAM McPHERSON

Morning Fresh
Glastonbury Tor, Somerset, England

I live near Glastonbury on the Somerset Levels and, particularly in late autumn, we can have thick fog before dawn. As the sun rises and the mist begins to lift there is a window of opportunity for shooting an atmospheric image of the Tor. Sometimes the window is only a minute or even seconds. This image was taken on one of those magical mornings.

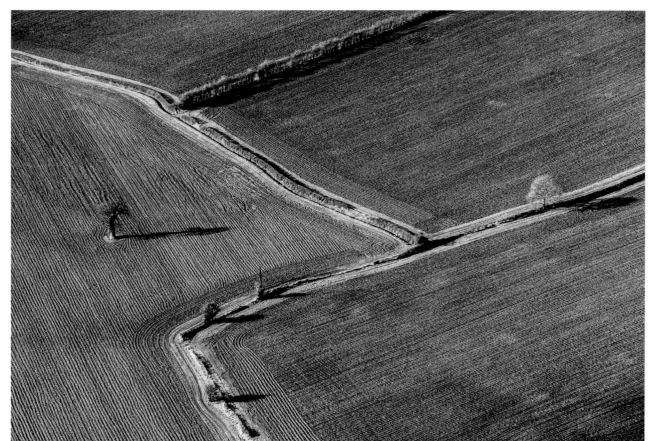

GRAHAM HOBBS

February Fields
Gloucestershire, England

This low-level aerial shot of the ploughed fields and hedgerows of a Gloucestershire farm was taken during a wonderful ride on a track inspection helicopter courtesy of Network Rail, which was the prize for last year's 'Lines in the Landscape Award'. They even lent me the camera! I had a great experience and took many, many pictures, so it seems fitting that one of them should carry the flag forward.

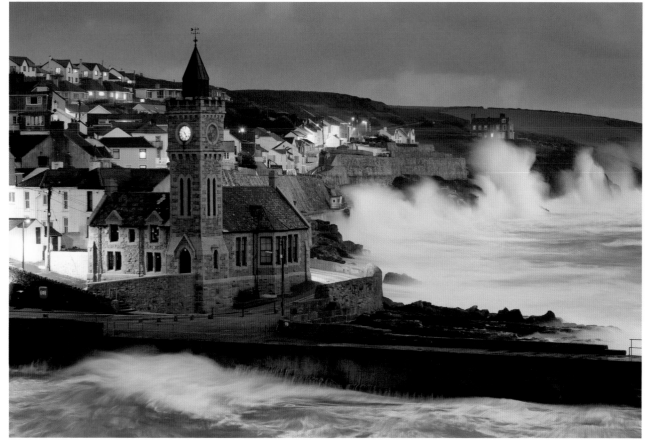

RUSSELL PIKE

Porthleven
Cornwall, England

An iconic scene for Cornwall that every now and then steals the limelight, gracing the front pages of the nation's papers, showing the impact of winter storms. As a surfer with more than enough respect for the ocean, I've spent my whole life being captivated by old postcards on sale throughout Cornwall showing this and other views in horrendous conditions, making my photograph look tame by comparison. I don't view this as a finished piece but more a work in progress as I'm constantly on standby waiting for that moment, preferably as night closes in, when a sense of warmth and protection is added by the glow of the seaside cottages.

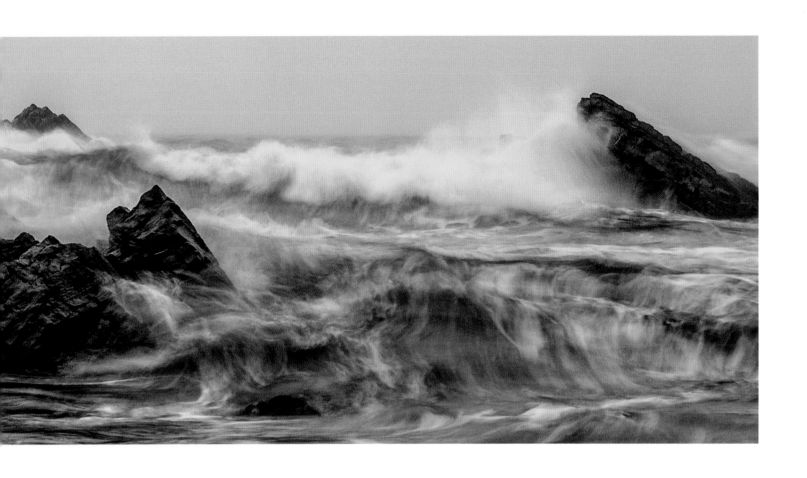

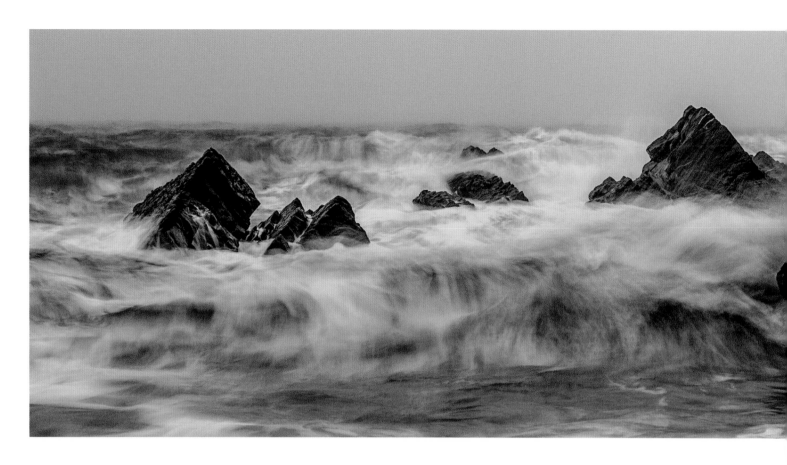

SCOTT WILSON

Hartland Quay
Devon, England

North Devon on a bad day. I travelled to Hartland Quay with a very different image in mind – a fiery sunset – yet encountered some of the wildest coastal weather I have seen. Filters were not an option, so I switched to a 50mm lens and just captured what I saw...I will get back for that sunset though.

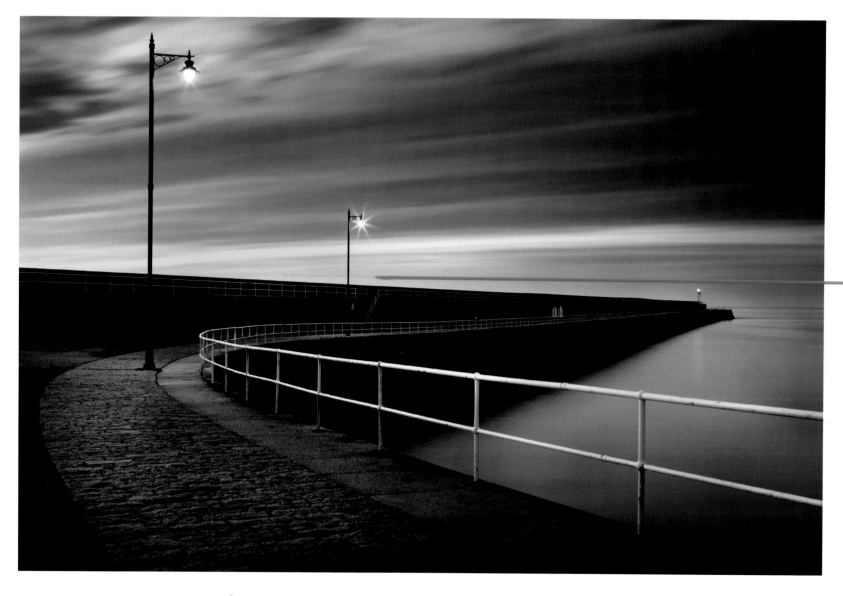

🕈 ANDY LE GRESLEY

Early Morning at St Catherine's Breakwater
Jersey, Channel Islands

St Catherine's Breakwater is situated on the east coast of Jersey, just 10 minutes from where I live. After visiting the area a few times with lots of walkers and fishermen about, I decided that the best time to shoot a clean image would be early morning when it would be quiet and the contrasts would be more profound in the early light. I picked a calm morning and took time to position myself in the right place to show off the long pier and its dramatic perspective. I decided on a long exposure so that the viewer's eye would not be too distracted by the different textures in the clouds and from the ripples in the water.

Judge's choice Rupert Grey

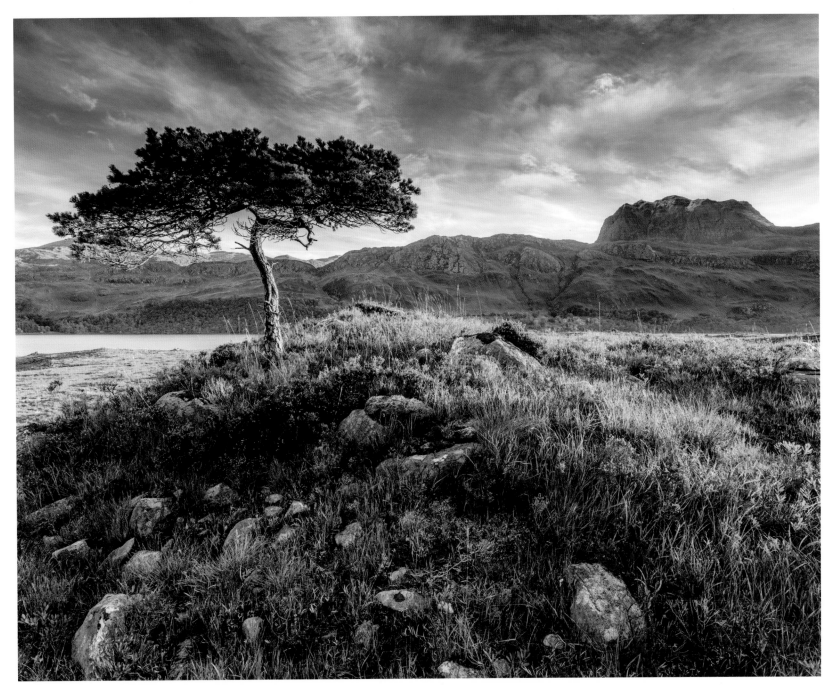

JIM ROBERTSON

Towards Slioch at Dawn, from Loch Maree
Wester Ross, Scotland

I made this photograph when on a short mid-October holiday break to Gairloch. I had scouted the location on the previous afternoon and drove down from Gairloch to Loch Maree before dawn to reach the location in time to catch the early sun the next day. It was a glorious autumn morning and I waited for the sun to catch the stunted pine.

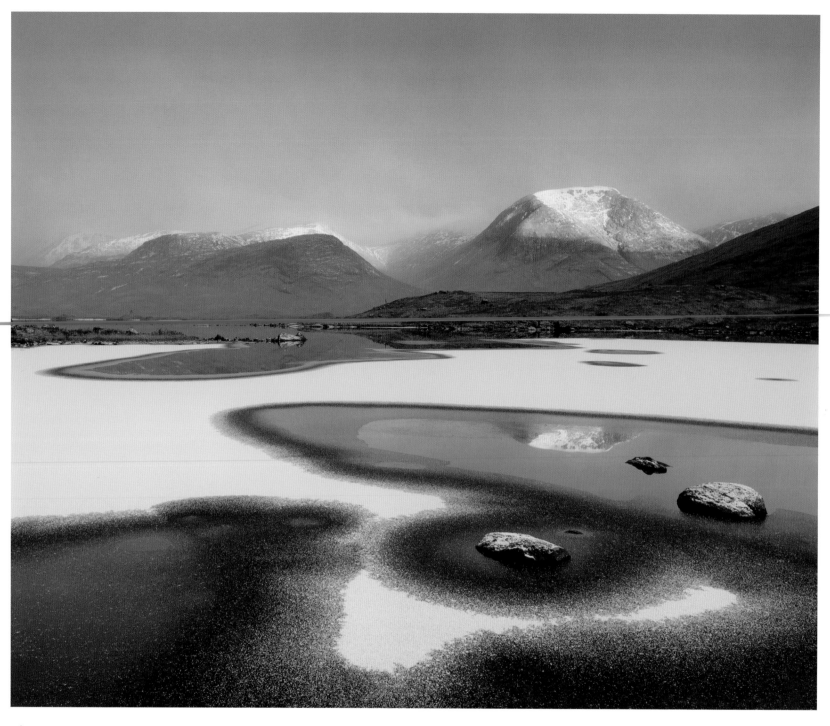

PAUL HOLLOWAY

Loch Dochard at Sunrise
Glen Kinglass, Scotland

Loch Dochard is a remote loch nestled in the hills south of Glencoe, five miles from the nearest road. I camped on the shore of the loch so I would be there for sunrise. A light overnight snowfall had formed these wonderful sculpted snow shapes on the loch ice. I composed the image to fill the foreground with the ice forms curving around three rocks in the loch, the lovely lines of the ice leading towards the mountains, being careful to keep the reflection of the mountain separate from the rocks. As the sun rose it painted the mountain with golden light and a passing snow shower above the mountains caught the morning glow beautifully.

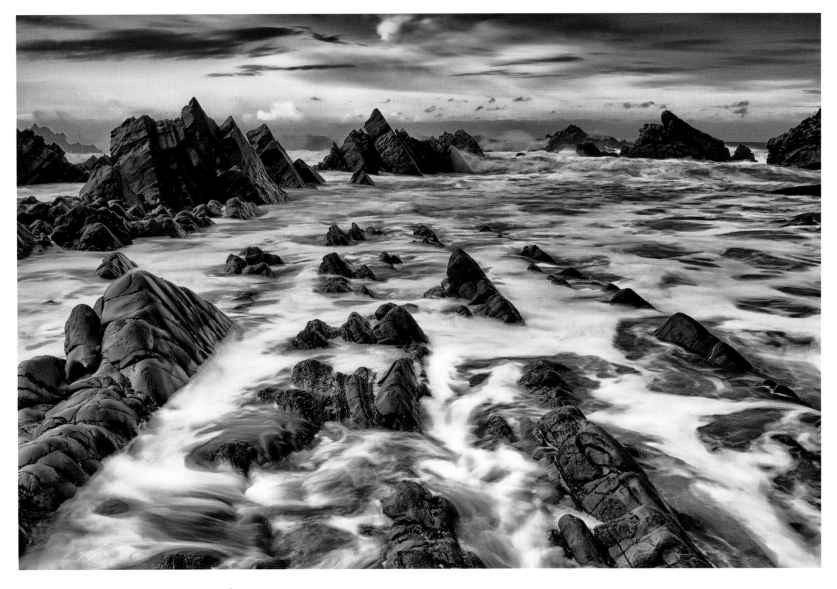

ALAN RANGER

Atlantic Ruins
Hartland Point, Devon, England

It took several months of planning and watching weather/tide information to make the trip in the middle of the night from Coventry to Hartland in Devon for this shot. Not knowing exactly where to go in the darkness, or what to expect, added to the excitement. The violent incoming tide made this shot dramatic in the capture and in reality, as I was in danger of becoming cut off from an escape route and getting a regular waist-high drenching, but the stormy nature of the scene was compelling. I could quickly see and appreciate the pure power that the ocean has, carving the rocks into sculptures that resemble something you might see on a lunar landscape.

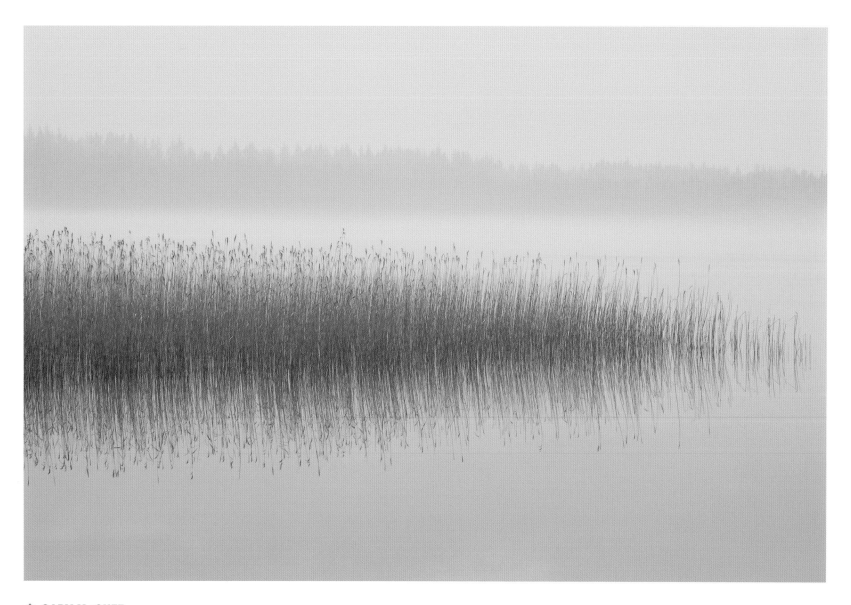

⚘ **GARY McGHEE**

Reedflection
Lake of Menteith, West of Stirling, Scotland

Shoreline reeds taken at the Lake of Menteith on a foggy afternoon. Whilst looking for a composition of these reeds, I noticed the placement of the layers – the main subject being the reeds, the outline of which is nicely helped by the water and sky splitting the two land groups. I also noticed the shape of the distant trees that echo the shape of the reeds.

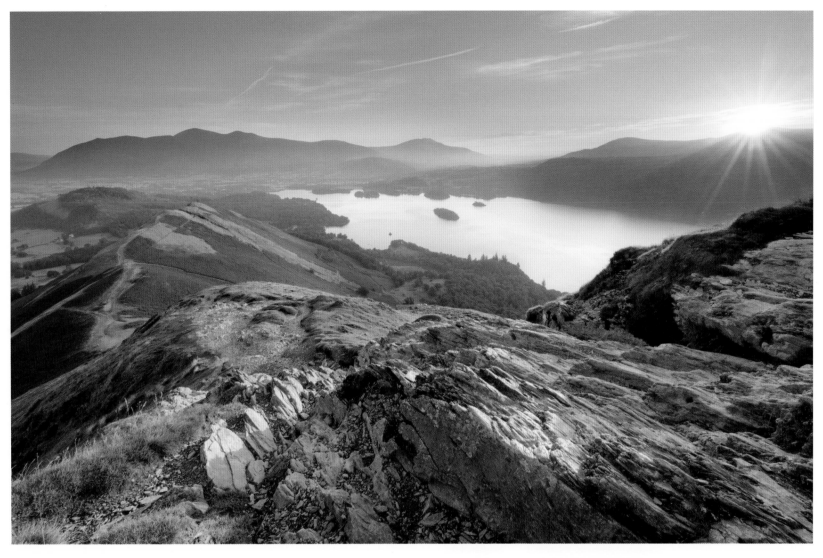

BART HEIRWEG THE VISITBRITAIN 'YOU'RE INVITED' AWARD

Catbells Sunrise
Cumbria, England

Although many photographers had already done this before me, the summit of Catbells, overlooking the famous Derwent Water, was one of those viewpoints I definitely wanted to photograph when visiting the Lake District for the first time. It's a fairly easy climb up and the view from above is breathtaking. I placed a large rock in the foreground and, with the path leading the eye towards Skiddaw in the far distance, this turned out to be the most pleasing shot of the trip.

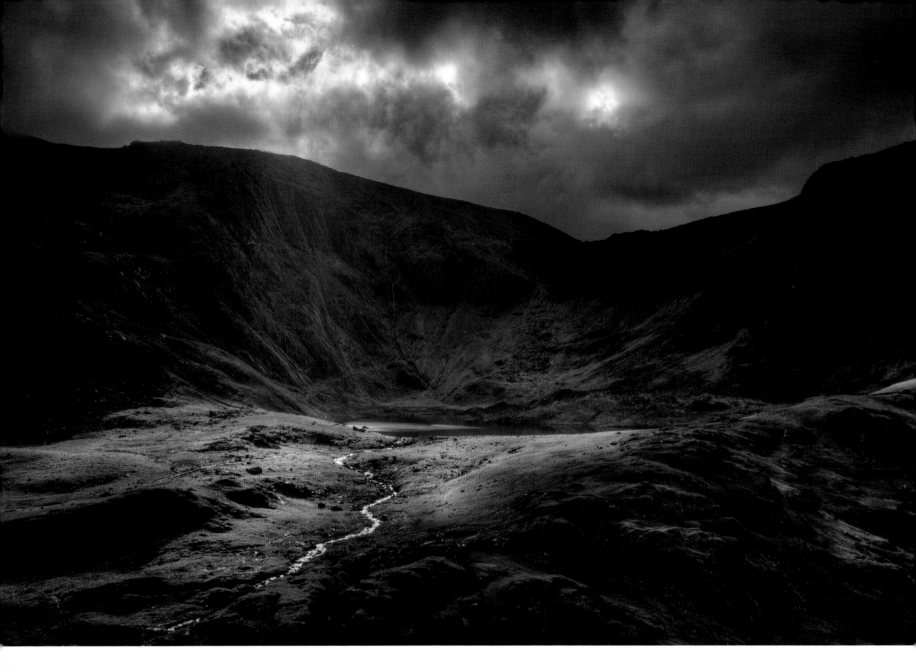

✝ RORY TRAPPE

Cwm Idwal
Snowdonia, North Wales

The scene is of Cwm Idwal in the Ogwen Valley of North Wales. I was photographing aircraft at the time from a hill opposite called Pen yr Ole Wen. I only had one camera body with me, so it was a frantic few seconds when I spotted the cloudburst. I quickly took off the 300mm lens and set up the camera on a tripod. I must have been talking to myself at the time, reminding myself to check levels and avoid knocking the tripod during the exposure, as my dog, Gelert, was looking at me in a puzzled way. This is what photography is all about for me; always expect the unexpected and try to make the most of it. Great fun.

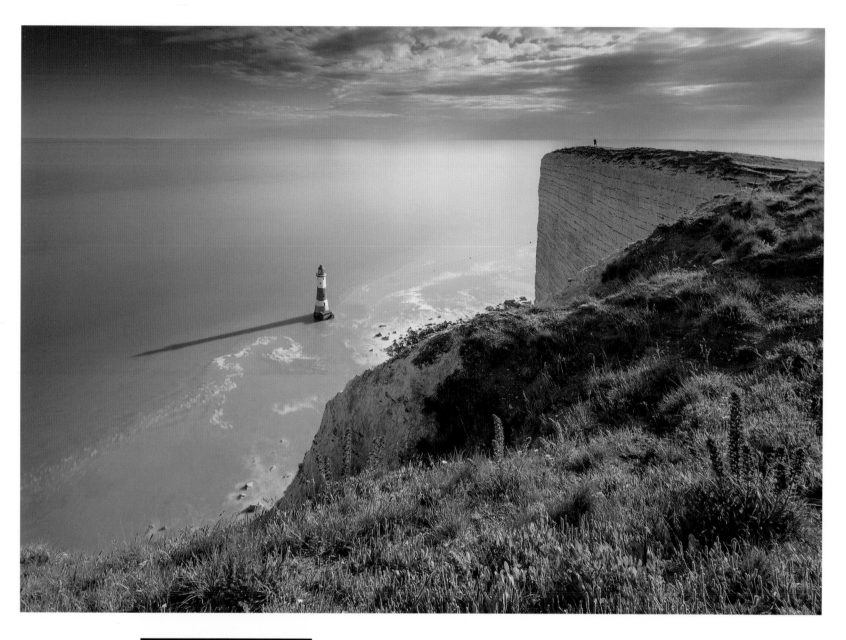

HEAVEN OF PHOTOGRAPHY

🕇 **MIREK GALAGUS** THE CALUMET PHOTOGRAPHIC 'THIS IS BRITAIN' AWARD

Sundial
Beachy Head, East Sussex, England

I have visited Beachy Head lighthouse many times and got numerous shots from the top and the bottom of the cliffs. This photograph is special to me, as it shows the enormous size of the cliffs. I was lucky to capture in shot a man who came to the edge, making the frame more interesting.

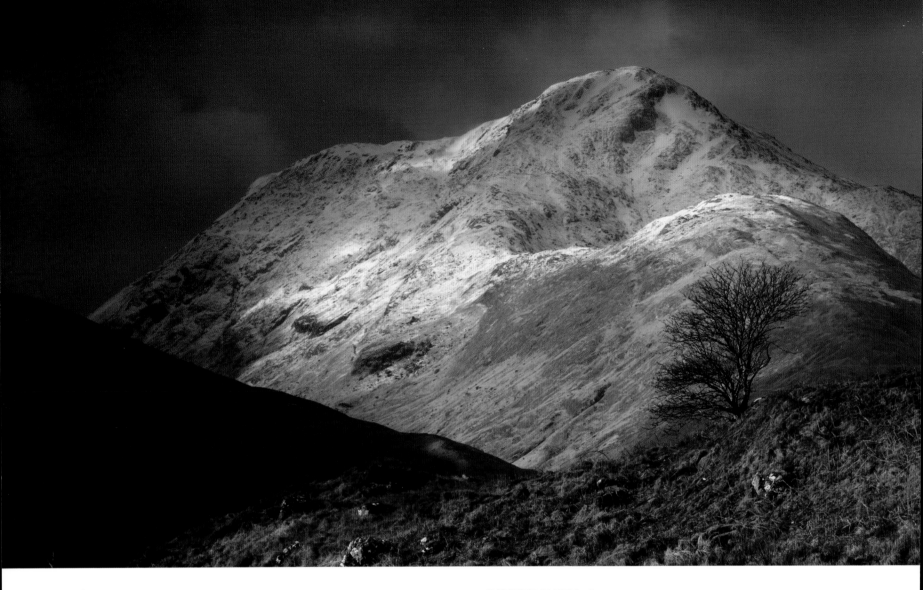

⊤ ANGUS CLYNE

Storm Light
Sgùrr Thuilm, Glen Finnan, Highlands, Scotland

A mixture of dark storm clouds with driving snow and sleet showers during a North Westerly gale are interspersed with fleeting sunbeams lighting up the peak of Sgùrr Thuilm in the northwest Highlands of Scotland. Of the 30 or so images taken in the five-minute period when the light was really good, most were unusable because of camera shake caused by the strong, gusting wind.

GARY WAIDSON ⋯⟩

Tŵr Mawr
Llanddwyn Island (Ynys Llanddwyn), Anglesey, Wales

Tŵr Mawr is one of two towers built on this small tidal island. The earliest, Tŵr Bach, was a beacon for ships but was later replaced when this building became the main lighthouse around the middle of the 19th century. Reminiscent of local windmills, it may indeed have served that purpose before being used as a lighthouse. The mountains in the distance are part of Snowdonia. This was my first visit to the island and I had set out to produce a series of shots overnight and this was taken in the last full light before the sun dipped below the horizon. Shortly after this, the last of the visitors drifted away back to the mainland and I had the place pretty much to myself until morning.

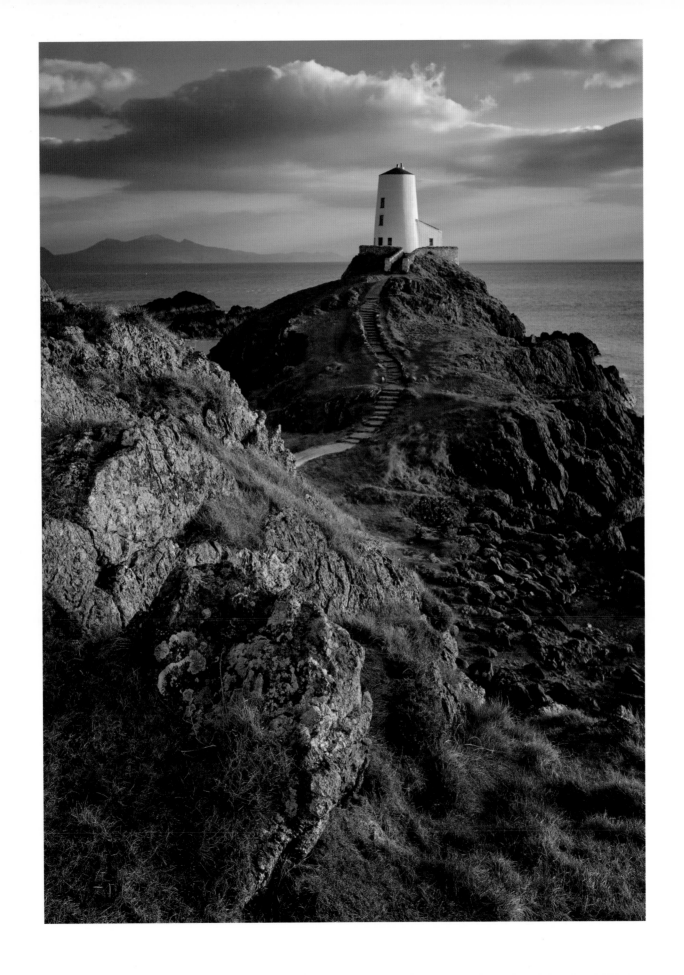

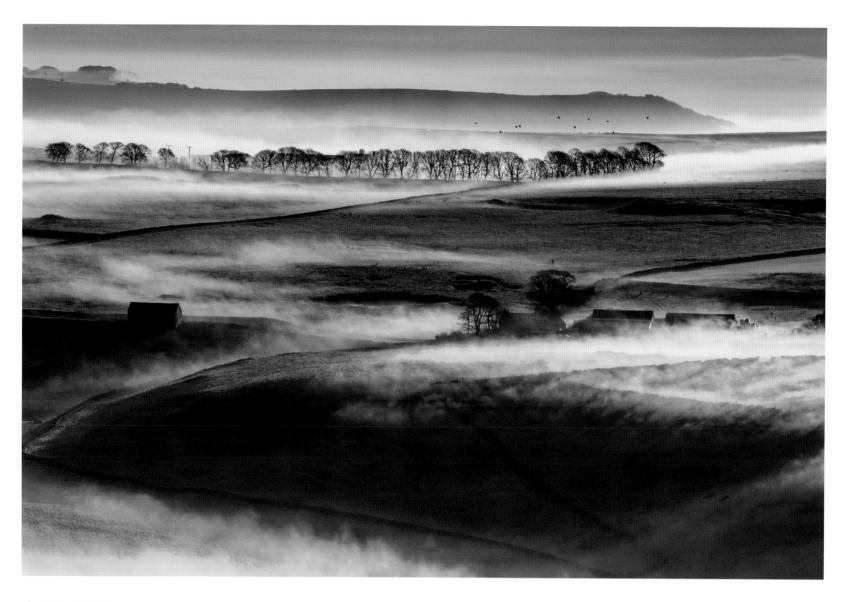

JOHN FINNEY

Windy Knoll
Castleton, Derbyshire, England

I set off from home in the dark and headed to Rushup Edge for sunrise in the Peak District, about a 20-minute drive from my house. The weather forecast was nothing special, just a small chance of mist. To my surprise the conditions were much foggier than I was expecting. As I climbed Rushup Edge, the curtain of fog suddenly cleared to reveal a golden sky from the rising sun, with mist rolling along the hills on the other side of the valley. In this shot you can see the farmer just setting off to feed his livestock.

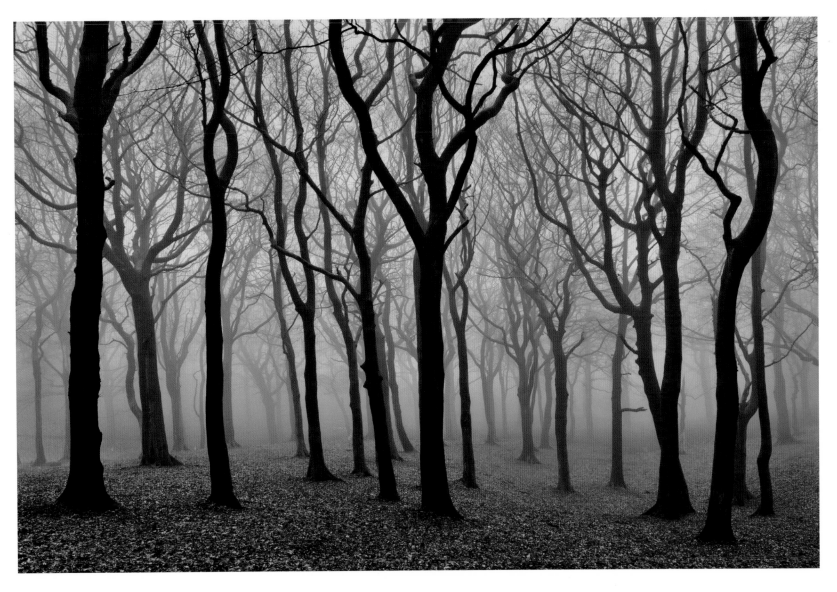

MATTHEW ASPDEN

Tandle Woods in Fog
Oldham, Lancashire, England

Tandle Hill Country Park is a location close to my house, therefore it allows me to take advantage of any promising weather conditions that may occur. I had noticed the potential of this viewpoint, with its symmetry of the mature beech trees, a couple of years earlier, and knew it would be suited to foggy conditions. I just needed to be patient to bring this visualisation together. For me, the image works because of the balance of the trees and the depth given by their gradual recession into the fog.

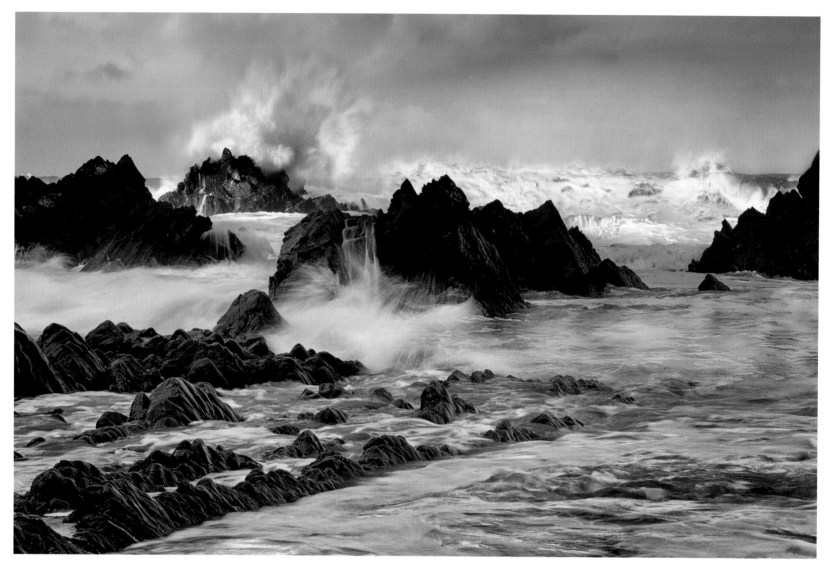

ALAN RANGER

Atlantic Force
Hartland Point, Devon, England

After a drizzly start I was rewarded with a burst of sunlight that just appeared from the cliffs behind me and lit up the rocks perfectly, which combined with the violent incoming tide made this shot dramatic in the capture and in reality, as I was in danger of becoming cut off from an escape route.

RAYMOND BRADSHAW ···›

Skye Lighthouse
Neist Point, Isle of Skye, Scotland

I arrived early evening in the depths of winter so that I might hopefully capture some interesting light and mood. I eventually settled on the composition and patiently waited for the light to darken so that I could try a long exposure. I used a 10-stop ND grad for 302 seconds to soften the sky and sea as I wanted the softness to contrast with the hardness of the jagged, unforgiving rocks.

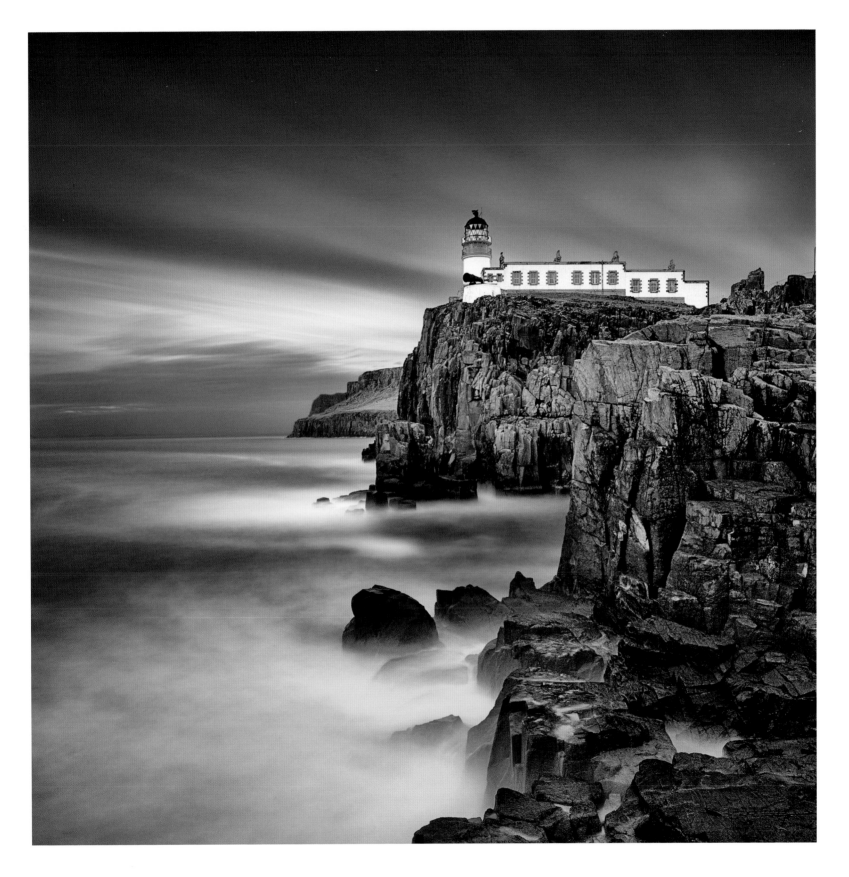

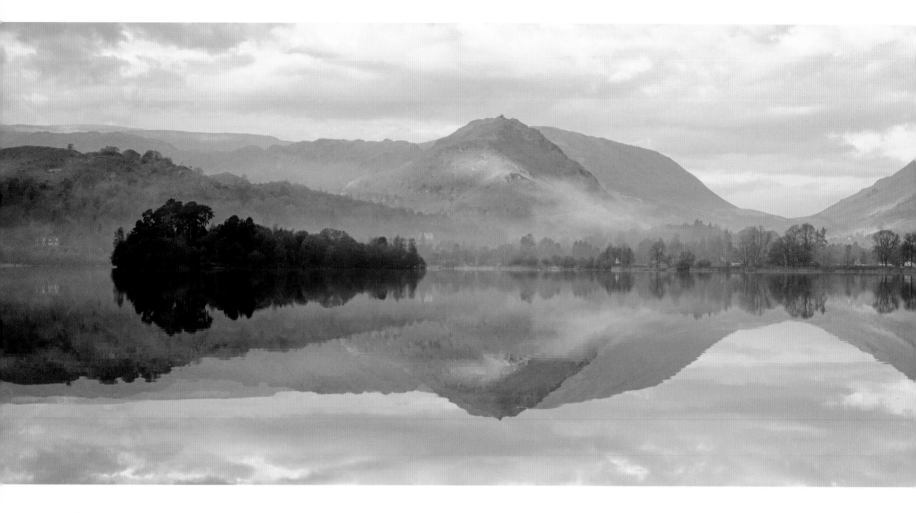

ALAN RANGER

Grasmere Light
Cumbria, England

There's no such thing as bad weather or light when it comes to photography; just different light and weather to suit different types of shots. This image was taken on a dull, hazy, damp day in the middle of November. The diffused light enhanced the tranquillity of the scene and helped to produce the subtle, opaque feel.

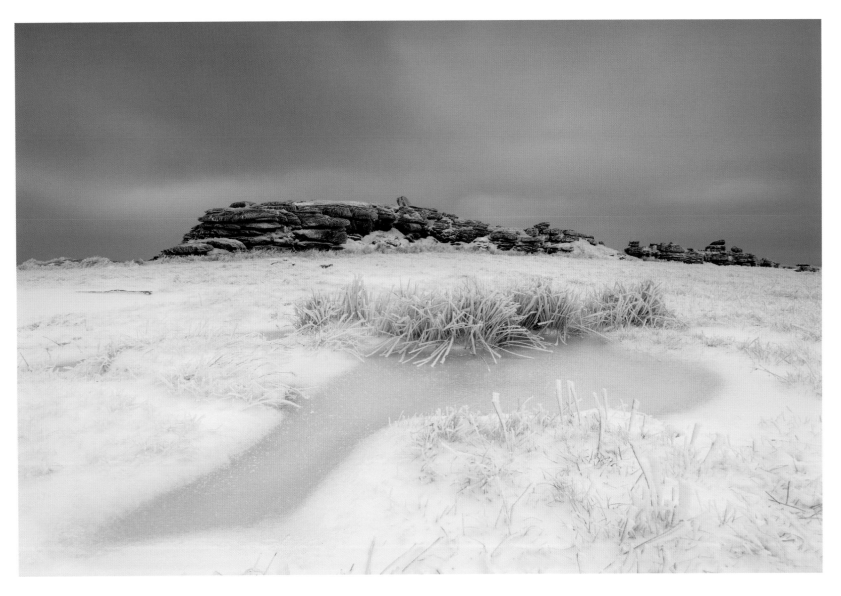

GARY KING

Winter on Great Mis Tor
Dartmoor, Devon, England

The summit of Great Mis Tor in the depths of a harsh and bleak winter. Driven overnight by high, freezing winds, the ice crystals form on the granite rocky outcrop and blades of grass surrounding it. Small frozen pools litter the Tor and the ice thickens in sub-zero temperatures as foreboding storm clouds approach from the west.

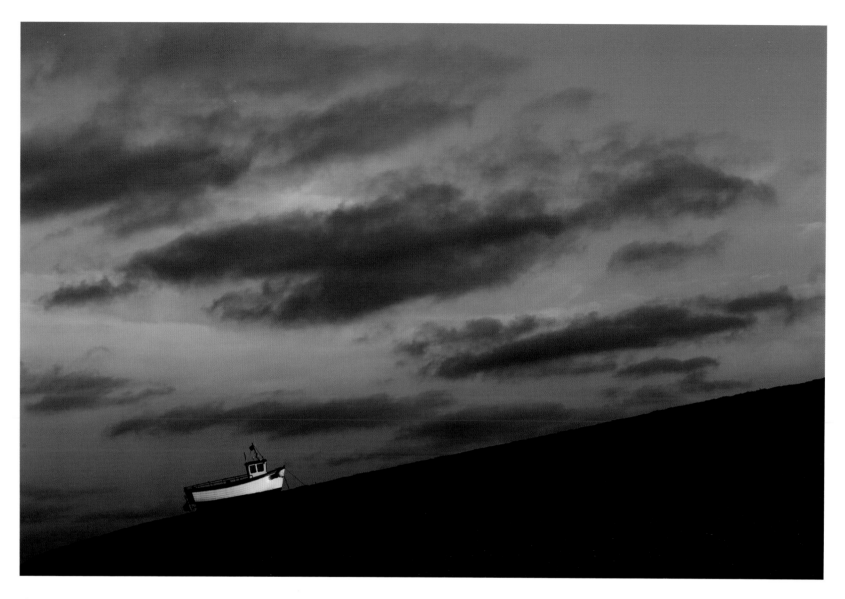

✝ **ALAN O'RIORDAN**

Dungeness Beach at Sunset
Kent, England

This was an attempt to present a slightly different take on Dungeness Beach, where the temptation is to fill the frame with fishing boats lined up against fading beach huts. I liked the isolation of the single boat in this scene, caught in the sunset and dwarfed by the sky.

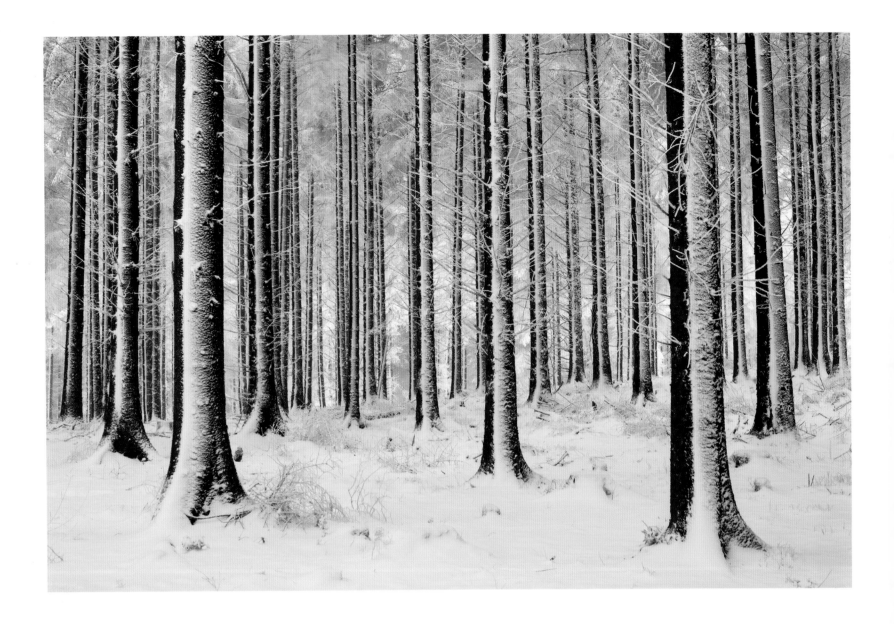

🌲 **ESEN TUNAR**

Not Black & White
Somerset, England

After the heavy snowfalls in January, I went to the Quantock Hills in Somerset to find myself in a totally different world. Snow covered pretty much everything in sight, including these conifer trees, and there was not a soul to be seen all day.

TERRY GIBBINS ⋯⟩

Underwatch
Dartmoor, Devon, England

An early start and drive to a planned location led us through banks of mist and fog. We decided to abandon our original plan to make the most of the conditions around us. I spotted this small tree under the watchful eye of its elders and took its picture as the mist swirled around me.

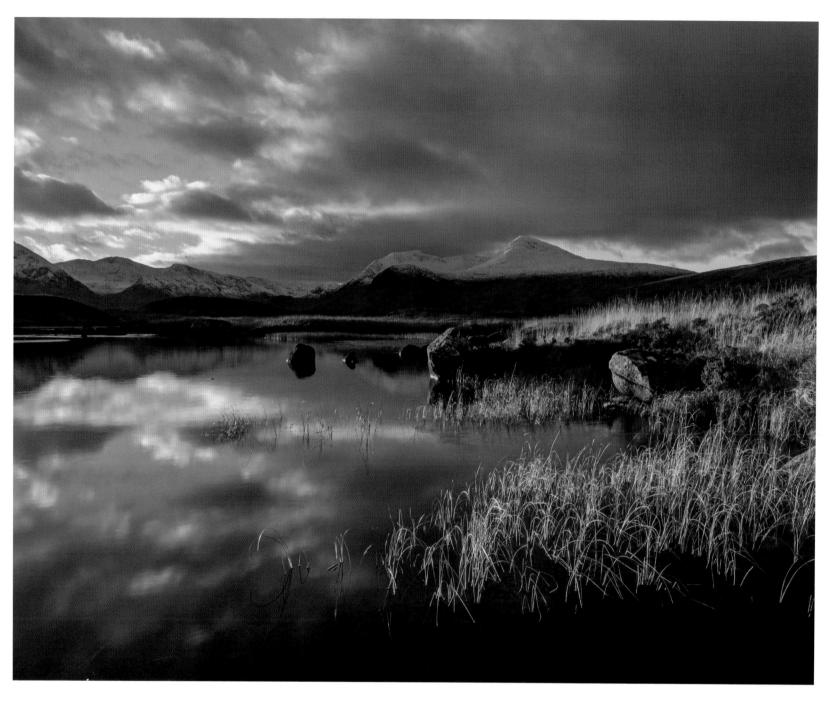

✝ **DAVID TAYLOR**

Lochan na Stainge
Rannoch Moor, Scotland

The Scottish Highlands are a favourite destination. This was shot on the first evening of a photography trip in the last week of November. In terms of the light, it was the best evening of the trip. A few days later it started snowing and kept on snowing. Fortunately, I was on my way back south by then. Though I can think of worse places to be stuck...

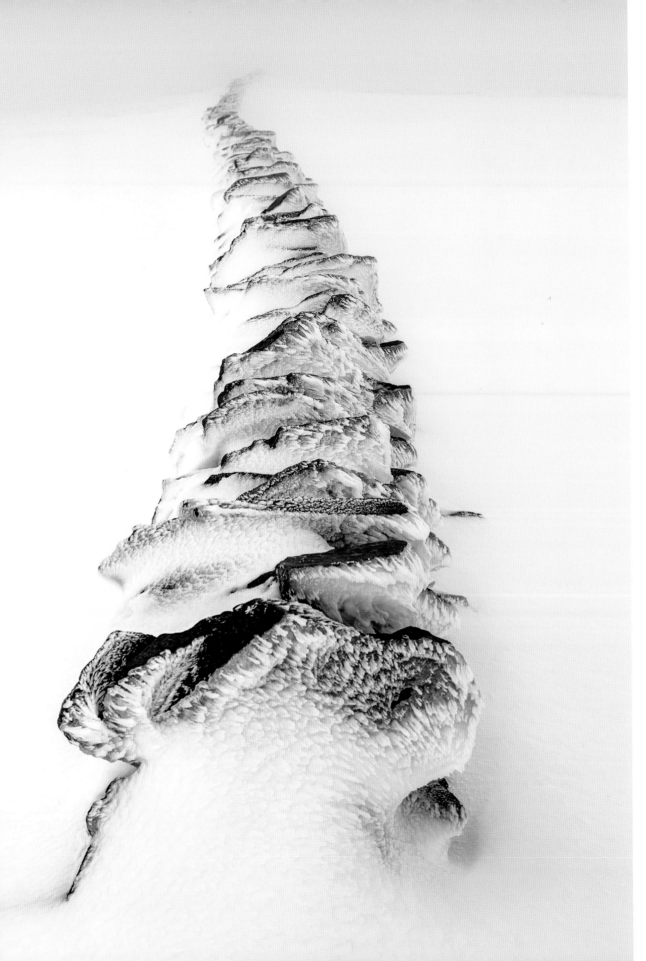

···› ALUN ALLCOCK

**Y Draig Cysgu
(The Slumbering Dragon)**
Snowdonia, North Wales

High on Foel-fras, winter has taken hold of
everything within its frigid grip. Encased
in ice and in the soft light of a misty lair, a
slumbering dragon lies motionless in the
snow waiting for warmer times to stir again...
Built by Napoleonic prisoners of war, this wall
normally stands over four feet high and at
over 3,000 feet above sea level is the highest
in Wales.

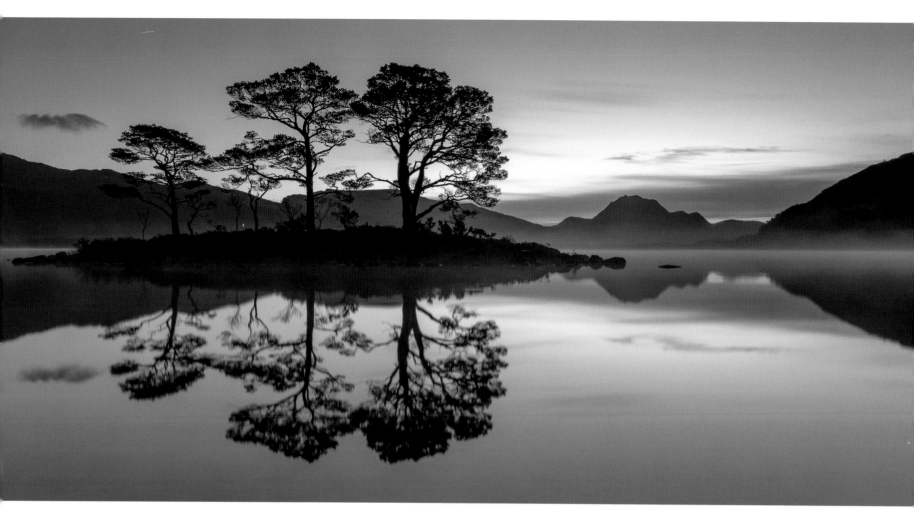

ANDREW JONES

Loch Maree at Dawn
Wester Ross, Scotland

The weather forecast the previous night had looked promising, so the following morning an early start was necessary to get to this location before it started to get light. Over the next hour the conditions were perfect. A thin mist floated over the surface of the loch and the distant clouds were flushed with the colours of twilight as the sun began to rise. As usual when visiting waterside locations with a view to taking some photographs, I was wearing my Wellington boots. This allows more compositional options. Here, I waded out a few metres into the loch so I could get a composition without any distracting foreground rocks or vegetation. Each time I moved my feet I had to wait about a minute for the ripples I created to abate before taking the next shot.

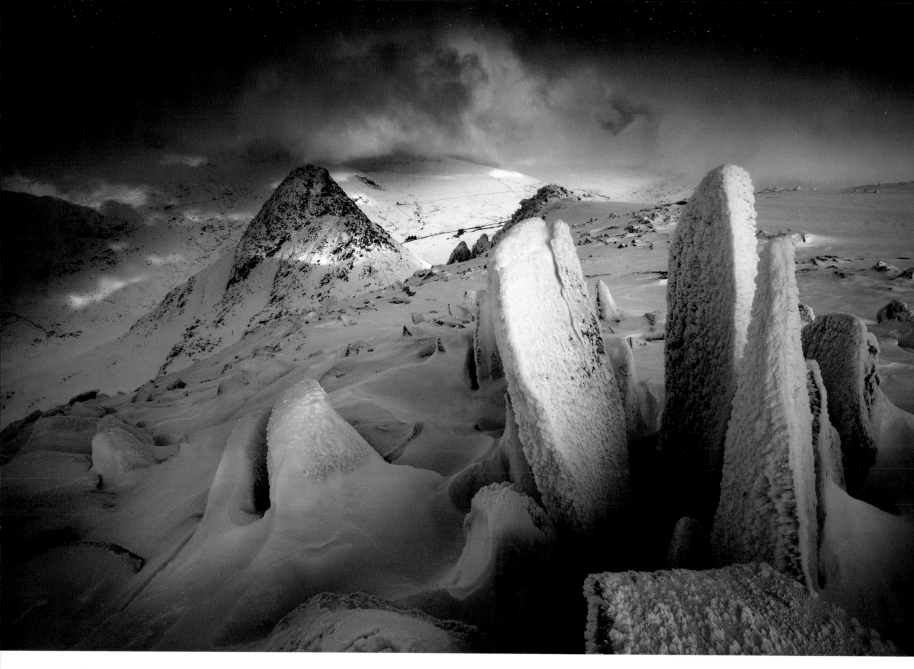

JAMES APPLETON

Rime Ice on Bristly Ridge
Snowdonia, North Wales

After a bitterly cold night camped out by Bristly Ridge and on waking up to thick cloud around the summit, I decided to sit the morning out in hope of better weather later on. A few hours into daylight the clouds began to clear the peaks and light started to illuminate the valley below. These incredible iced slabs of rock provided a solid and detailed foreground to complement the view of Tryfan in the background.

GRAEME KELLY

Talisker Point
Isle of Skye, Scotland

It seems so often that the landscapes of the UK are overlooked in favour of those in the wilder parts of the world. The scene that greeted me that evening at Talisker Bay rivalled anything I had seen anywhere else, even in picturesque New Zealand. The isolated sea stack, smooth rocks and the magnificent sunset reflected on the dark sand made for a magic scene I was only too happy to capture.

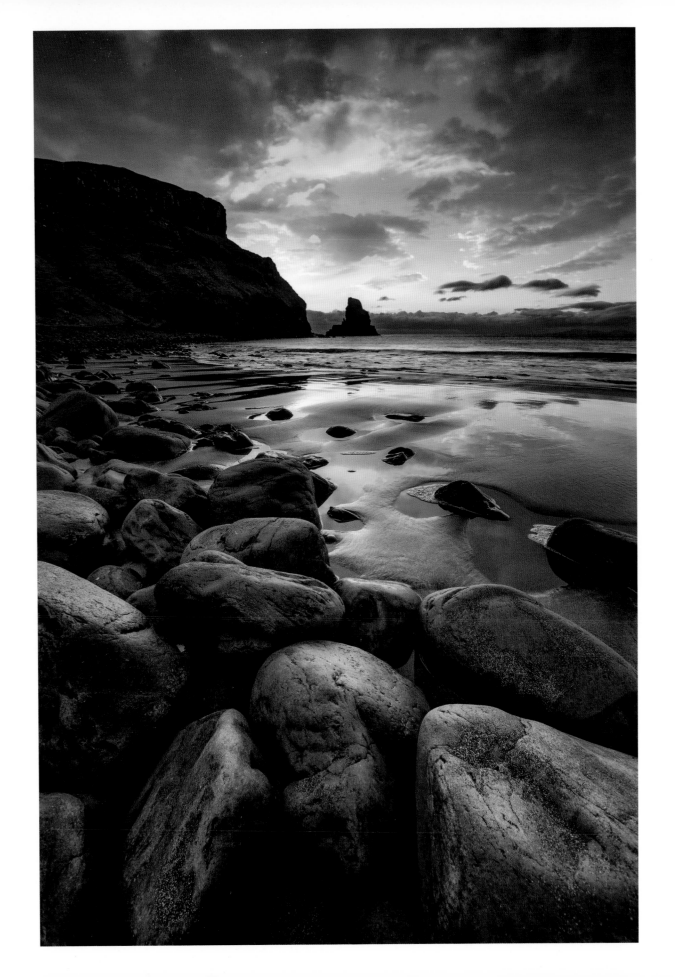

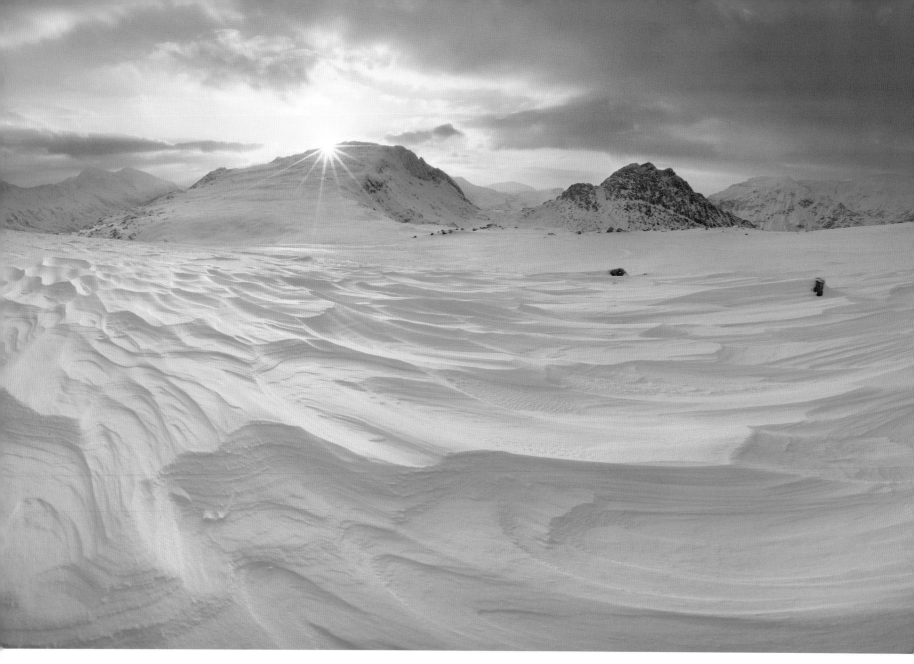

ALEX NAIL

Y Foel Goch
Glyder Ridge, Snowdonia, Wales

There was a heavy snowfall in March 2013 and I set out with two friends to go wild camping on the Glyders one weekend. We made very slow time up to Caseg Fraith because of deep snowdrifts but, after a last-minute rush up Y Foel Goch we were rewarded with a brief moment of light. Pictured are Glyder Fach to the left and Tryfan to the right. Not long after, we were pitching our tents on two feet of snow.

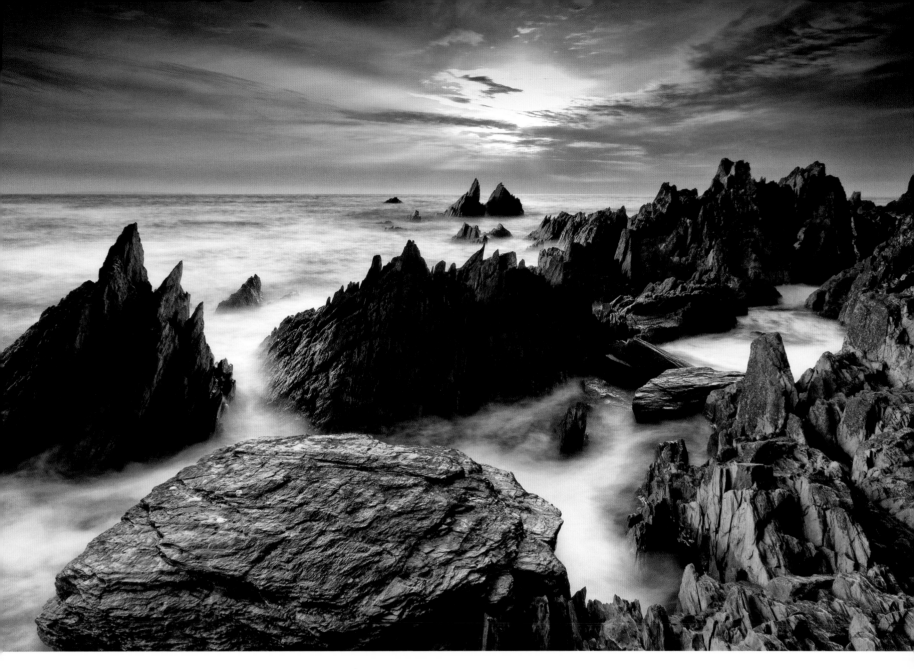

WILLIAM WARD

Approaching Sunset at Rockham Beach
Devon, England

Rockham Beach is one of my favourite places in Devon. Hidden away from the road, it's a short hike down the coast path. There was quite a significant swell in the water, which I'd surfed earlier in the day, but snuck away to catch the sunset. A fair amount of rock scrambling, a fast incoming tide, and a deserted beach. Perfect.

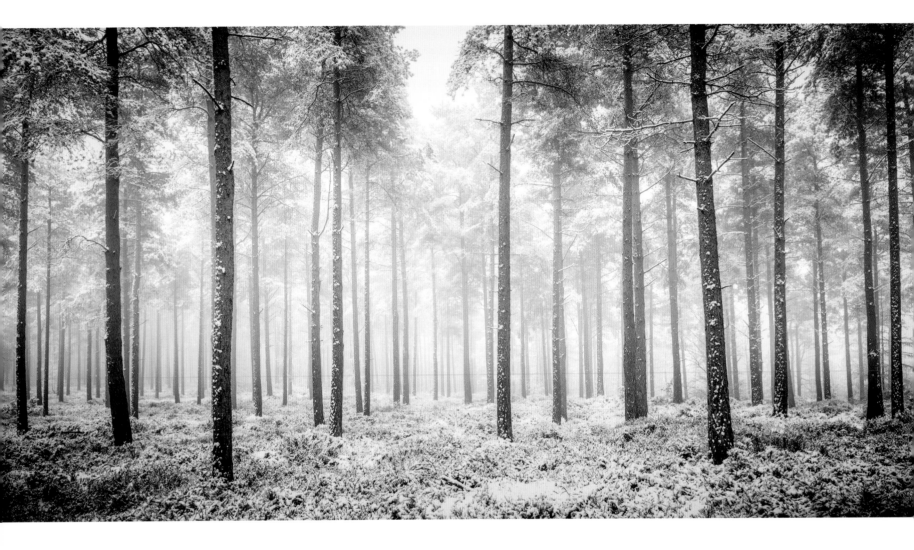

✝ **MARK LITTLEJOHN**

The Beacon in Winter
Penrith, Cumbria, England

I had been waiting to do trees in snow with a wee bit of mist all winter but the conditions had not been kind. One morning, as my wife and I travelled across to Great Salkeld past the Penrith Beacon, we were surprised to find that the very top of the hill was obscured by low cloud and had fresh snow with a hoar frost. I had just received a Nikon 24mm f1.4 lens so was carrying it with me. The car was abandoned and I just wandered amongst the trees for an hour or so. I was struck by the extreme feeling of silence as I took this, almost as if the whole area was cocooned from the outside world.

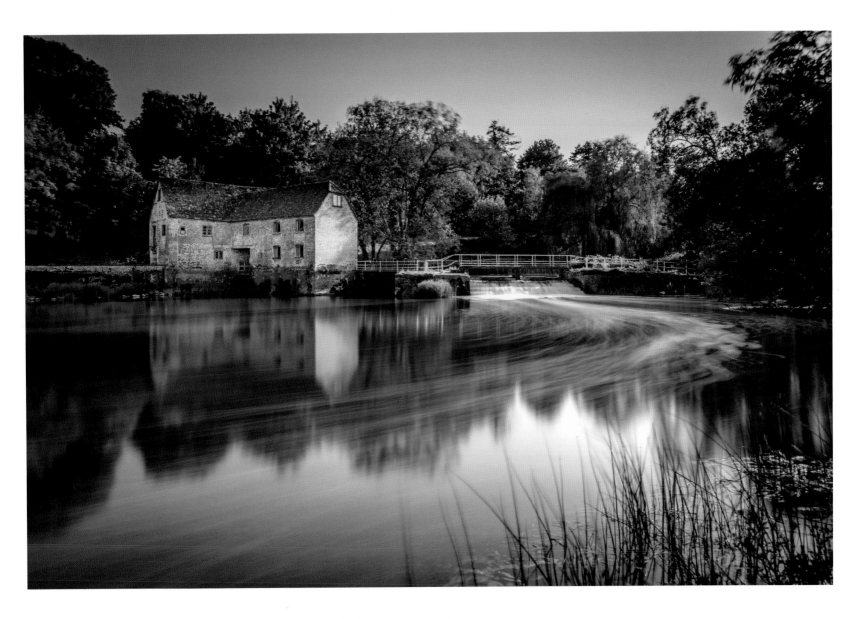

✝ **MARK SIMPSON**

Sturminster Newton Mill
River Stour, Dorset, England

I took my sister out on her birthday for a day of photography in Dorset and Wiltshire and Sturminster Newton Watermill was one of the locations. I'd had this image in mind for a while, with the late afternoon sun highlighting the mill and the long exposure smoothing the fast-flowing water of the River Stour, creating some nice lines and reflections. It is a busy spot and often a dog walker appears over the weir during the exposure.

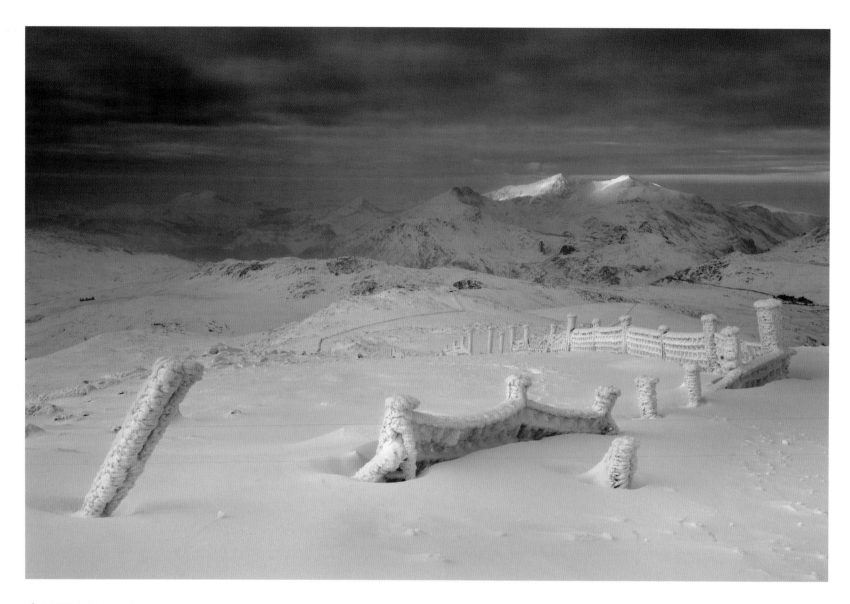

JAMES APPLETON

Rime-iced Fence on Moel Siabod
Snowdonia, North Wales

After an early start and a climb through the darkness to reach here in time for sunrise, low cloud around the summit meant the incredible views were completely hidden. Not wanting to have to make a return trip later in the day, I dug a snowhole and sat the bad weather out. The reward was some lovely mid-morning light slicing through and lighting the distant Snowdon Horseshoe.

SIMON HARRISON ···>

Island in the Sky
Derwent Water, Cumbria, England

Derwent Water was very still and reflective on this autumn morning. I used it as a canvas on which to isolate St Herbert's Island and portray its trees in full autumnal splendour.

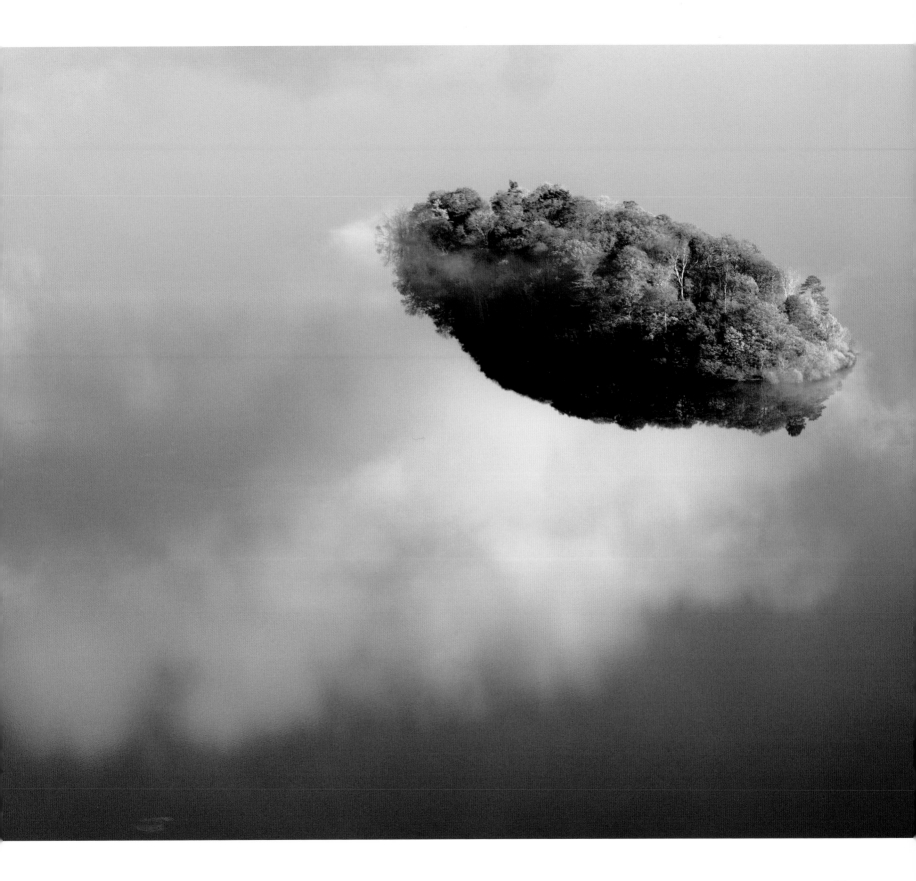

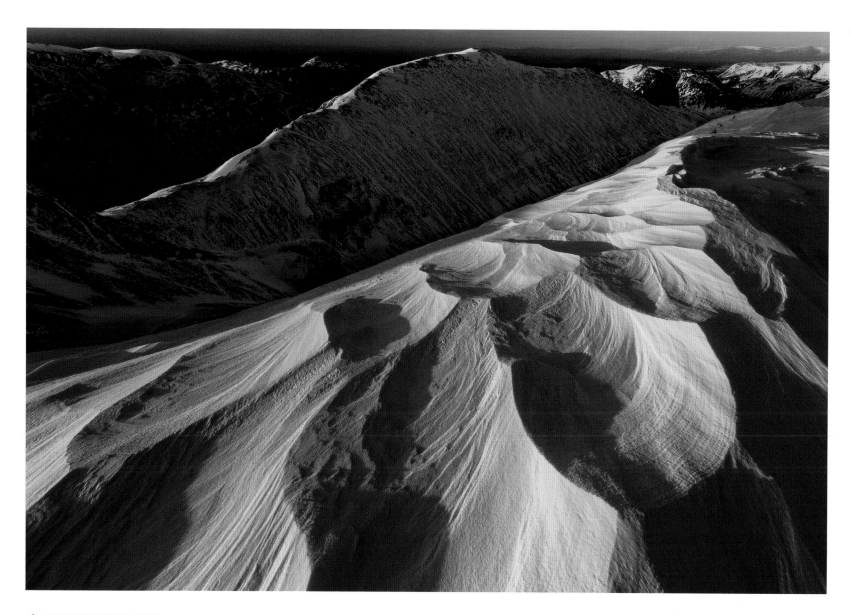

🕇 **STEVEN THOMPSON**

Looking to St Sunday Crag
Cumbria, England

This image was taken as the last of winter's light fell on to St Sunday Crag's narrow ridge, picking out the delicate wind-carved snow at the edge of Fairfield's summit plateau.

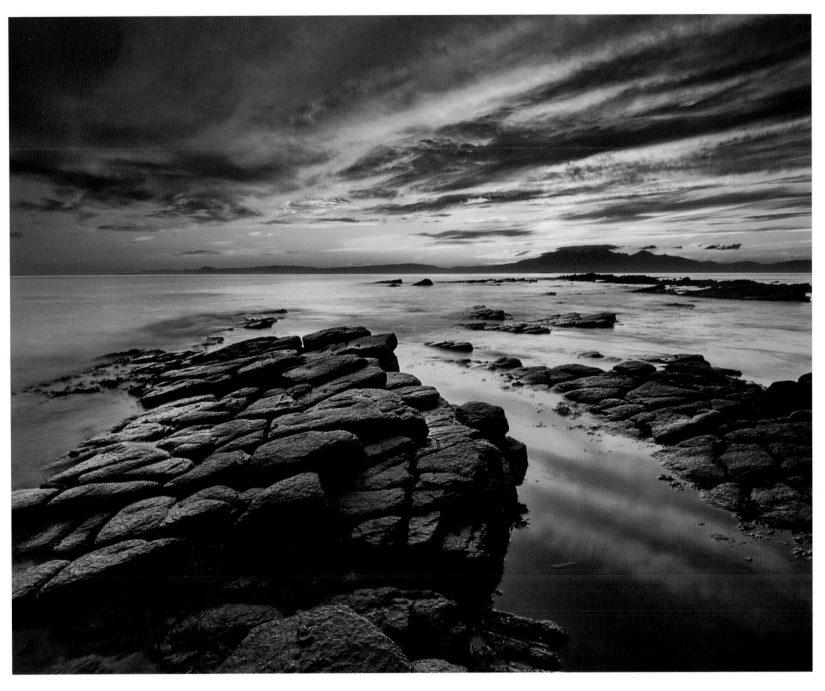

✝ PETER RIBBECK

Fiery Sky over the Isle of Arran
Firth of Clyde, Scotland

On this night down at Seamill beach the light just got better and better. It was easily one of the best sunsets that I have witnessed on the west coast of Scotland.

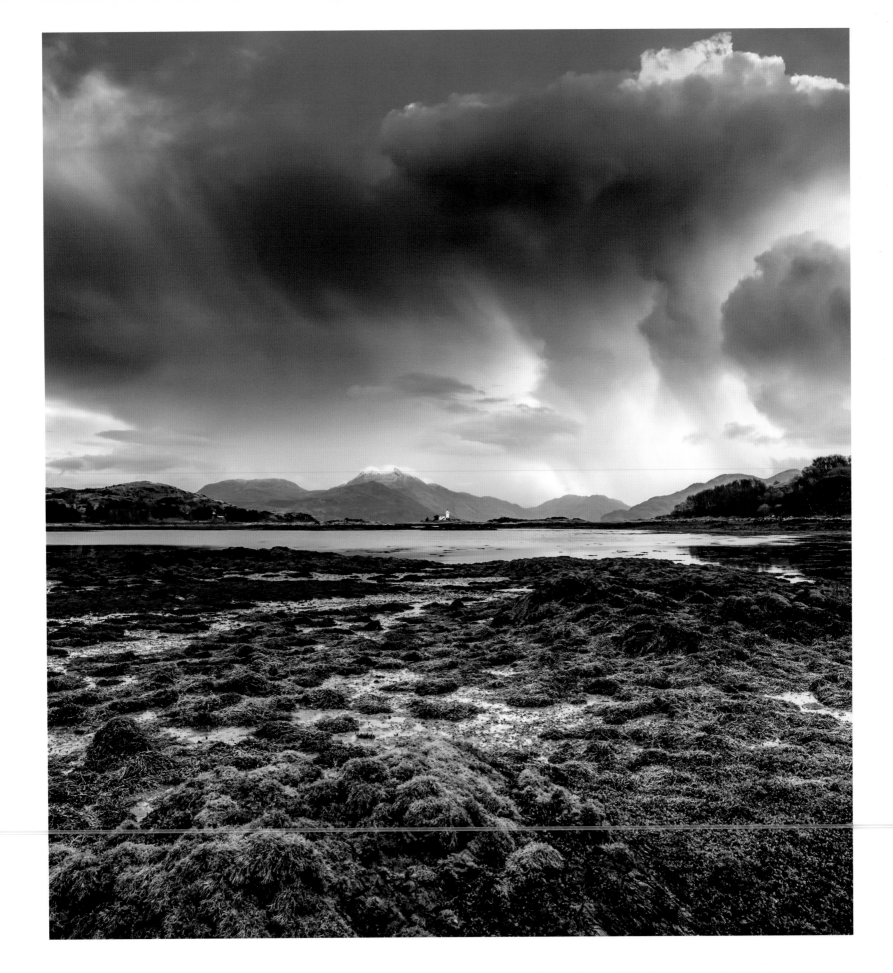

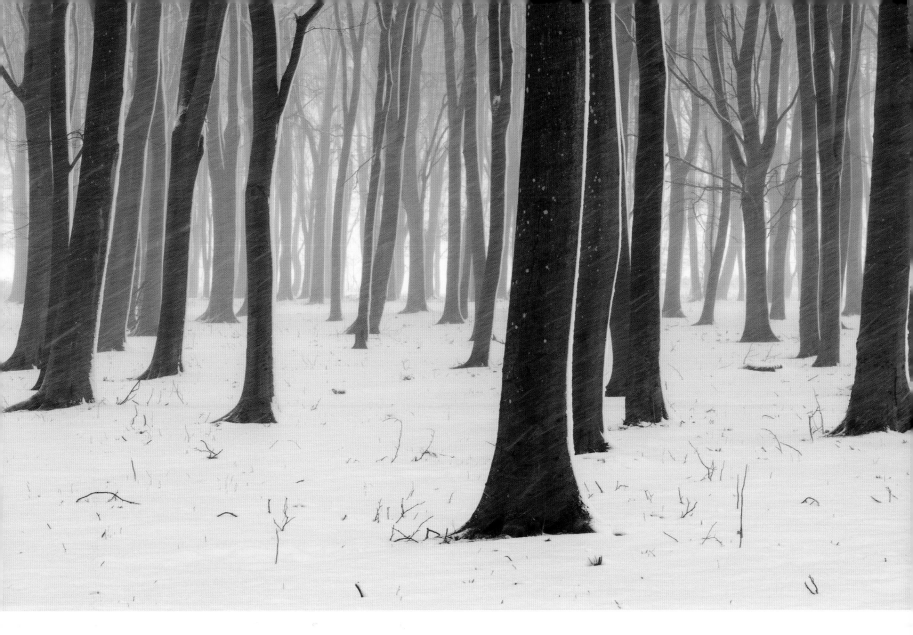

TIM WAY

Sky on Skye
Isle Ornsay Lighthouse, Inner Hebrides, Scotland

This image represents a turning point with my photography. It was part of my 'get focused, dig down and get on with it' philosophy. Armed with my D700, boxers and my Smart Car (and maybe a few accessories), I set off on what was a 1,670-mile round trip from Poole to Skye. The view is from a place called Camuscross looking towards Isle Ornsay Lighthouse. It was around 10am (not my normal time for shooting by a long way). There was a sense of calm and a feeling that everybody had got out before the storm, including the wildlife. Just the occasional birdsong. I could feel the moment arriving, my heart rate picked up a gear and the nervous paranoia set in of the 'check and double check' variety...hold your breath...squeeze the cord release...click...and breathe. Perfect.

ROBIN BOOTHBY

January Snowfall
Badbury Clump, Oxfordshire, England

Badbury Clump is a small area of beech wood which is managed by the National Trust. I had photographed the wood with snow on the ground the previous day but was disappointed with the results, so resolved to revisit it come what may. The new morning brought fresh, still falling snow, which clung to the east side of the trees. This image shows the wood viewed from the south, with the snow on the trunks providing clear delineation between overlapping trees, giving an impression akin to a woodcut print.

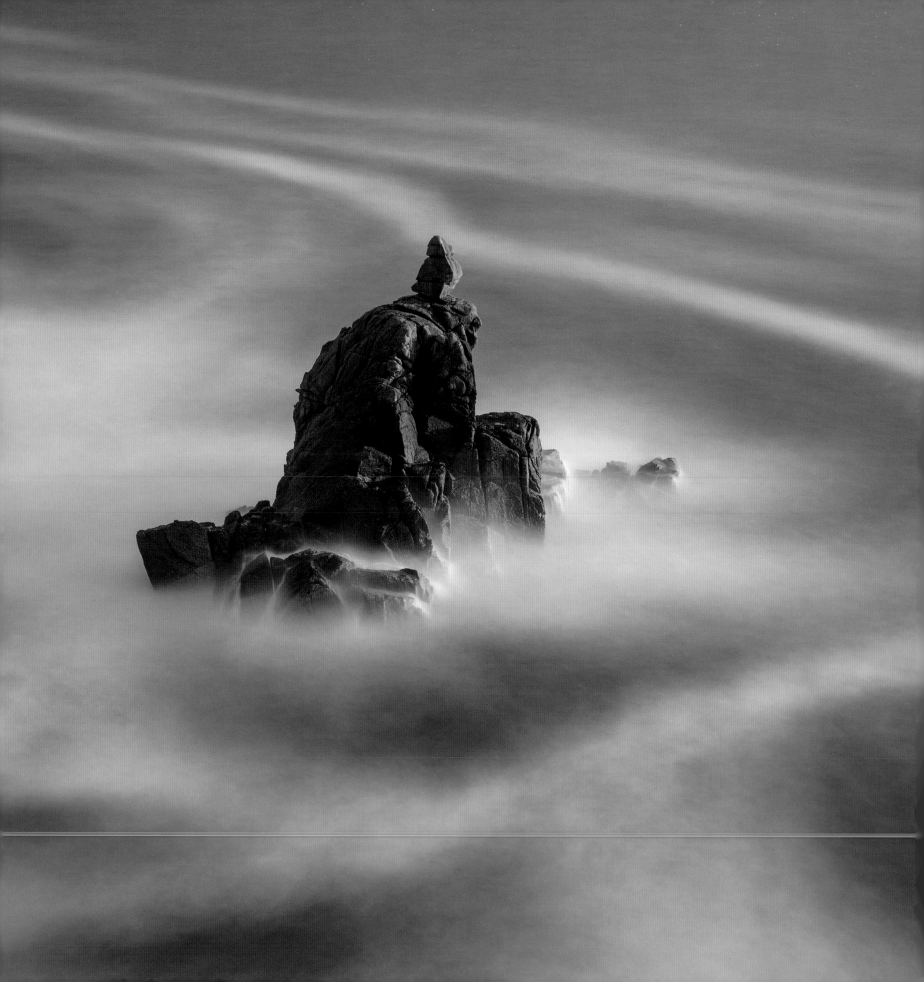

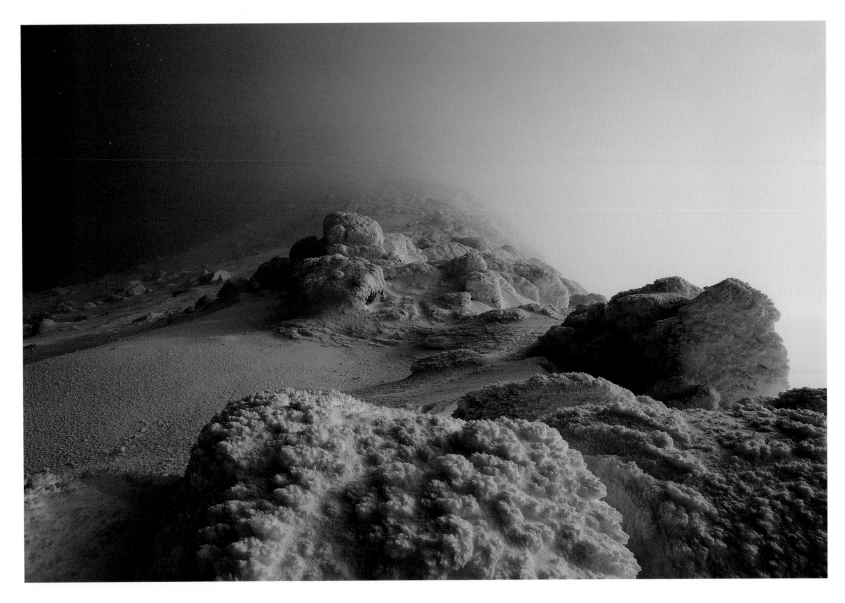

← JOHN HODDINOTT

The Irish Lady
Near Sennen Cove, Cornwall, England

During a short stay in Cornwall, a friend already holidaying in the area suggested we head off to the cliffs above Sennen Cove to photograph the headland in the evening sunlight. I was immediately taken with the curiously shaped rock known as the Irish Lady and the patterns created by the waves swirling around her. A long exposure seemed appropriate and created just the mood I was looking for. It was only later that I learned of the heart-rending folklore which gave the rock its name. It is said that, in days long ago, sailors from Ireland were shipwrecked at night on this rock and every soul perished save a lady, who was seen in the morning perched upon it, but it was impossible to save her. Now, when the winds and waves are high, fishermen sometimes see a lady still sitting on this rock.

↑ JOHN PARMINTER

Schiehallion
Perth & Kinross, Scotland

I set off with great expectations of grand, sweeping summit vistas when climbing Schiehallion but unfortunately the cloud had closed in by the time I reached the top. I was greeted with incredibly strong winds and found it almost impossible to operate my camera but I was determined to make at least one image for the effort I had put in. Despite the conditions in the image, Schiehallion is really a pleasing mountain to climb. It has gentle, graded paths that lead up a broad shoulder and terminate on the summit, where rewarding views over Rannoch Moor and Loch Tay await, I can almost guarantee!

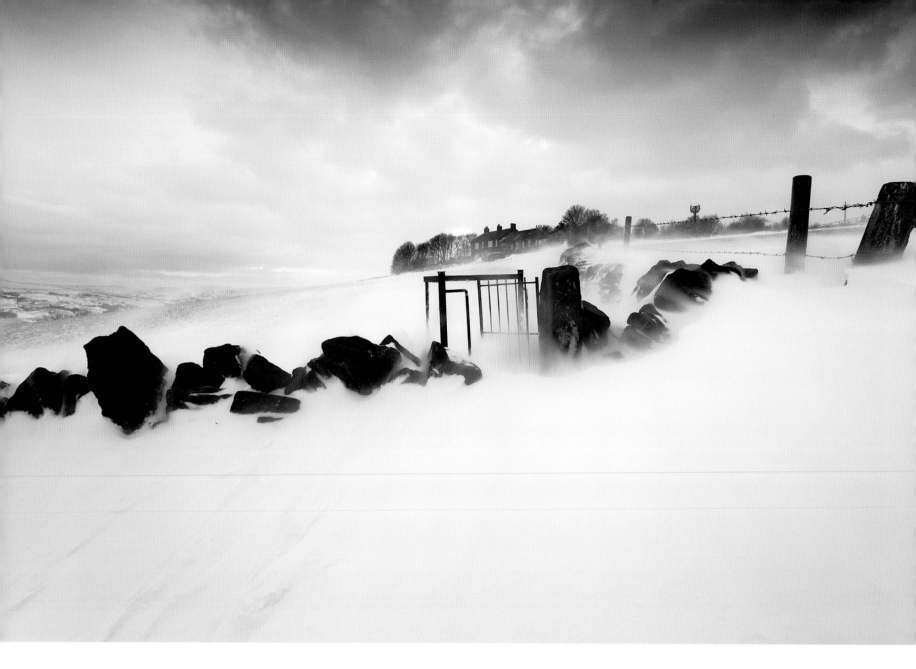

MARK HARROWSMITH

Wellhouse
Huddersfield, West Yorkshire, England

A favourite local walk through the fields above my Wellhouse. This place surprises and inspires me throughout the seasons; weather, light and time make for an ever-changing landscape. Taken after heavy snow in late March, high winds rake up the snow into deep, impressive drifts and almost obliterate familiar landmarks.

STUART LOW ⋯⋗

Sea Foam at Bass Rock
Firth of Forth, Scotland

This is Seacliff beach looking towards the Bass Rock. It's a very shallow, sloping beach, so when a wave recedes the foam trails can extend to over 100 feet. I was going for a 'near–far' type shot so I had to crouch down to about 10 inches above the water to get the right angle, getting soaked in the process!

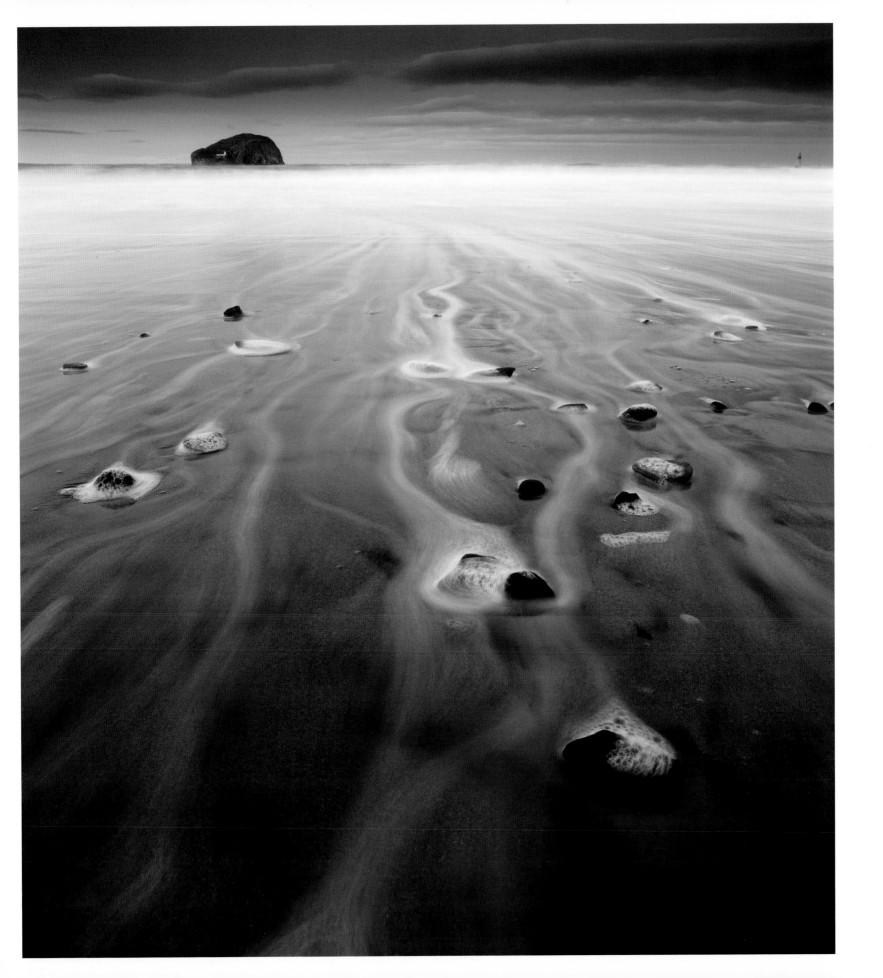

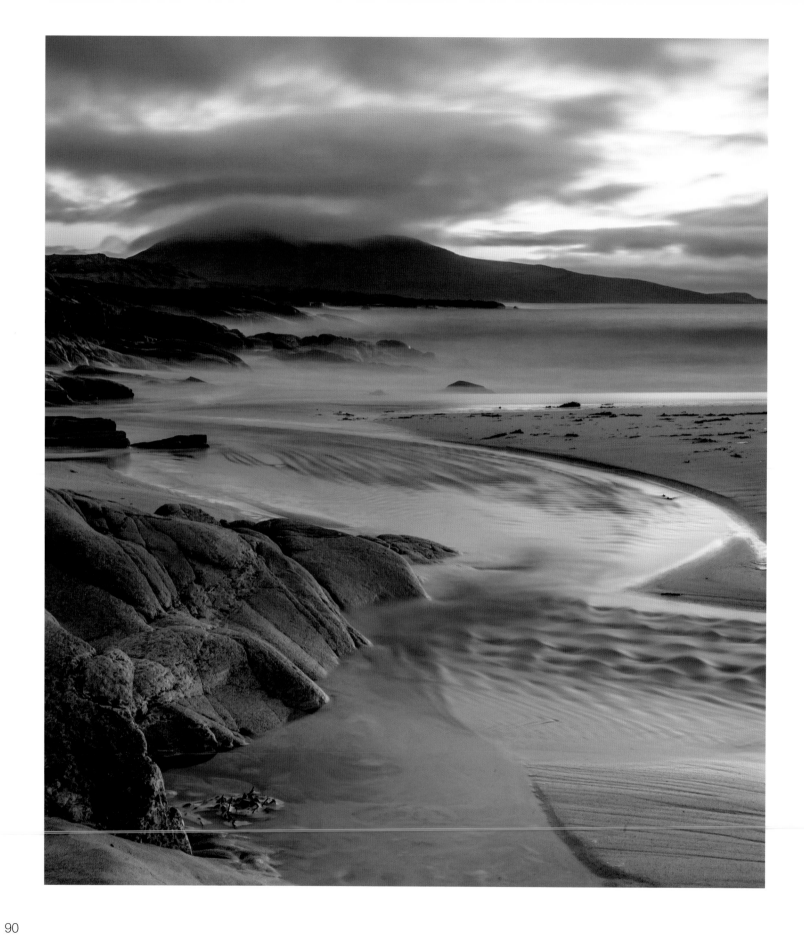

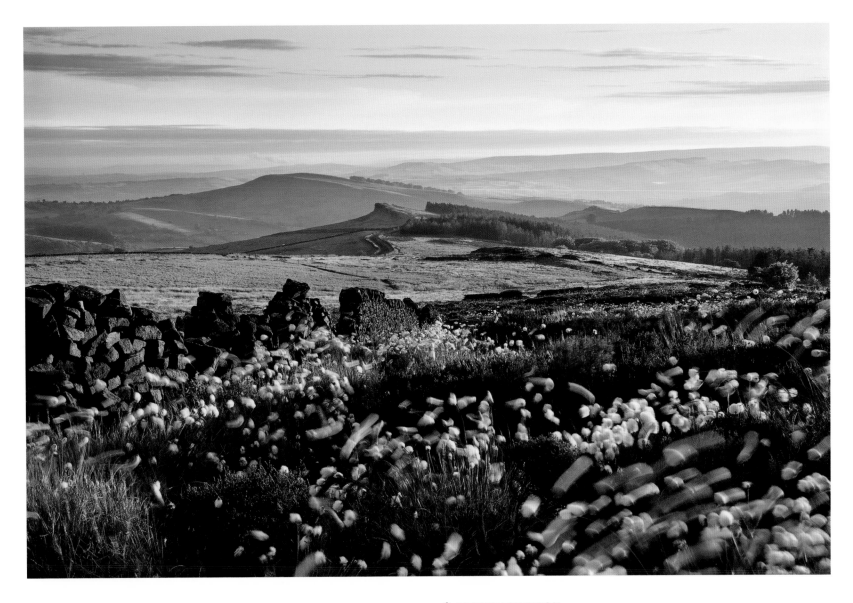

ROBIN GOODLAD

Horgabost at Dusk
Isle of Harris, Outer Hebrides, Scotland

After shooting sunset over Taransay, my eye was caught by the stream of the ebbing tide cutting at angles across the sand, bouncing off the rock before heading out to sea, with the brooding dome of Gob an Tobha in the background. The resulting tranquillity was in contrast to the fierce winds actually present.

JACKIE ROBINSON

Bobbing Cotton Grass near Windgather Rocks
Peak District, England

A rather cold and blustery June morning – I wish I'd had my hat and gloves with me! I often pass this view on my way to other photographic locations but decided to stop here when I saw the mass of cotton grass. Despite the cold hands I had a great morning photographing the rising sun lighting the landscape.

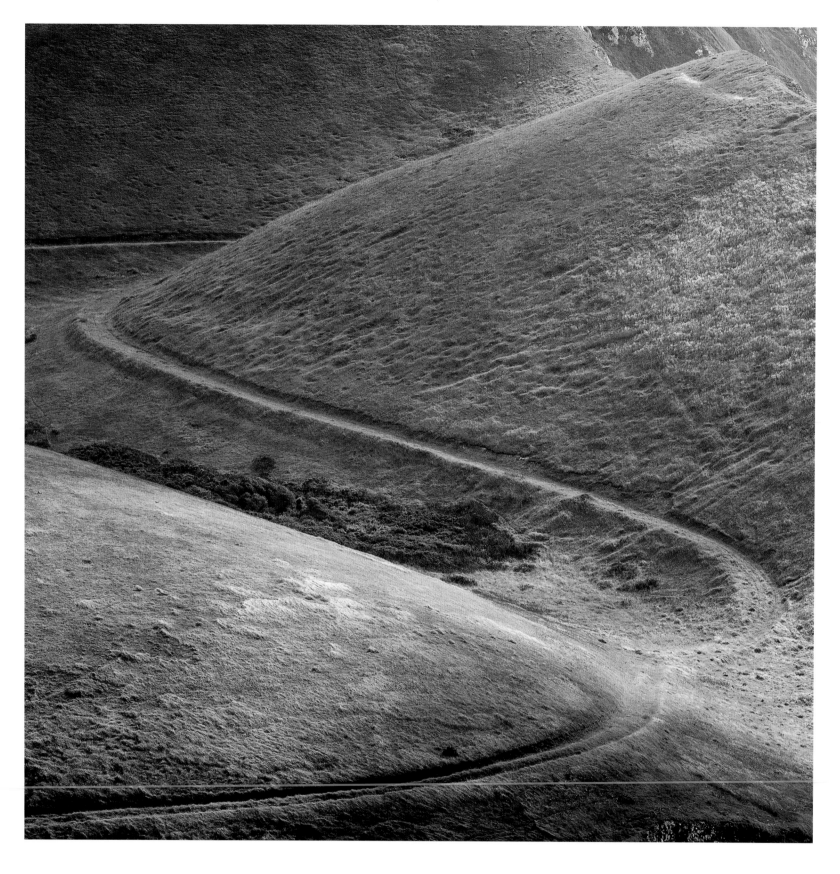

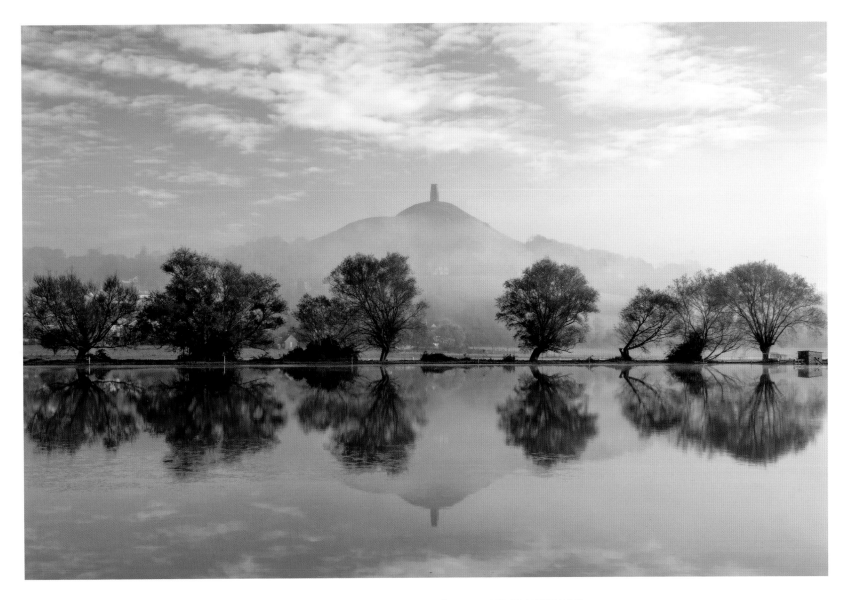

↤••• TIMO LIEBER

Serpentine
Dorset, England

I found this spot more or less by accident after a long weekend shooting the Dorset coastline. I am always on the lookout for simple geometrical patterns and the long, winding road embedded in the coastal hills next to Lulworth Cove was a stunning example.

⚛ GRAHAM McPHERSON

Ethereal Tor
Glastonbury, Somerset, England

The floods of 2012 here in the UK gave us an insight into why Glastonbury Tor was once called 'The Isle of Avalon'. Many years ago the Somerset Levels were under water and the place literally was an island. It was my good fortune that I was able to capture this shot as the sun was burning off the dawn mist around the Tor and the willows were reflected in the still floodwater.

CLASSIC VIEW
youth class

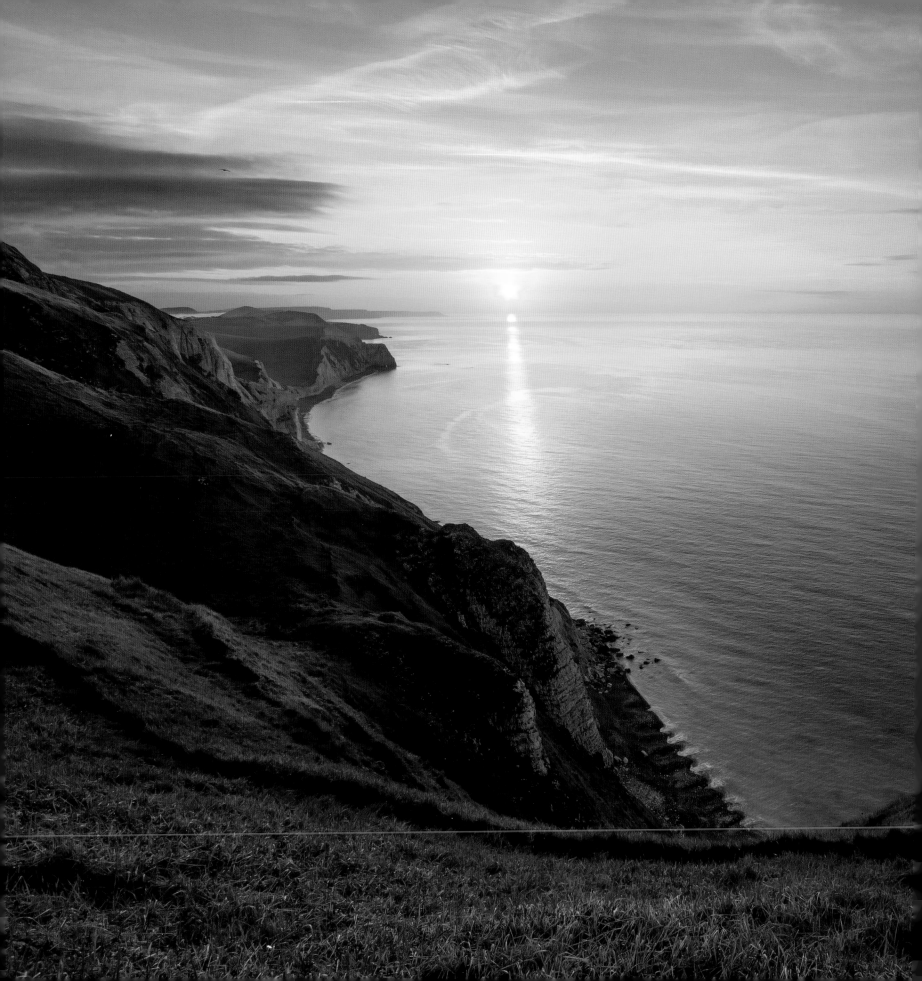

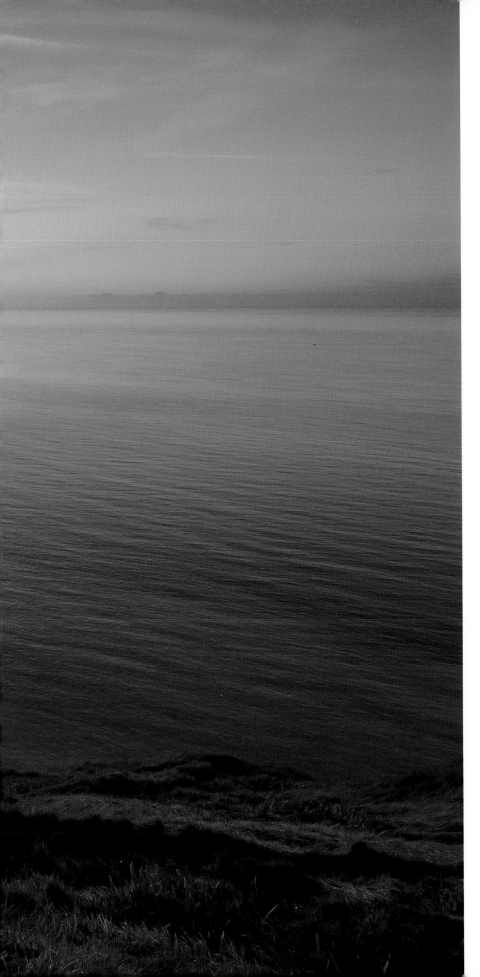

JAKE PIKE

Jurassic Coast
White Nothe, Dorset, England

I cycled through thick fog on my way to the coast the morning this image was made – I had hoped for some sea fog around the cliffs where I had planned to base my sunrise shoot. However, when I arrived, it was clear around the sea and I began to have second thoughts as to whether I had made the correct location choice or not. In spite of this, I stuck to plan A, locking up my bike and plodding on towards the view I wanted to photograph, ignoring the fog behind me. When I got there, I wasn't disappointed at my decision; the cloud was just starting to catch the light and give some colour – there wasn't much of a pre-glow but when the sun came up, it was beautiful!

LIVING THE VIEW
adult class

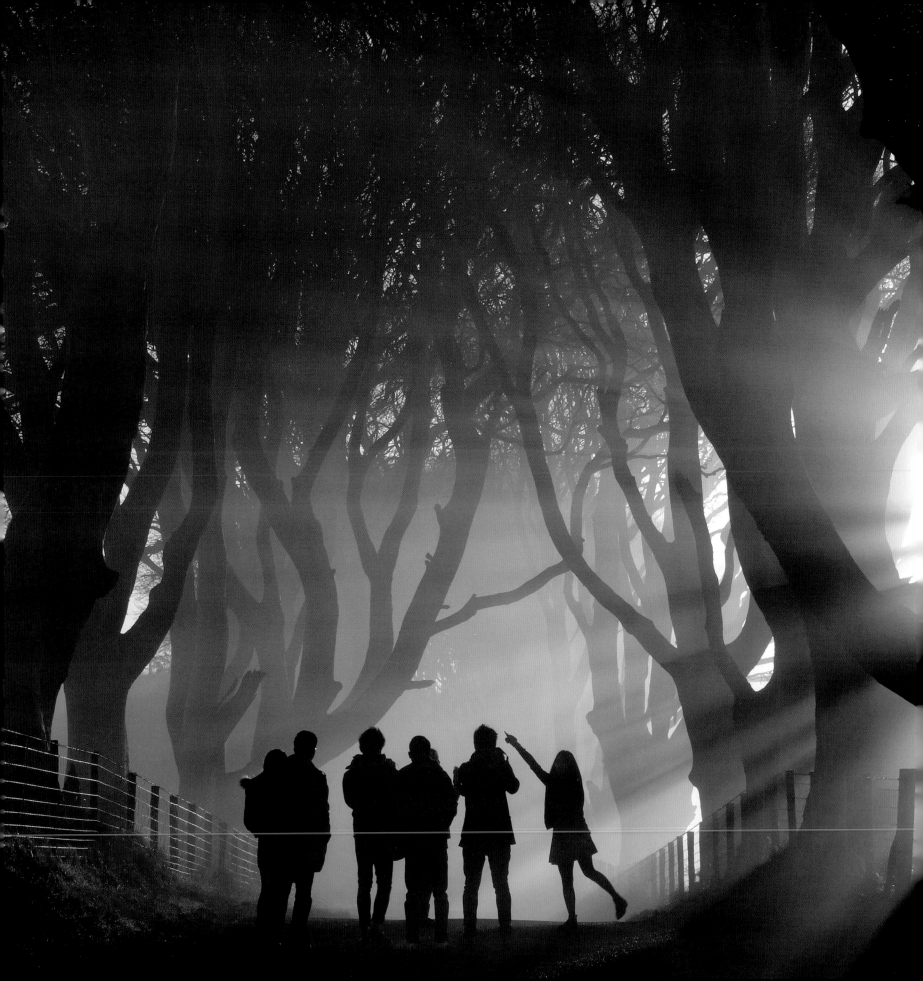

LIVING THE VIEW ADULT CLASS WINNER

 BOB McCALLION

Mystical Morning, The Dark Hedges
County Antrim, Northern Ireland

This enchanting tunnel of beech trees has become a magnet for
visitors from all over the world and it is hard to avoid people at
any time of the year. As I pressed the shutter, a slim, almost elfin-
like girl broke away from the main group and started pointing, as
if to mimic the surrounding branches. I managed to capture her
in mid-pose.

Judge's choice John Langley

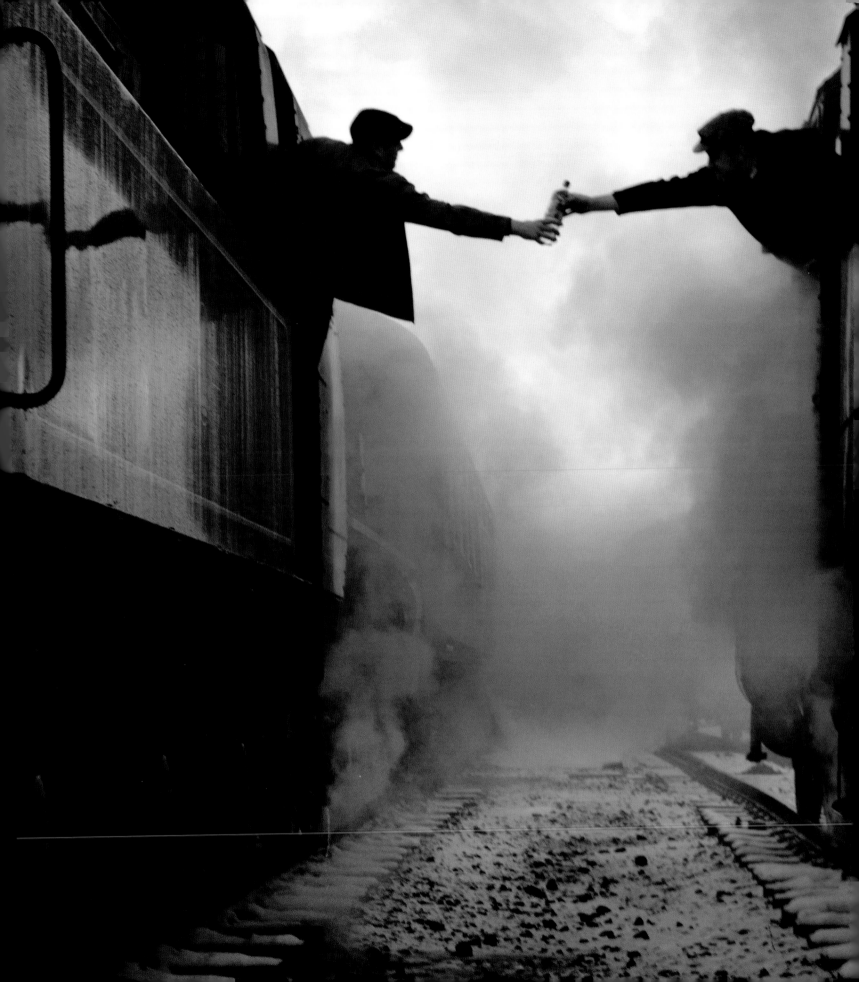

‹··· ROBIN COOMBES

Hand Over
Loughborough, Leicestershire, England

A timeless shot that I always wanted, from a freezing cold January morning at Loughborough Station. The photo captures the natural camaraderie of two crews exchanging a drink of water before beginning their duties. The crew will face a mixture of blasting heat from the firebox and a biting cold wind. The distance between the cabs is just about at the limit of stretch. The shot was just by chance and I almost missed it as my numb fingers struggled with the settings. There is very little in the shot to date it. It could easily be the mid 1950s but was taken in 2013.

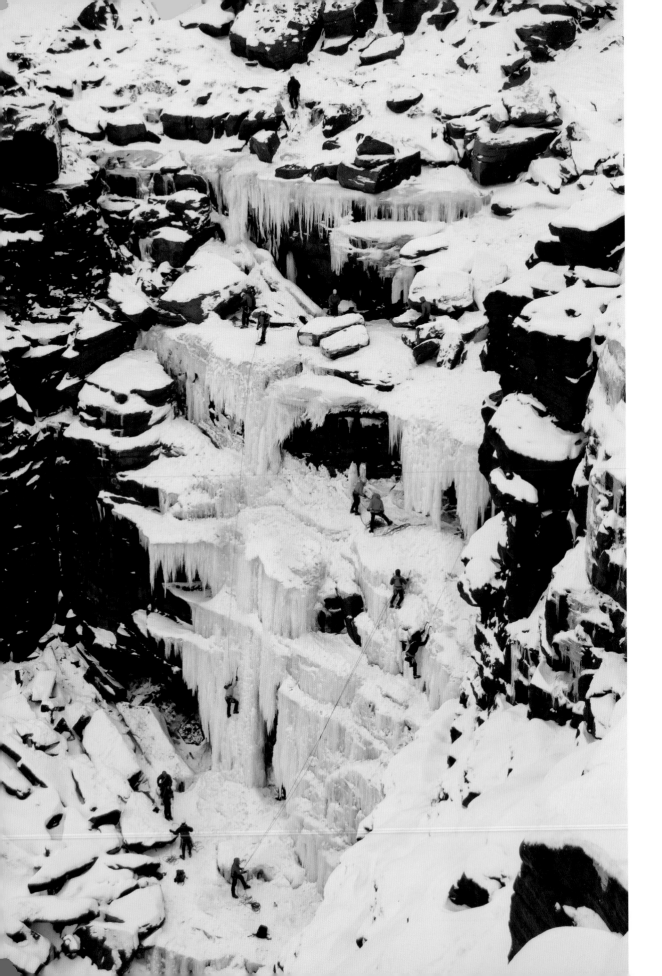

❖··· **DAVID HASTINGS**

Ice Climbers on Kinder Downfall
Derbyshire, England

I was walking across Kinder Scout after heavy winter snows. The temperatures had been well below zero for a long time, allowing the usual water trickle over the waterfall at Kinder Downfall to form huge ice structures strong enough for these climbers to enjoy. They almost look like tiny toy figures dwarfed by the enormous frozen waterfall.

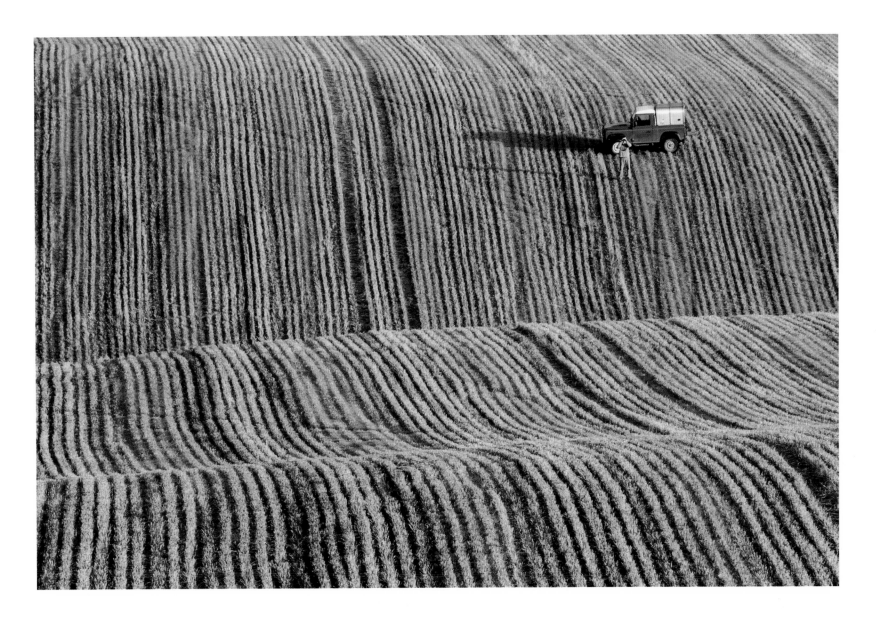

✦ **PAUL SANDY**

A View to a Kill?
Raddon, Devon, England

I was walking on my favourite local mid-Devon hill one September morning when a curious scene unfolded below. I had been photographing trees and distant landscapes in the mist, then the colourful undulations of a harvested field immediately below the hill, when, unexpectedly, a Land Rover appeared over a ridge in the field and stopped. The driver got out and looked through binoculars, which is when I took this image. He then proceeded to get a chair from the back of the vehicle, at which point a pick-up truck drew up alongside. I continued my walk, returning almost an hour later, by which time there was only the original Land Rover, the chair and the driver left in the field. I do not know exactly what activity was underway, but assume that shooting pigeons, or perhaps rabbits, was the purpose as I heard shots during my walk further along the ridge.

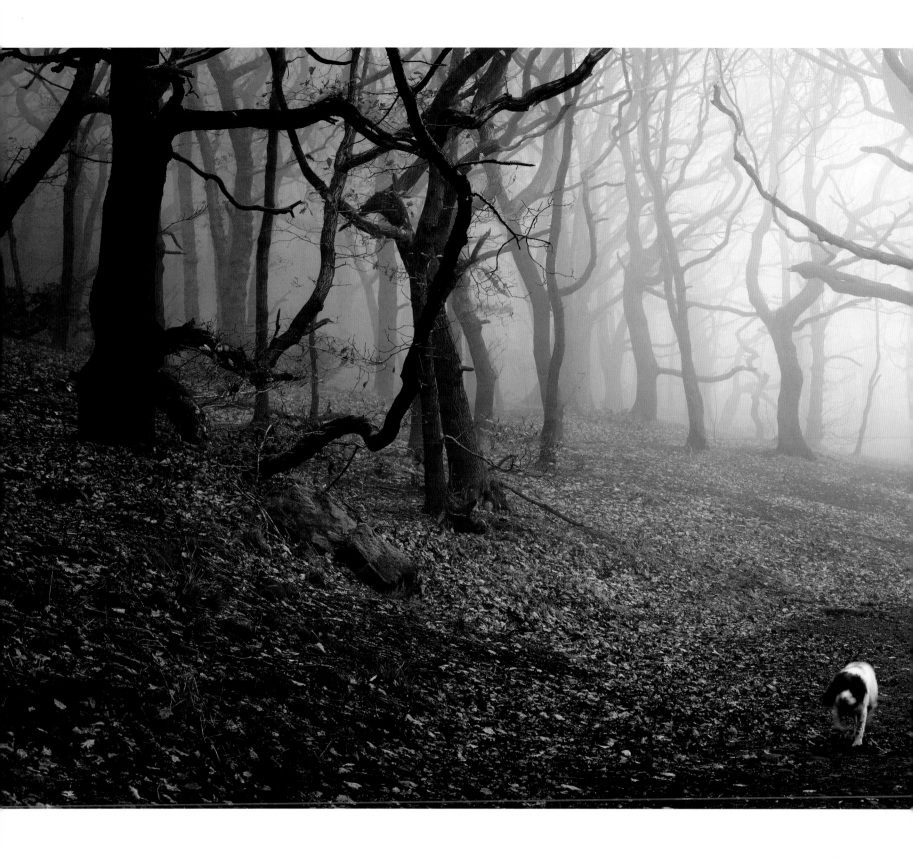

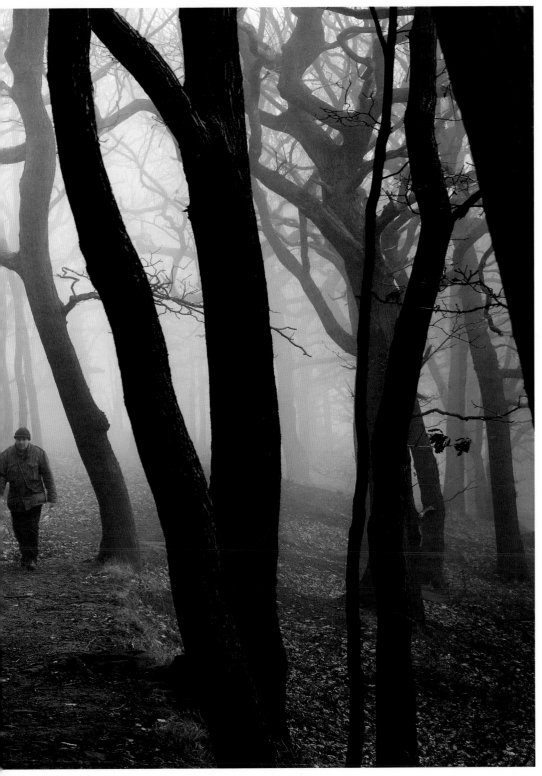

◀··· ROBERT BIRKBY

One Man and His Dog
Halifax, West Yorkshire, England

I enjoy walking through woodland on foggy days. The gradual fading of the trees always seems to create some atmospheric photographs. I liked this particular spot at a local patch of woodland, using the path to help draw the viewer into the scene. The first photo I took seemed to be lacking a subject, but right on cue a man walking his dog approached. I waited until both reached an optimal position in the frame before taking this shot.

107

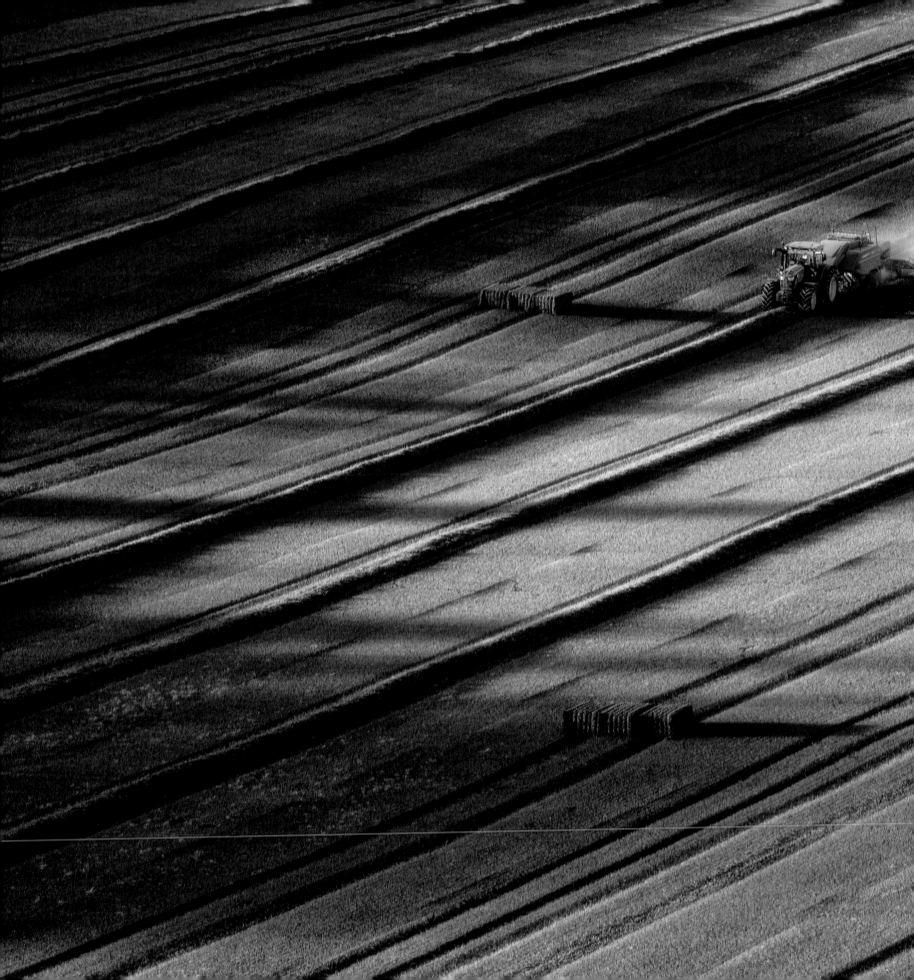

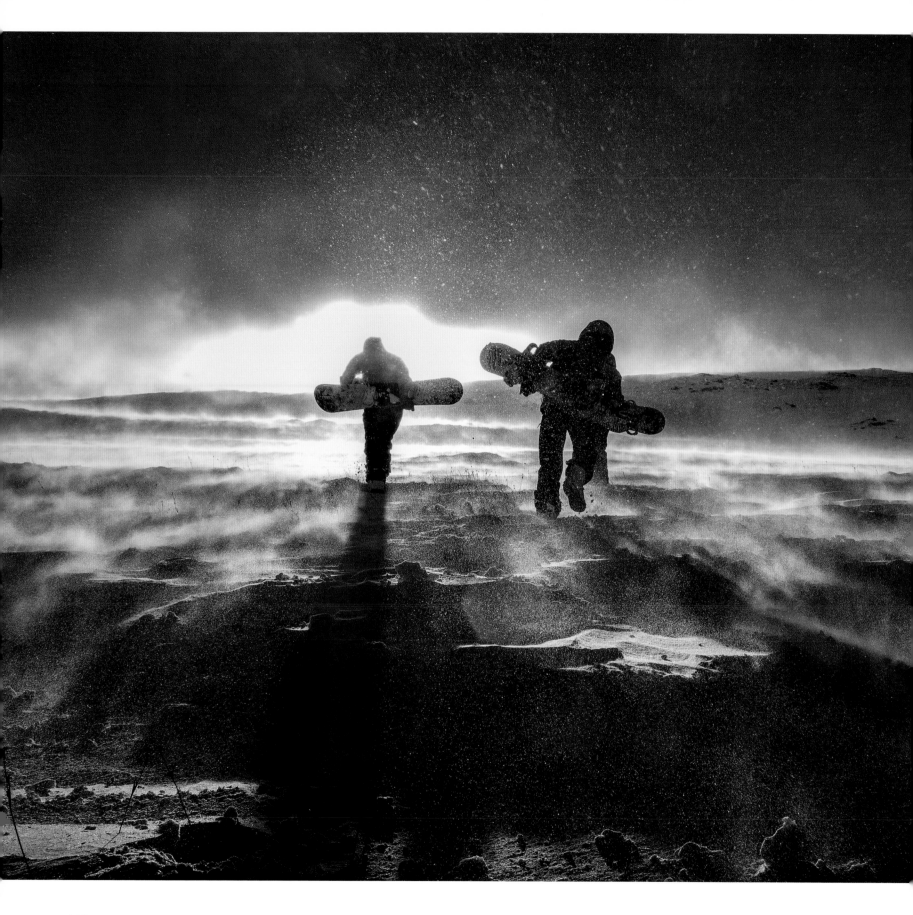

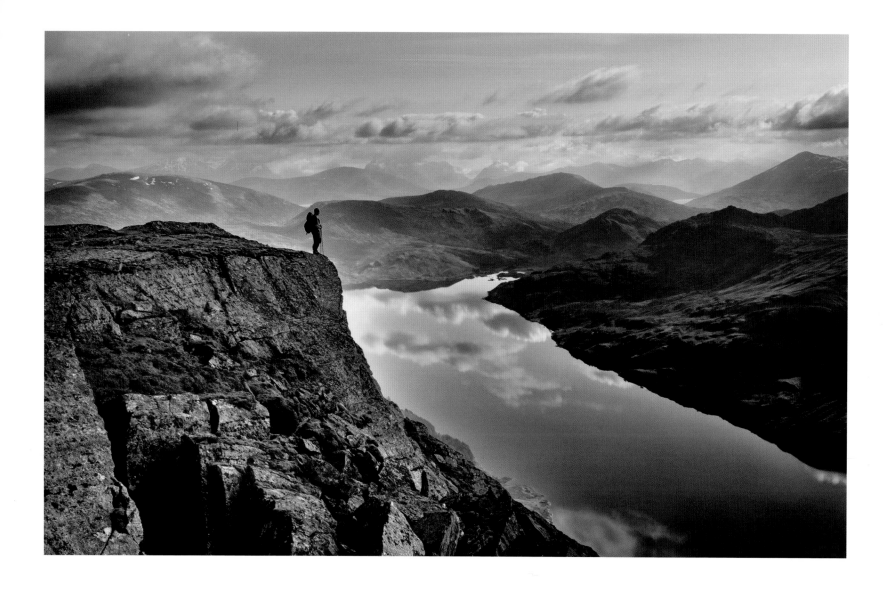

⟵ **MARK LITTLEJOHN**

Haweswater Quads
Cumbria, England

We had just had very heavy snow, which blocked most of the roads into the Lakes. However, I decided to have a go with our 4x4 to Haweswater. I got to the bottom of the Old Corpse Road and decided to wander up to the old ruins there. I cut round the back of the path to avoid leaving footprints and as I did I was struck by the scene below. I liked the way the road snaked away from me and the fact that it made a nice, simple mono image. I managed to make my way to a great viewpoint for the shot and, just at that time, three guys came through on quad bikes, snaking away through the snow and obviously having a whale of a time. I managed to get this shot, which was certainly not the one in my head when I set out.

⟵ **DAVID KIRKPATRICK**

View over Loch Treig
Lochaber, Scotland

Loch Treig, situated 20 miles east of Fort William in Scotland, is surrounded by mountains, including Munros (hills over 3,000ft). This shot was taken on top of Stob Coire Sgriodain (3,211ft) on a hot day while camping on top of the ridge to get the sunset shots.

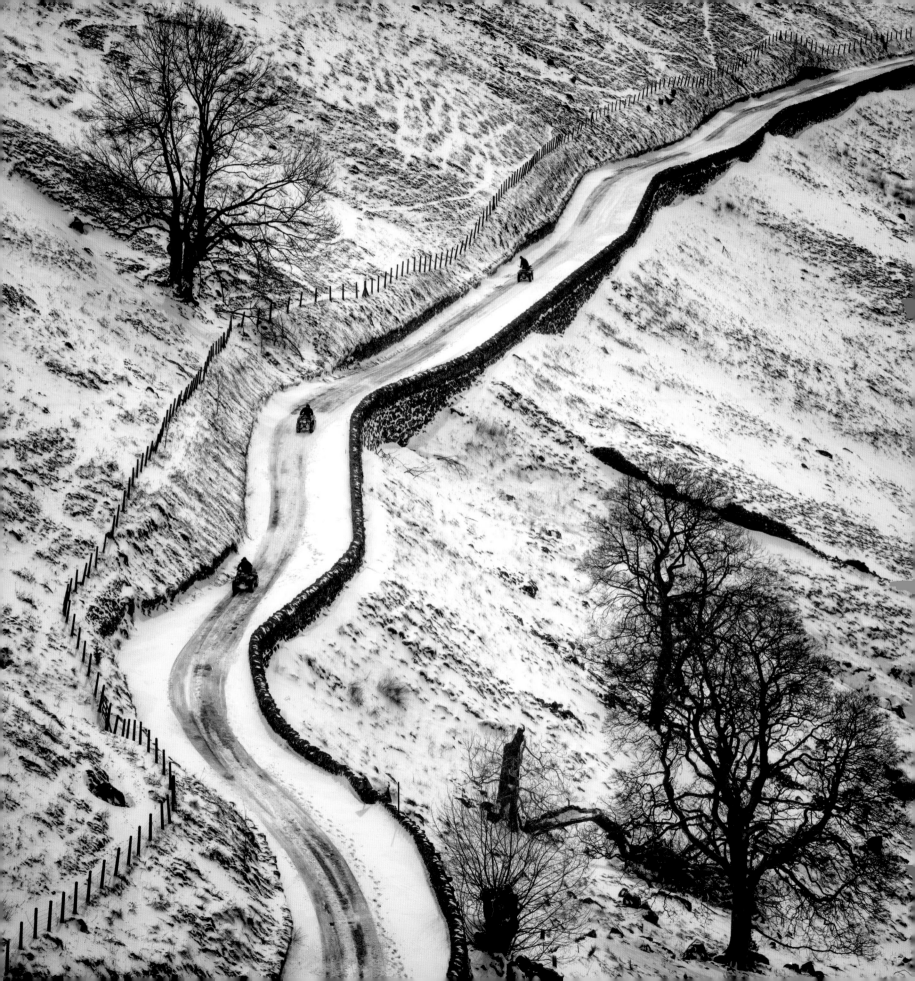

Mind the Tractor
Ashridge Estate, Hertfordshire, England

Ashridge Estate is filled with woodlands and picturesque fields. The beauty of this landscape can be admired from the top of its many hills. I came across this particular field years ago. One day, having finished work early, I decided to visit it for a breath of fresh air. When I got there in late afternoon the sun was still high up. I saw a tractor on the neighbouring field. I set the frame hoping that the tractor would get to the right place before sunset. I was very fortunate; it arrived just 15 minutes before the sun hid itself behind the hills and drowned the whole field in shadow.

NADIR KHAN

Hunting the Pow
Glencoe, Scotland

I was working on a shoot with snowboarders up in Glencoe in December. Conditions were terrible with high winds and spindrift being blasted on to the camera. Just getting a shot without the lens being covered in ice was the challenge. The light, however, was amazing and I took this shot as the boys were hiking to find some powder slopes to ride.

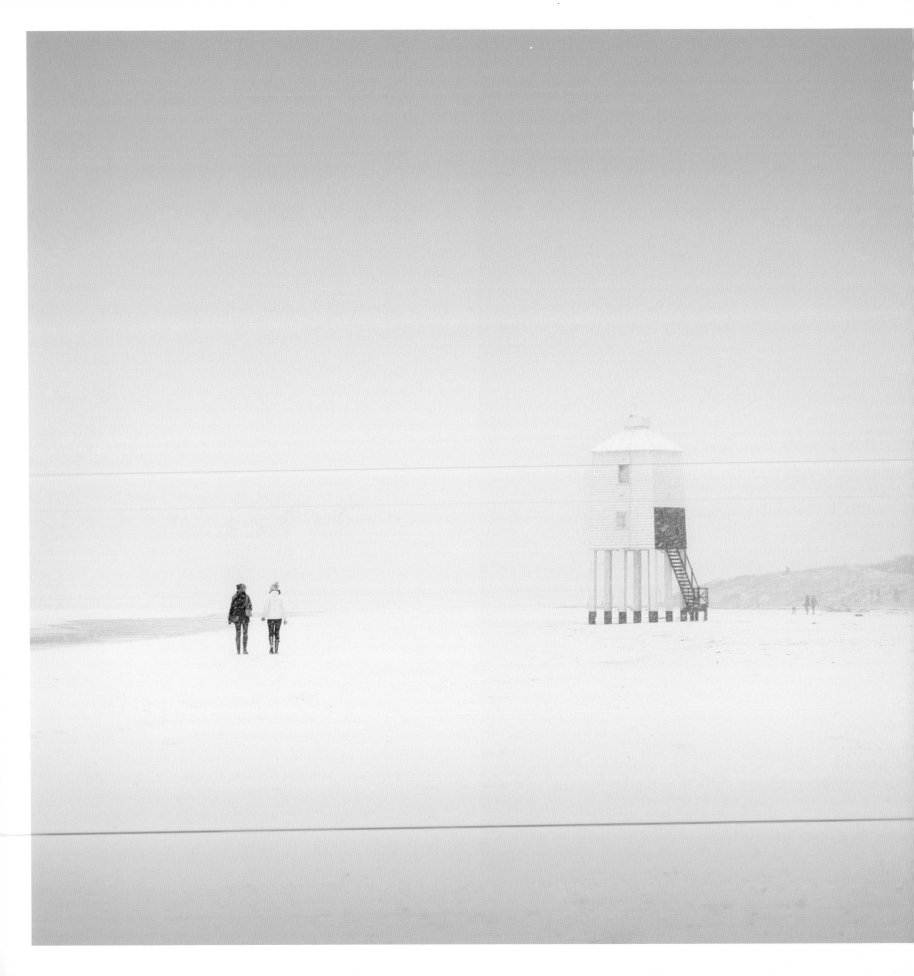

Winter Walk
Burnham-on-Sea, Somerset, England

A friend of mine had recently bought a DSLR and asked me to give him a few tips on how to use it. I decided to take him to one of my favourite spots, the Low Lighthouse near Burnham-on-Sea. Within minutes of arriving, a snow storm blew up the Bristol Channel and snow settled on the beach; it made for a very atmospheric and interesting day out. People's faces looked perplexed as they walked through the snow, not sand as expected, and children tried to make snow angels instead of sand castles. Within a couple of hours the snow had melted and the beach returned to its usual winter guise.

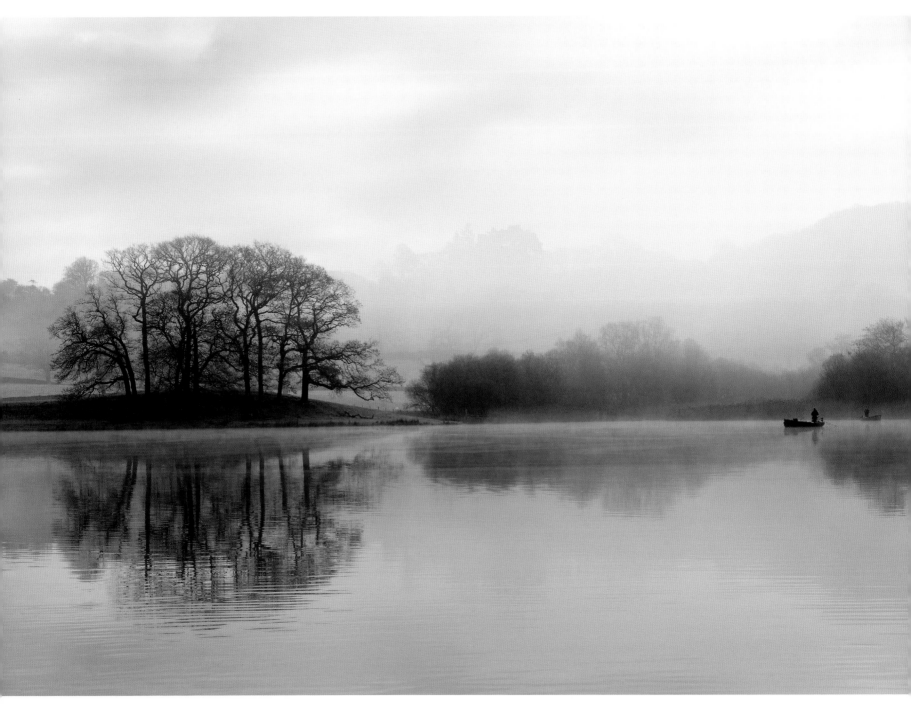

MARK BELL

Fishing on Esthwaite Water
Cumbria, England

This shot was taken on a cold November morning at the end of five days in the Lakes. For once, the weather was perfect – early morning sun breaking through clouds and a mist hanging over Esthwaite Water. I'd already taken a couple of shots at other points on the lake when I spotted the fishermen. I raced around the water to find a spot from which to get a good shot before the sun burned off the mist. Apart from the atmospherics, I like the shot because it is one of the lesser photographed parts of the Lakes and includes a human element, which I more often try to keep out of my images.

GARY TELFORD ···>

Comedy Carpet
Blackpool, Lancashire, England

I had the chance to visit the top of the
Blackpool Tower and knew that this would
give me a good view of the Comedy Carpet
below. Being a sunny day, there were
plenty of people walking on the carpet to
help give scale.

117

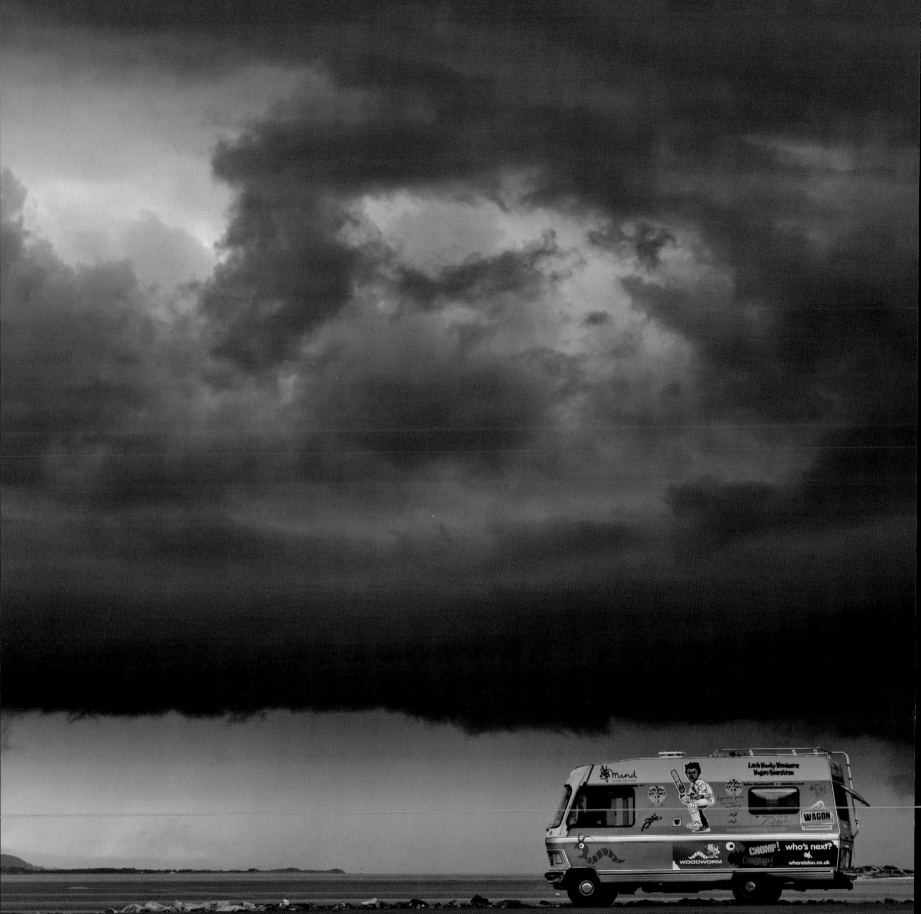

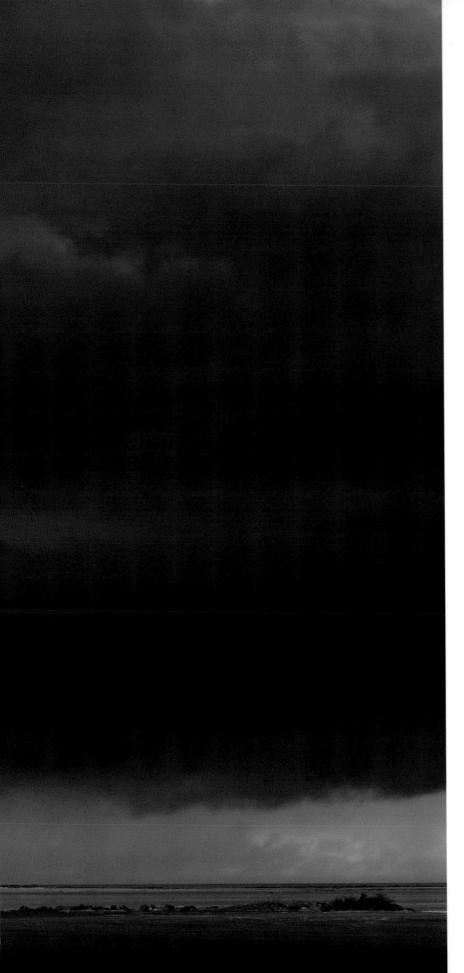

Campervan at West Kirby
Merseyside, England

I spotted this campervan in the car park of the marine lake at West Kirby on the Wirral. The view behind is looking over the Dee Estuary to North Wales, with approaching storm clouds.

The Household Cavalry at Holkham
Norfolk, England

Each year the Household Cavalry come up to Norfolk for a few weeks as part of their training. At the end of a session on Holkham sands, the troopers unsaddle their horses and ride them bareback into the sea. The previous day had been dark, cold and brooding, so I shot with the intention of producing black-and-white prints. Holkham beach is a huge area of sand and sky and I wanted to emphasise the vastness of the view. Monochrome seemed to give me what I wanted; a feeling of timelessness and space. All the ancient elements are there; the sound of drumming hooves and the surf, a big sky and the sea, riders and their horses.

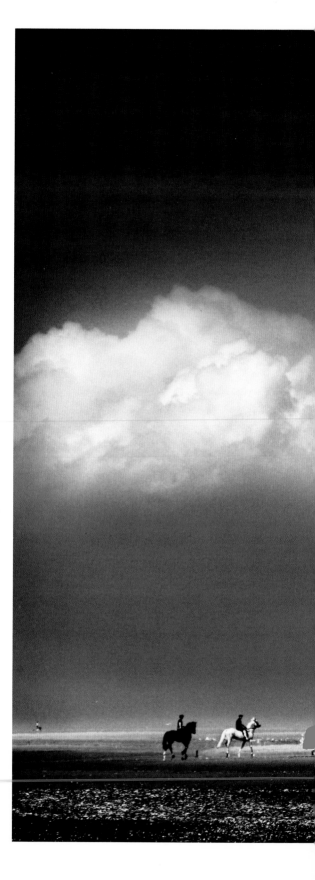

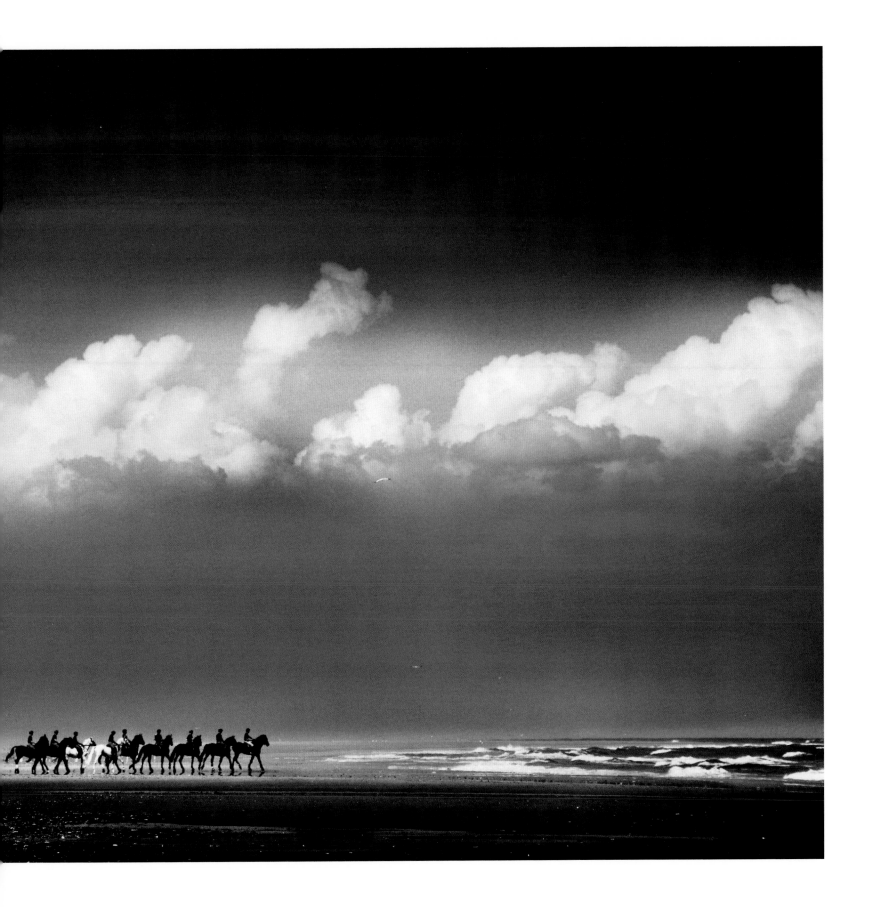

LIVING THE VIEW
youth class

LIVING THE VIEW YOUTH CLASS WINNER

CHARLOTTE BURTON ⋯⋗

Row Boat on the Cam
Cambridge, England

I took this photograph while out in a kayak with my friend on the River Cam. It was taken
in April and it was pretty cold, so for the best part of our time on the water the river was
completely empty. As I was doing a project on means of travelling on water, I had hoped
for a bit more activity, so wasn't going to miss the opportunity when this row boat passed.

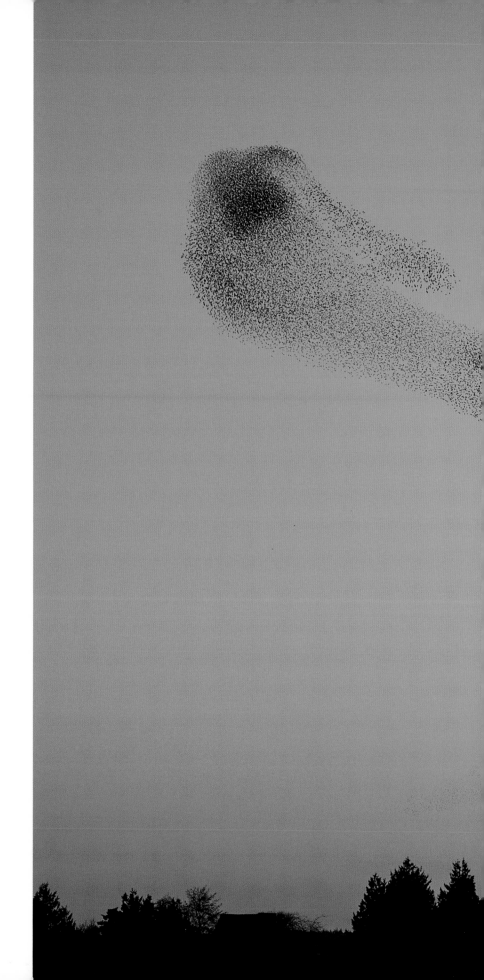

URBAN VIEW ADULT CLASS WINNER

NIGEL McCALL ···>

Starlings over Carmarthen
Southwest Wales

In January 2011, Carmarthen began to play host to some unusual visitors. Starlings were making part of the town their roost for the night. By early March it was being estimated that in excess of 250,000 birds were arriving every evening. The murmurations were a wonderful sight and this photograph captures probably the most spectacular combination of shapes seen above the urban skyline.

URBAN VIEW
adult class

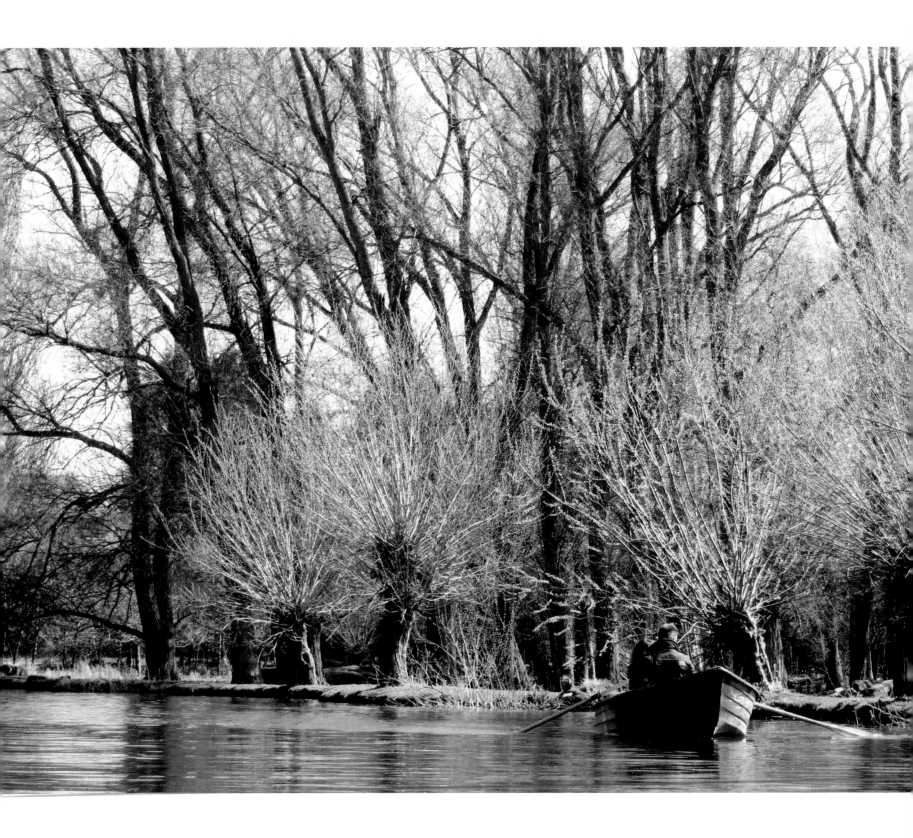

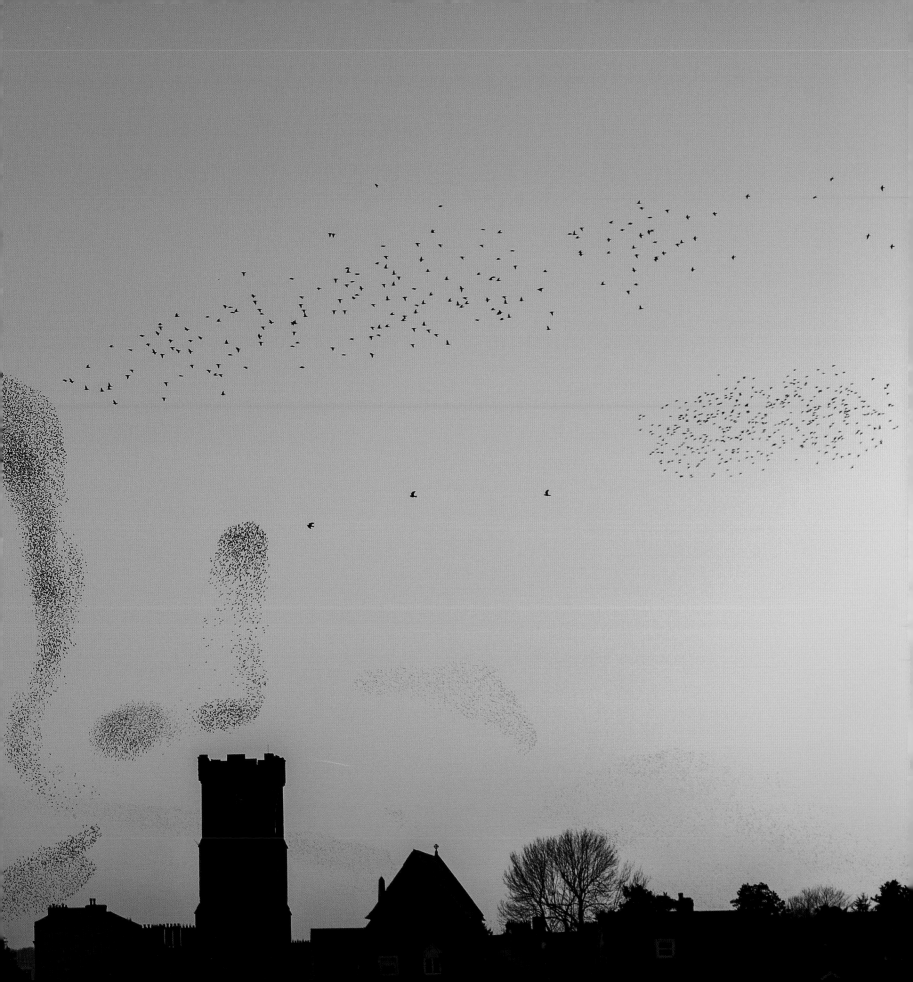

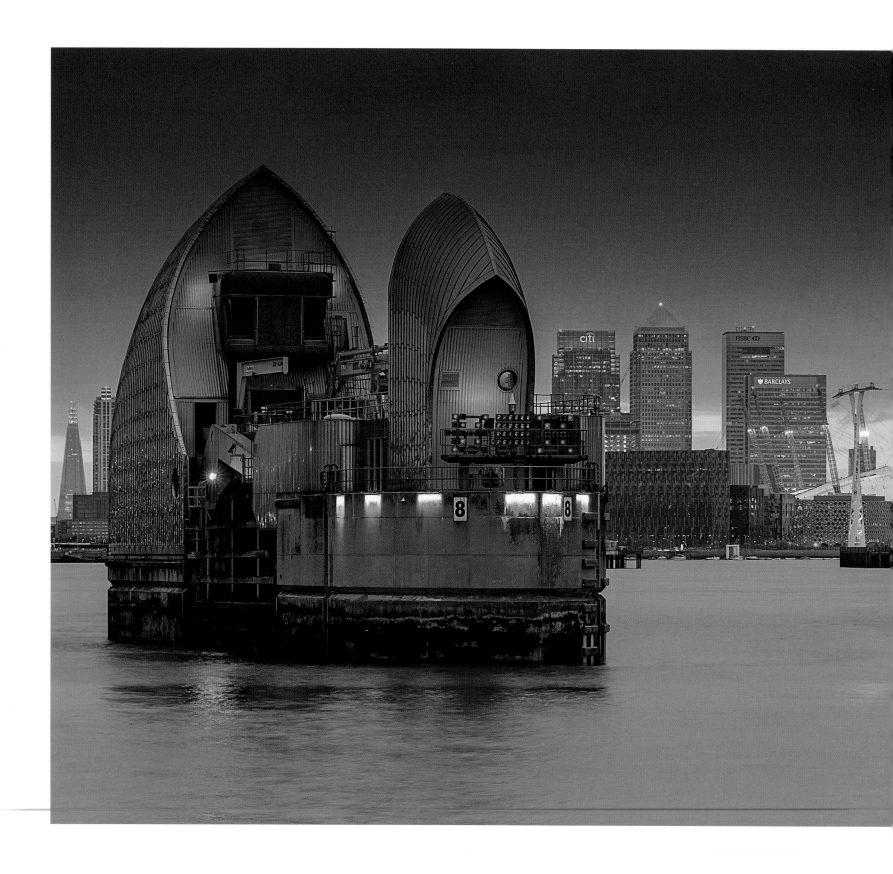

←··· CHARLOTTE GILLIATT

City Twilight
London, England

One of my favourite haunts along the river from Woolwich in London. A spring evening and a glorious sunset. I waited an age for the lights to finally come on to illuminate the barrier's defences, adding impact to the final image. I was conscious of getting as many of London's iconic buildings in the frame as possible. This was one of the last shots of the evening before the light changed altogether.

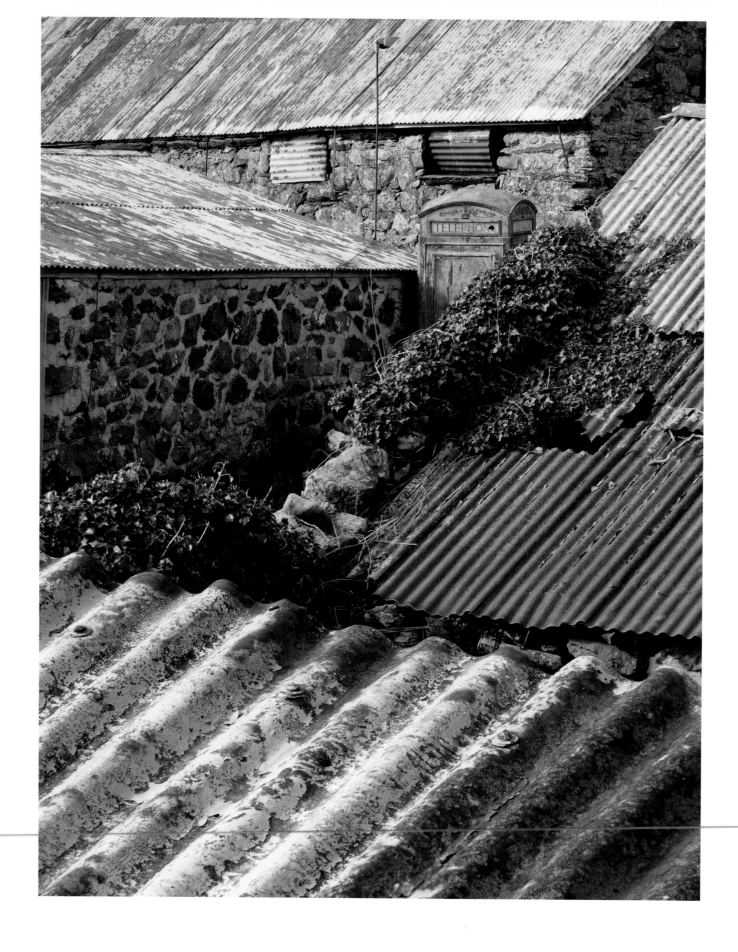

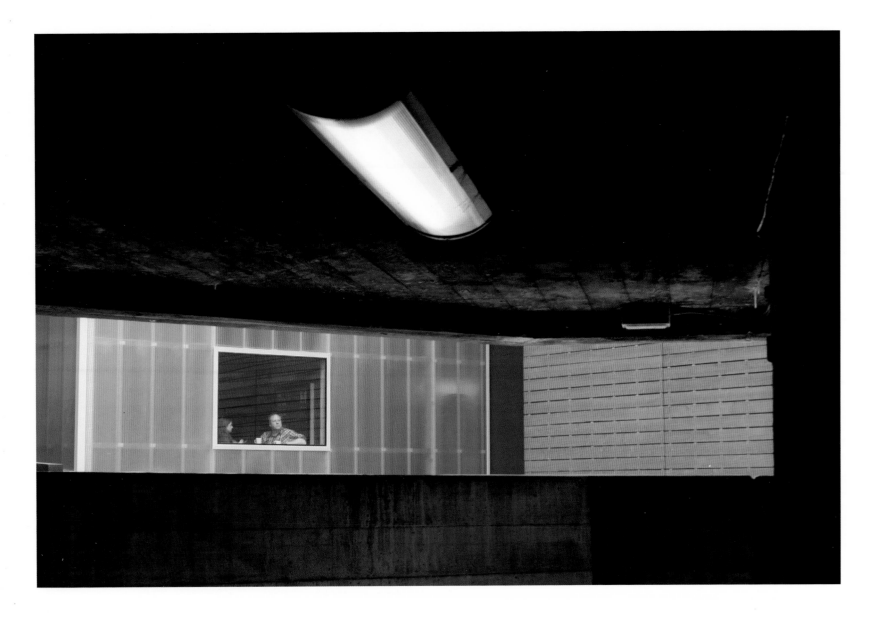

⟵··· SIMON HARRISON

'Great Britain'
Pembrokeshire, Wales

I discovered these rusting old dilapidated buildings and red telephone box with its flaking paint in rural Pembrokeshire. I used them to depict something more general about the state of urban Great Britain today, with its post-recession economy in the doldrums, high youth unemployment and town centres in decay.

↑ ADRIAN ELSTON

The National Theatre Cafe
South Bank, London, England

The South Bank area of the Thames is a fantastic place to take photographs at any time of year. The architecture, people, street performers and magnificent historic landmarks, all within a short walk, mean that there is always something interesting to take pictures of. This photograph was taken from a stairwell looking towards the cafe within the National Theatre. I think the picture works because it fulfils some of the rules of composition and the strong colours contrast with the grey bleakness of the stairwell.

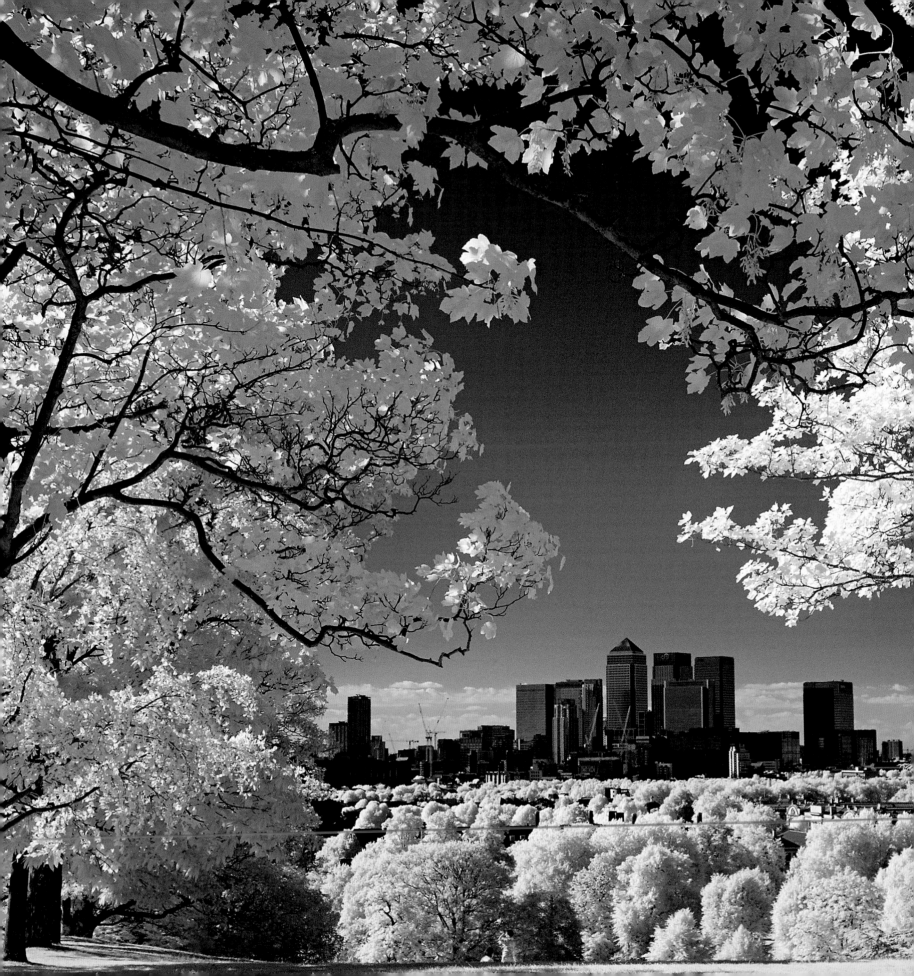

◆··· **MIKE CURRY**

Canary Wharf from Greenwich
London, England

Canary Wharf on a summer's day as viewed from Greenwich Park. I thought the trees formed a natural vignette which was further enhanced by the infra-red effect.

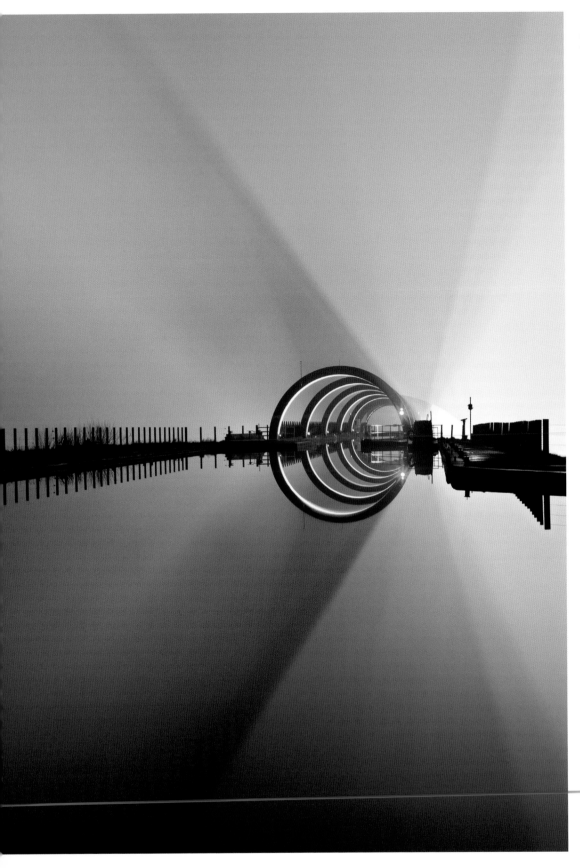

⋯ JOHN IRVINE

Falkirk Wheel in Winter Mist
Scotland

This image was taken in the winter months of early 2013. The structure itself is fairly local to me and I was aware of how many times it had been shot in a similar composition. However, I researched the weather, which told me that a winter mist would settle overnight. Once there, I used the light spill from the spotlights below, which sliced through the winter mist to create a more abstract view of this wonderful piece of architecture.

DAVID BREEN ⋯⟩

Jacob's Ladder
London, England

Wandering the South Bank of the Thames I came across this scene, fascinating in its contradictions – structural symmetry and twisted ladder, river height and ladder height – leading to a hidden London we can never see.

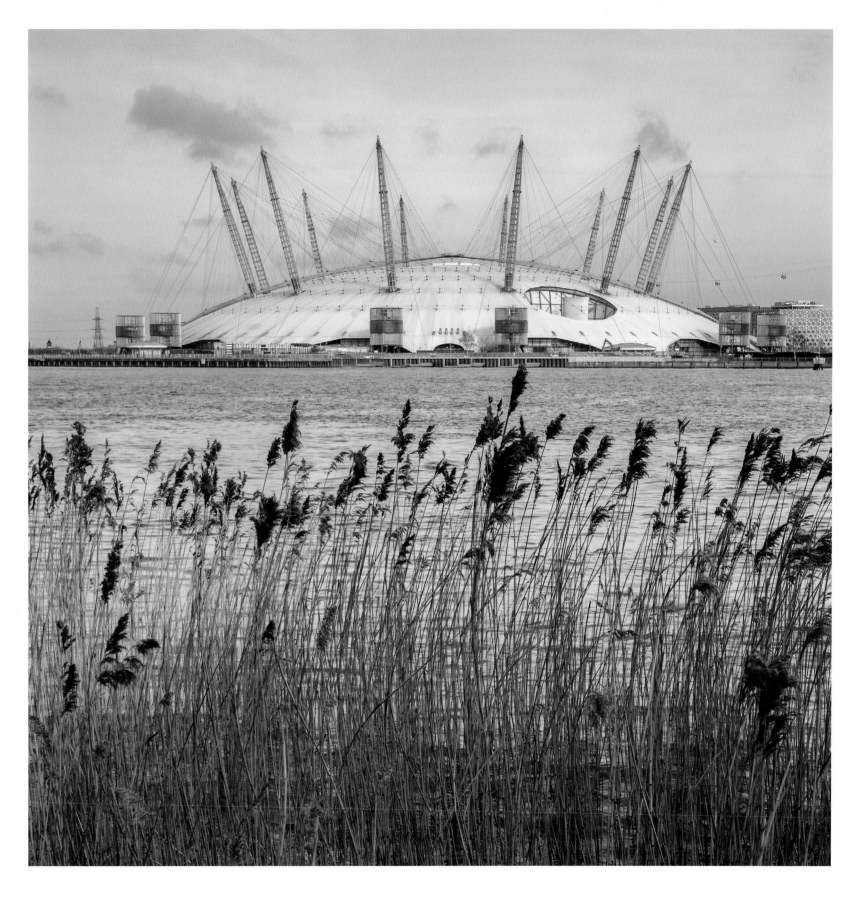

← **ANDREW HOWE**

Fiddlers Ferry Power Station
Cuerdley, Cheshire, England

I was born not far away from Fiddlers Ferry and it has always dominated the skyline in and around this area; it can be seen from miles away. I have photographed it a few times and, on this particular December morning, snow was forecast but didn't materialise, just overcast moving cloud and very cold air. I wanted to capture the whole scene, with the River Mersey winding its way around the power station, so shot the scene from a nature reserve at Wigg Island on the opposite side of the river near Runcorn, a fair distance away. I used a longer exposure to accentuate the cloud movement and the water vapour from the cooling stacks.

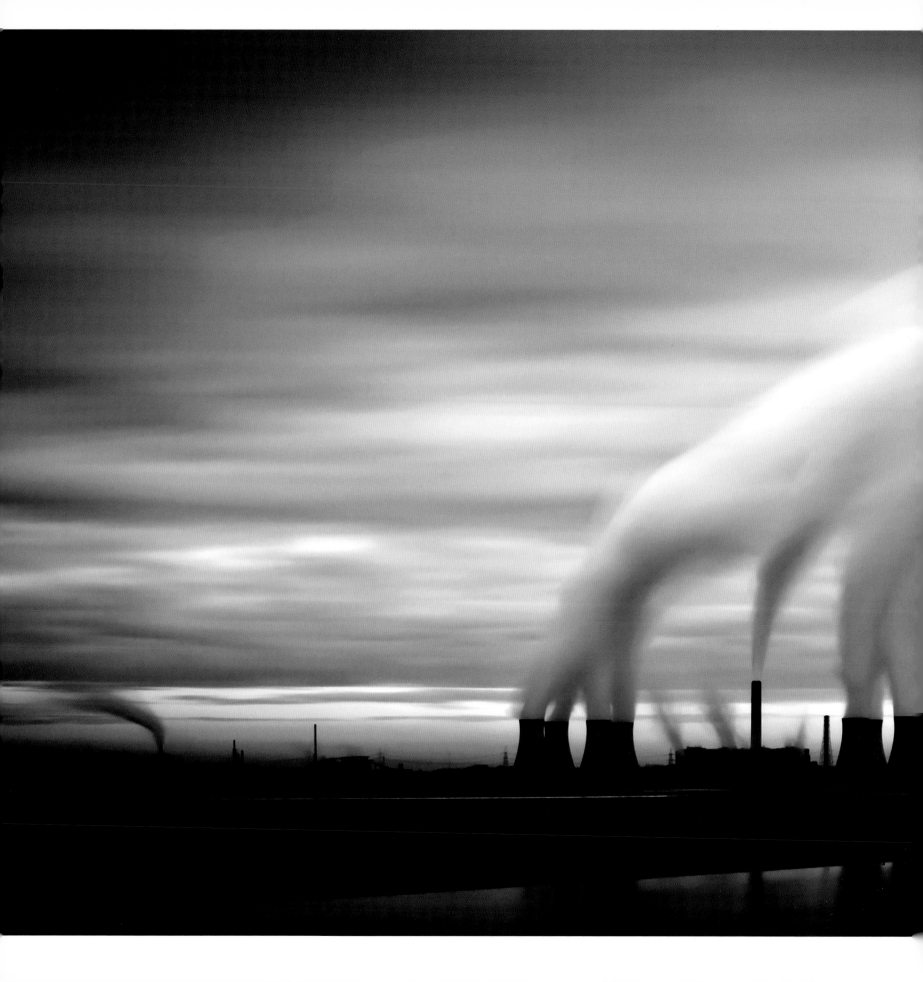

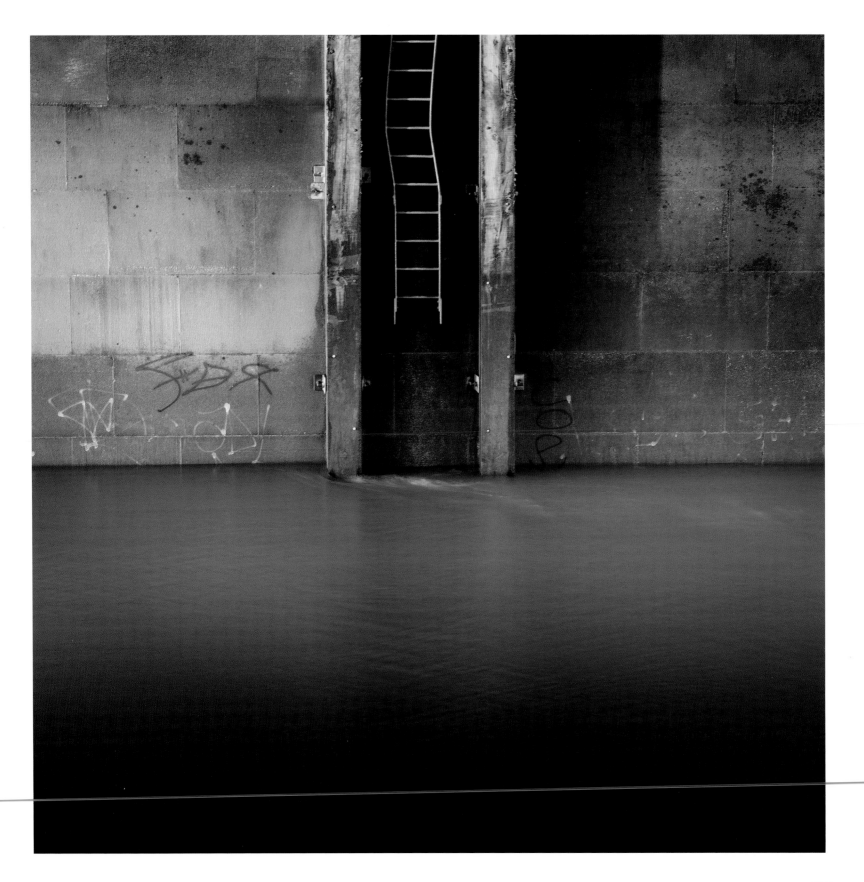

Urban Stretch
London, England

Everybody knows this building; most have an image of it in
their own collection. I wanted something different as it holds
a collection of personal memories. These days the Dome has a
glamorous persona and I wanted to show a gutsier natural look,
encompassing its roots as a reclaimed piece of land. The 12 tall
posts represent each month of the year around a 365-metre tent,
so the plan was to show it within a grassy, green environment; a
tough challenge within the concrete jungle of London. I knew of
a location on the Isle of Dogs with a view across the river and the
tall reed grass gave the perfect foreground balance, mimicking
the Dome tent poles. The grass also gives the feeling that it's
stretching out, almost trying to reach and grab the Dome, pulling
it back to its roots.

TOBY SMITH ···▸

Disused Phone Boxes
England

A stockpile of uninstalled British Telecom phone boxes of the K2
and K6 designs from across the 20th century. This large collection
of disused phone boxes is a privately owned investment. The 250
plus phone boxes of different designs are stored outside in various
states of decay awaiting restoration to their original specification
and subsequent private sales. The shoot was made more
interesting by the wind and rain of a February night.

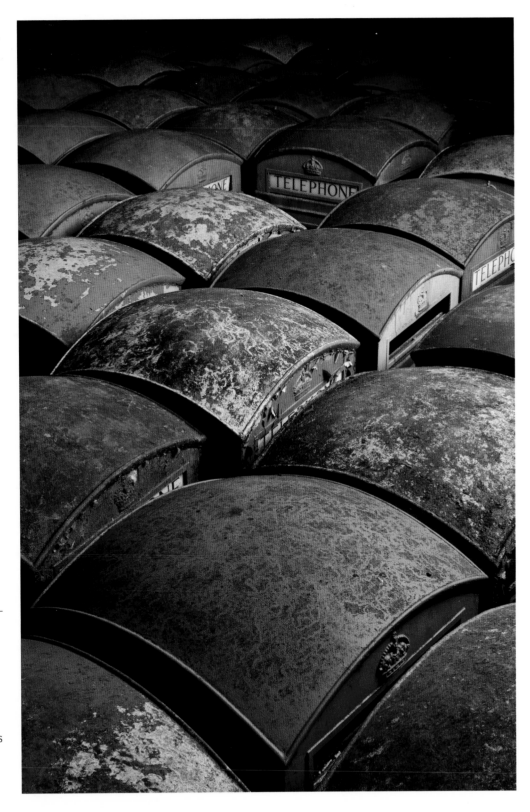

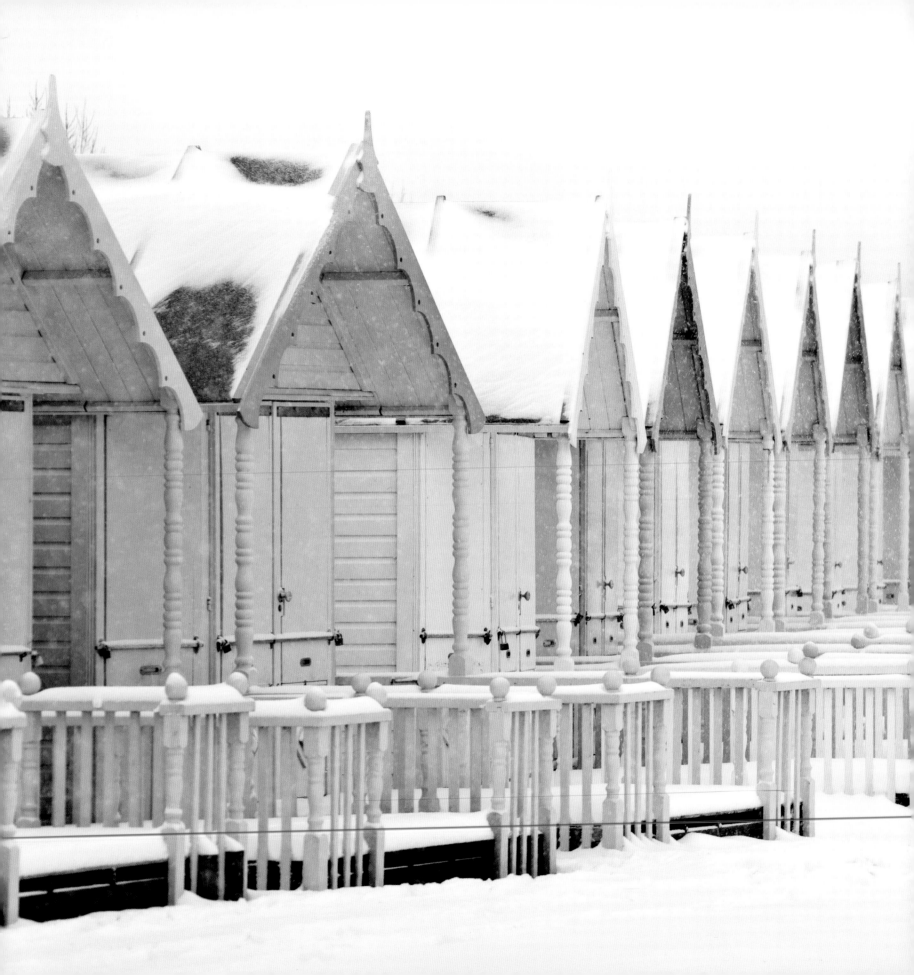

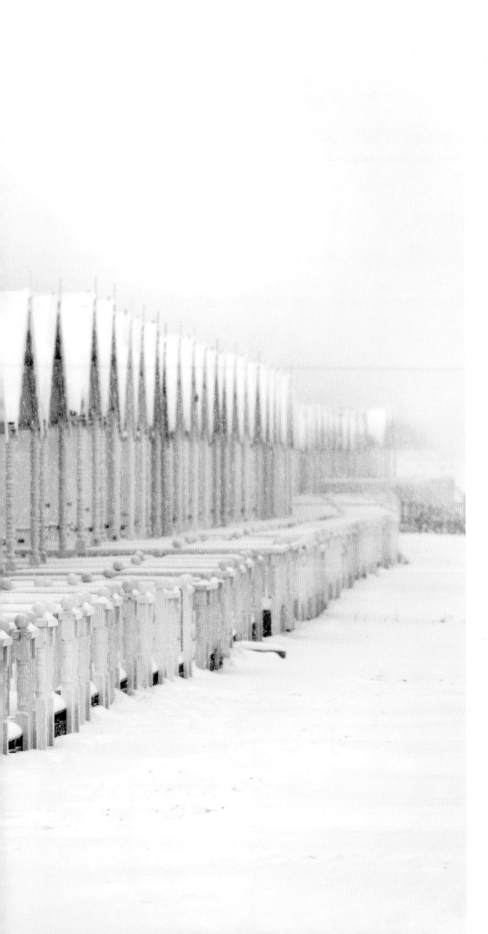

Beach Huts in the Snow
Mersea Island, Essex, England

When these beach huts were built about four years ago, I was immediately attracted by their delicate pastel colours and felt they could be a good subject for the camera. I envisaged taking them on a misty day, with the colours gently receding into the distance. I was eventually successful in getting my shot but then, just a couple of weeks after doing so, it snowed. This was a real bonus, as the snow, combined with the mist, added even greater simplification by suppressing the beach detail. The resulting high-key image more than realised my expectations. I also used the widest aperture on my zoom lens to minimise the depth of field, thereby enhancing the feeling of tonal and colour recession.

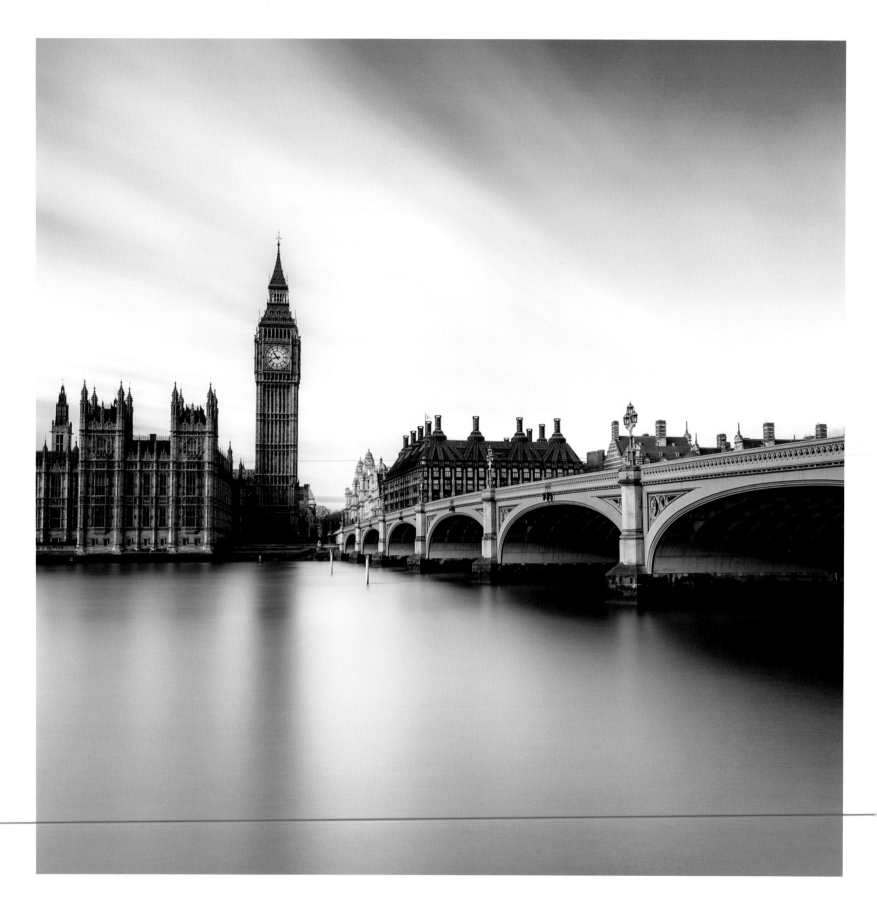

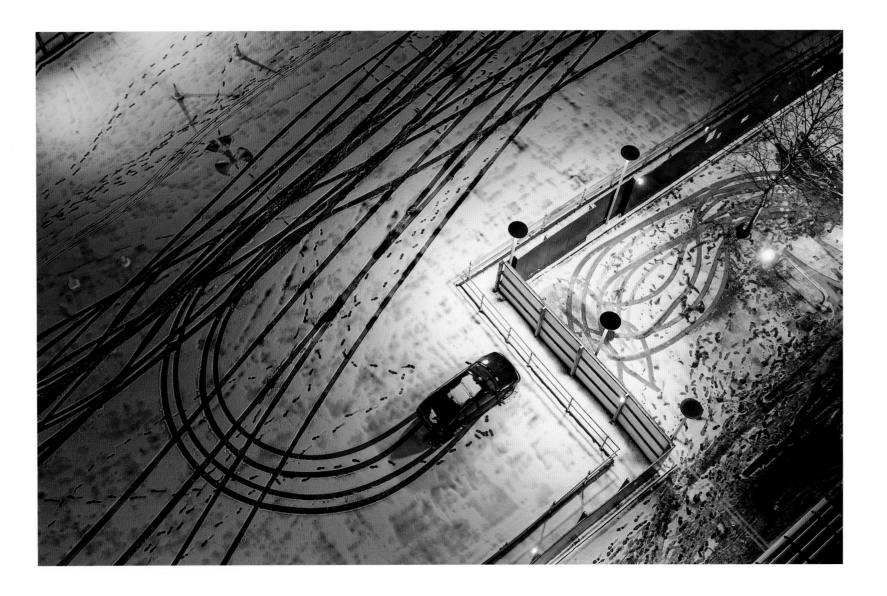

CHARLOTTE GILLIATT

Iconic
London, England

I managed to get a decent spot in amongst the tourists along the river wall on the south side of the Thames. Being a fan of long exposure, the 10-stop ND filter made another appearance. With hardly any cloud, I wasn't sure of the effect it would have on the sky but there was water and I knew I could do something interesting with that.

KAUSHIKLAL KORIA

Tracks in the Snow
Salford, Greater Manchester, England

Following a heavy snowfall, the view from my 10th-floor balcony revealed patterns created by car tracks and footprints. An 'angel' in the snow provided the final touch!

NIGEL MORTON ···⫶

Lightning Strikes The Shard
London, England

I composed this image as the electrical storm passed overhead, ensuring I had all the main features of the square mile included while allowing the sky to take up the majority of the frame. I used two stacked neutral density filters to achieve an exposure time of two seconds. I then left the camera to automatically expose consecutive shots until the memory card was full. After checking the 150 or so pictures, just two had captured lightning; the second of which was this direct hit on the newly completed Shard building. The picture was made from my apartment building in Muswell Hill, 6.5 miles away from The Shard.

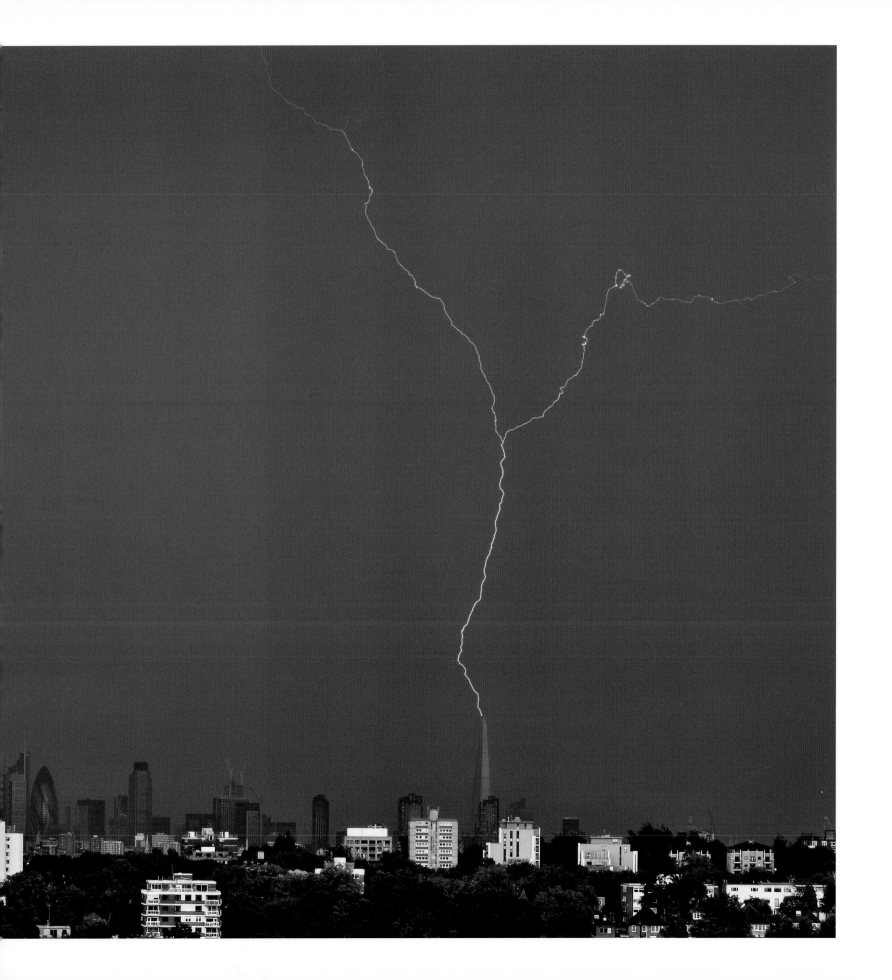

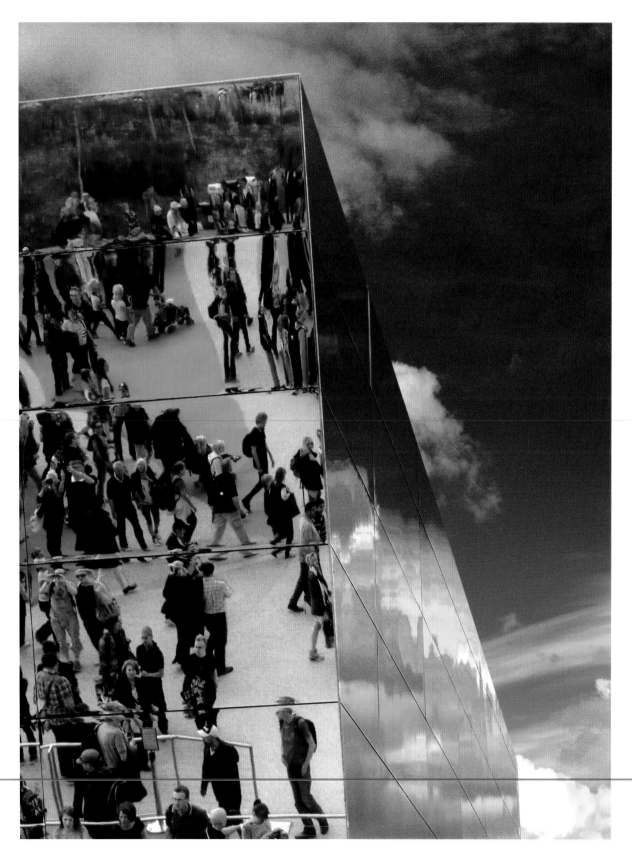

ROBERT BACK

Reflections of 2012
Olympic Park, London, England

This was taken at the Olympic Park in Stratford during the 2012 Olympics and is one of a number of Pavilions, each of which had its own distinct character.

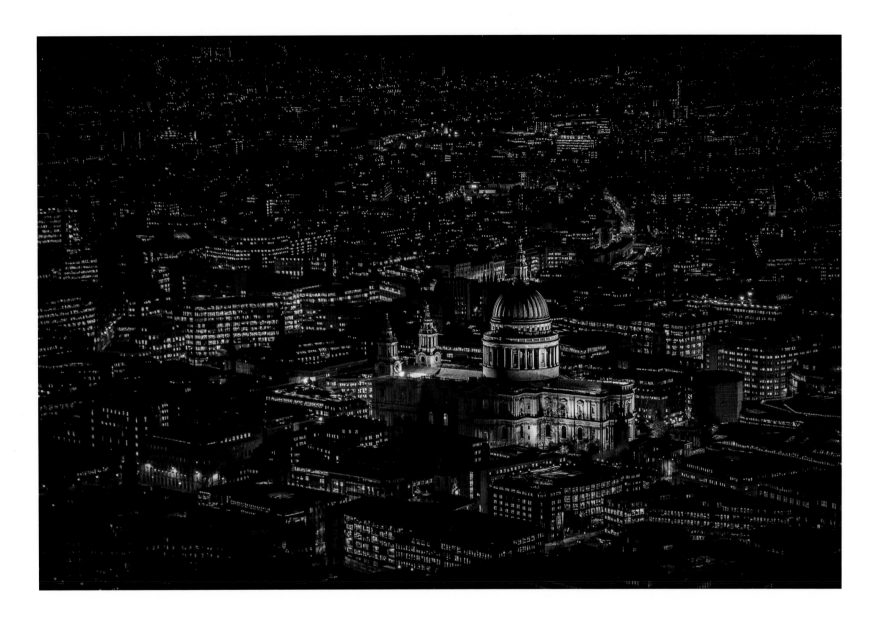

✝ **WARREN CHRISMAS**

The Pixels and St Paul's
London, England

St Paul's Cathedral and the surrounding area in London, viewed from the top of The Shard, the tallest building in western Europe. The over-sharpened look creates the 'pixel' effect, which I think works well when the image is viewed small or from a distance.

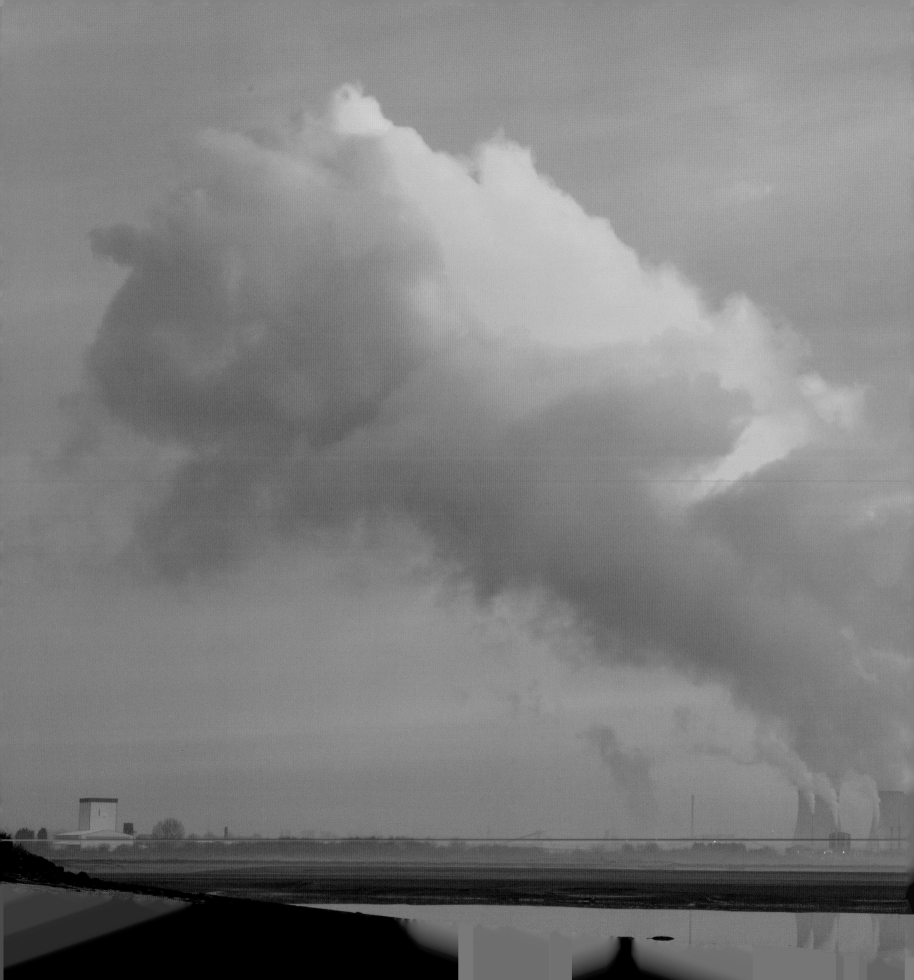

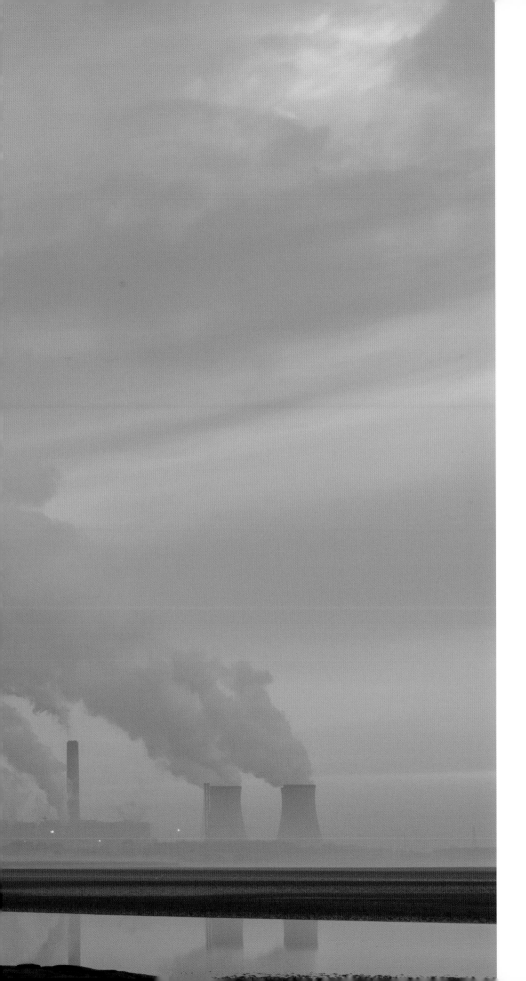

◀··· **JAMES WALLACE**

Fiddlers Ferry Power Station at Dawn
Cuerdley, Cheshire, England

On this particular January morning I had planned to capture a shot of the Runcorn Bridge at dawn but as colour started to seep into the sky I moved down the estuary to capture the colours of the sunrise over Runcorn. It was only by chance that I glanced to my left and saw what looked like a giant stick of candyfloss being pumped out of the cooling towers of Fiddlers Ferry Power Station.

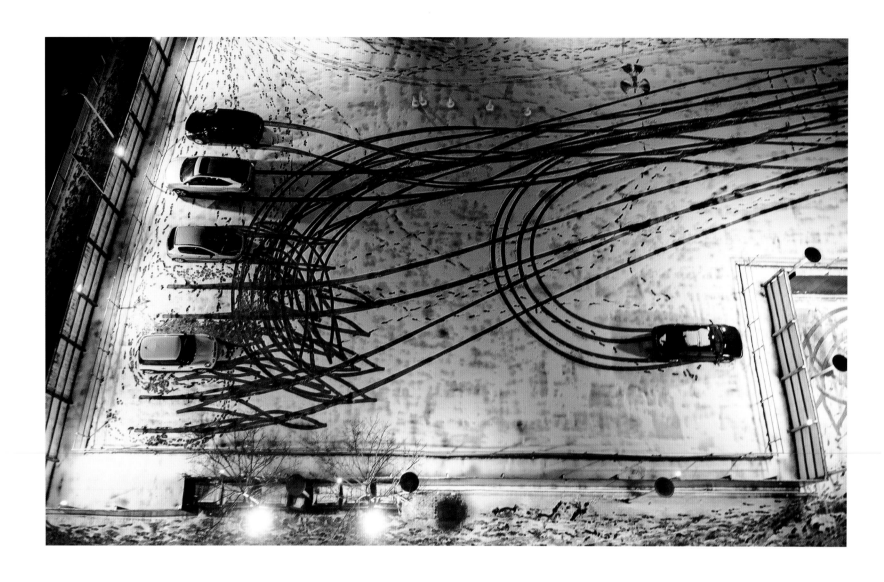

KAUSHIKLAL KORIA

Tracks in the Snow
Salford, Greater Manchester, England

After a December snowfall, I photographed patterns created by the car tracks and footprints in the snow from my 10th-floor balcony. Someone also created an 'angel' in the snow for the final touch!

URBAN VIEW YOUTH CLASS WINNER

CHARLOTTE BURTON ····⟩

Blue Sky Reflection
Cambridge, England

This image shows a fraction of the large block of new-build offices that were constructed near the station last year. The block is made up of rectangular glass panels, together creating the large, curved structure. The whole building's glass surface reflected the blue sky brilliantly but I wanted to photograph just a small section, creating a more abstract image.

URBAN VIEW
youth class

Avon View
Stratford-upon-Avon,
Warwickshire, England

Taken at the height of the November floods. This bench was in a riverside park next to the River Avon. It required high Wellingtons and careful probing with my tripod to check the depth of the water in front of me. This bench was isolated and looked surreal in its temporary environment. I wanted to show how an everyday, otherwise ignored piece of park furniture can be transformed into an object of beauty by a juxtaposition of environments.

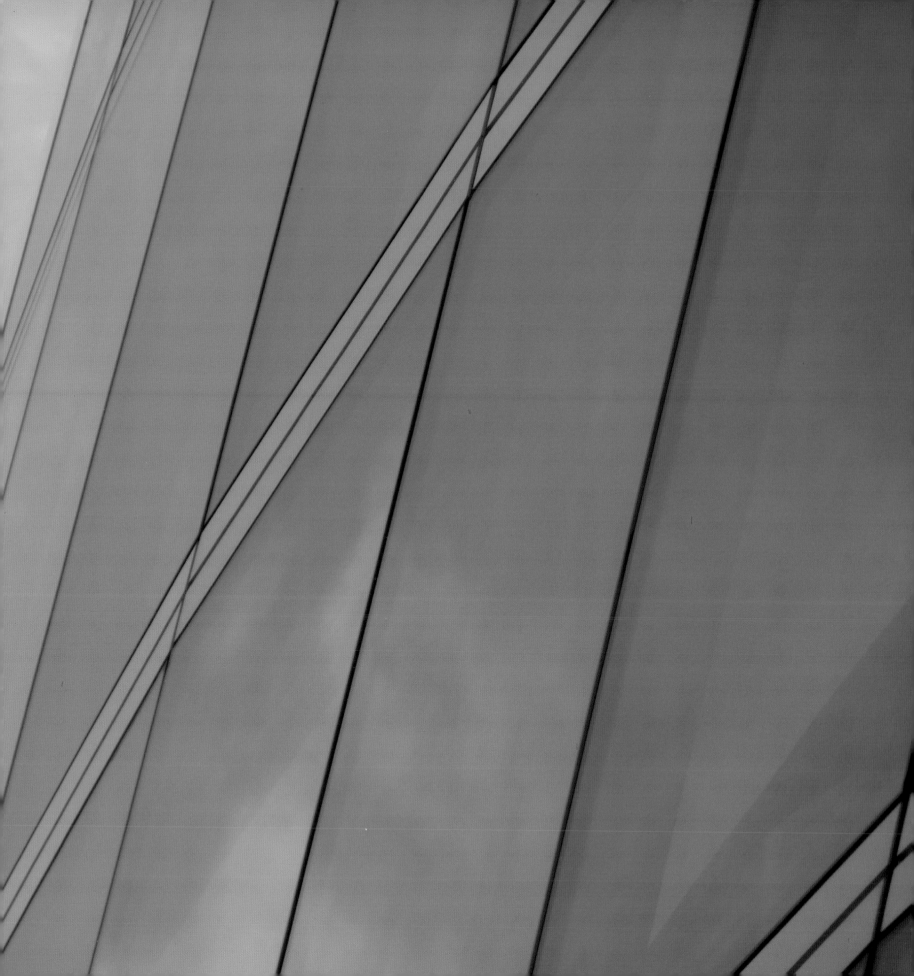

YOUR VIEW
adult class

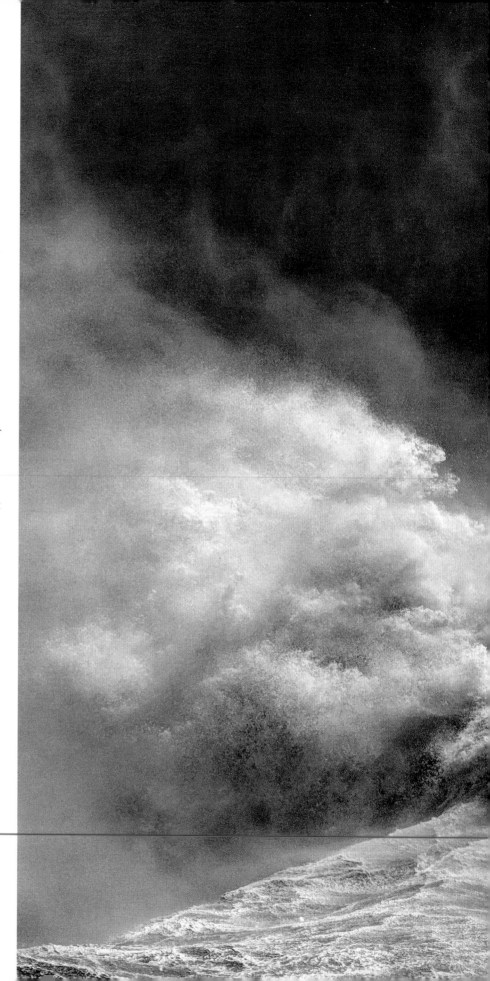

YOUR VIEW ADULT CLASS WINNER

DAVID LYON ···⟩

Ferry Leaving Newhaven Harbour in Storm
East Sussex, England

After shooting waves crashing over Newhaven lighthouse for about
an hour during a summer storm, I decided to change position and
try to get some shots covering the seaward side of the harbour
wall from the shingle beach. As I approached the beach, I saw the
funnel of the ferry over the sea wall, so I sprinted down the shingle
with the camera still attached to the tripod and managed to get a
few frames before it disappeared.

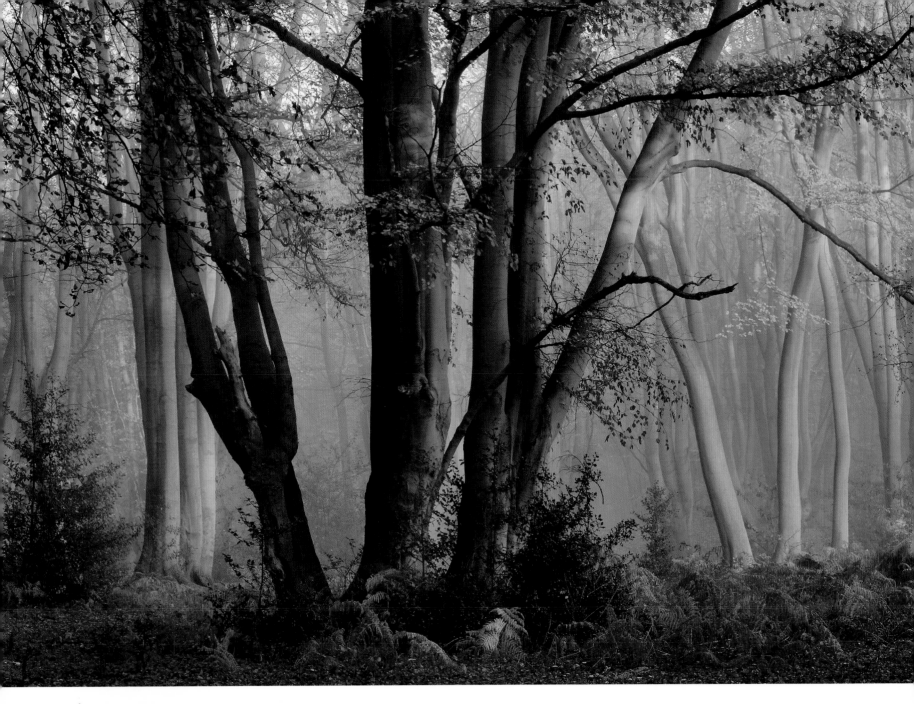

✝ **NIGEL MORTON**

Near Loughton Camp
Epping Forest, Essex, England

An autumn panoramic image made from three horizontal photographs stitched together and cropped back down to 17:6 aspect ratio. The location is Loughton Camp, an Iron Age hill fort in Epping Forest. The picture is part of my long-term project on photographing the area.

Judge's choice Colin Prior

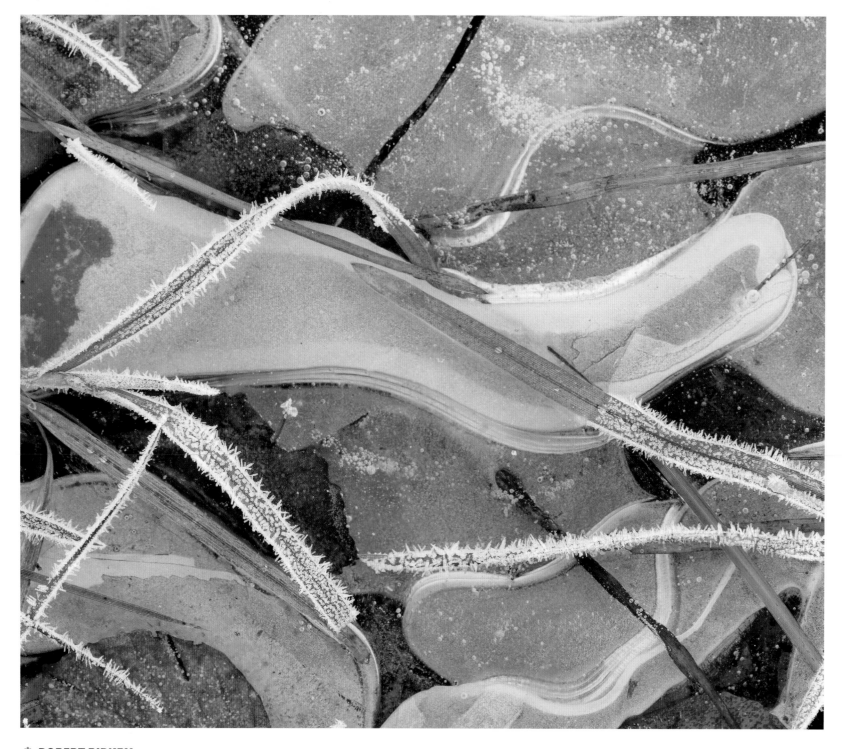

🌱 **ROBERT BIRKBY**

Icy Abstract
Calderdale, West Yorkshire, England

A forecast of sub-zero temperatures promised some great photo opportunities but, after spending a couple of hours out on this Sunday morning, I was disappointed to find very little. I set off back to the car, and passed this frozen puddle. There seemed to be some potential here; I could see texture, patterns and colour which appeared striking somehow, but had to study for a few minutes to find the optimal composition. A man walking his dog passed me, offering some very strange looks and no doubt wondering why someone would photograph a puddle!

Judge's choice Charlie Waite

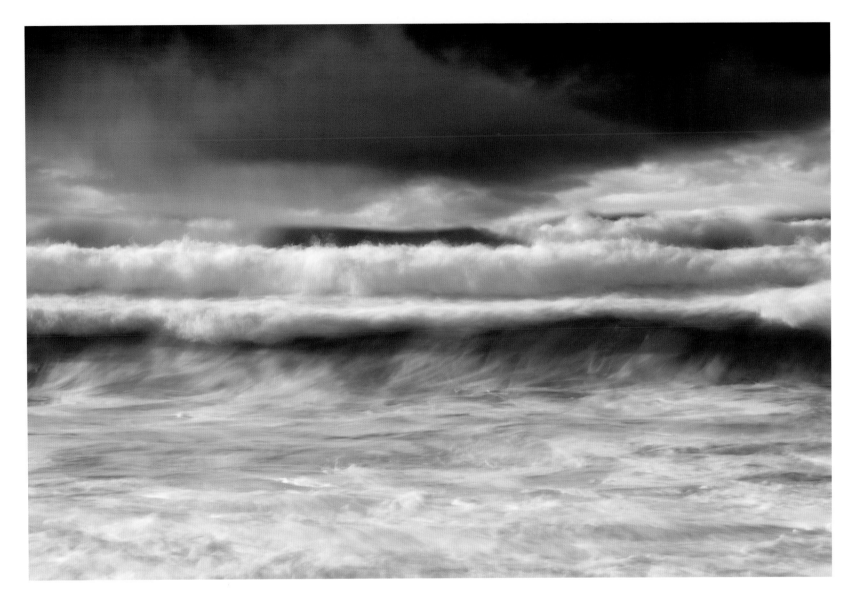

YOUR VIEW ADULT CLASS RUNNER-UP

DAVID BAKER

Hebridean Sea III
Outer Hebrides, Scotland

As a seascape photographer based in Southampton, I'm naturally drawn to the wild seas around northwest Scotland, especially those of the Outer Hebrides. It's the sense of power, force and colour, accompanied by the infinitely variable soundtrack. This photograph was taken on my second visit to Lewis and Harris specifically to capture the power, energy and surge of the seas via the ever-changing possibilities of the combination of sea and sky.

Judge's choice Monica Allende

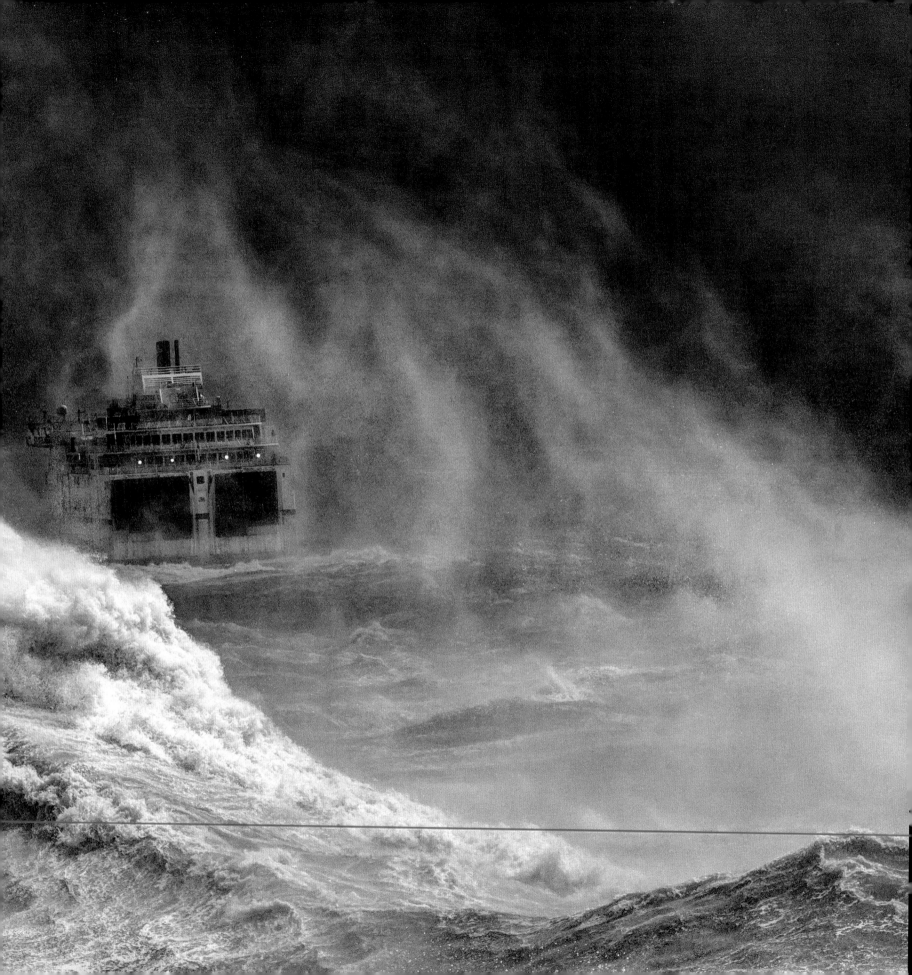

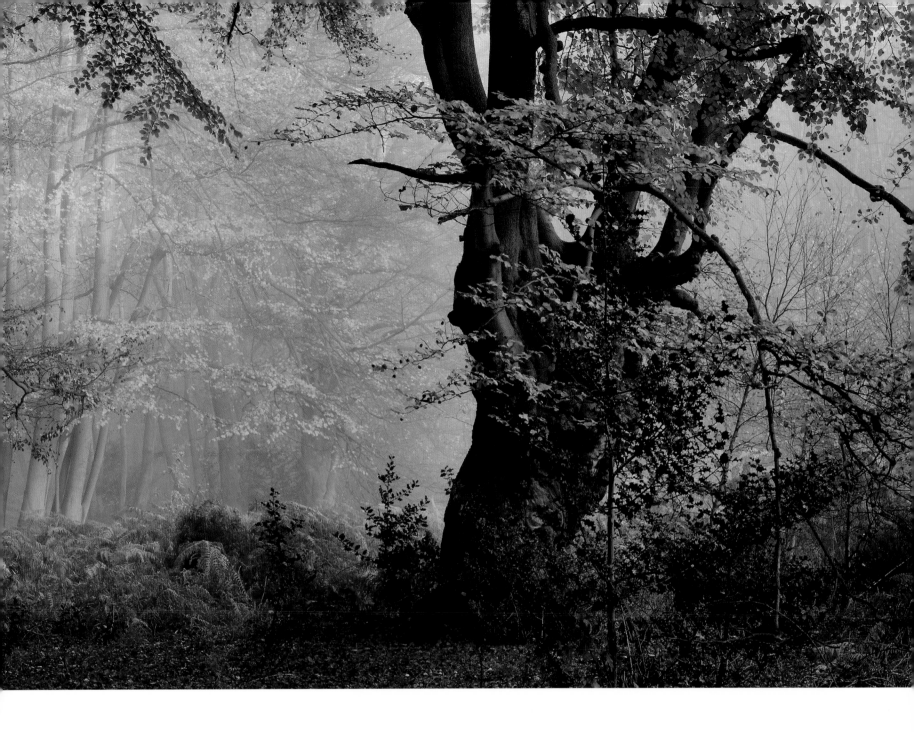

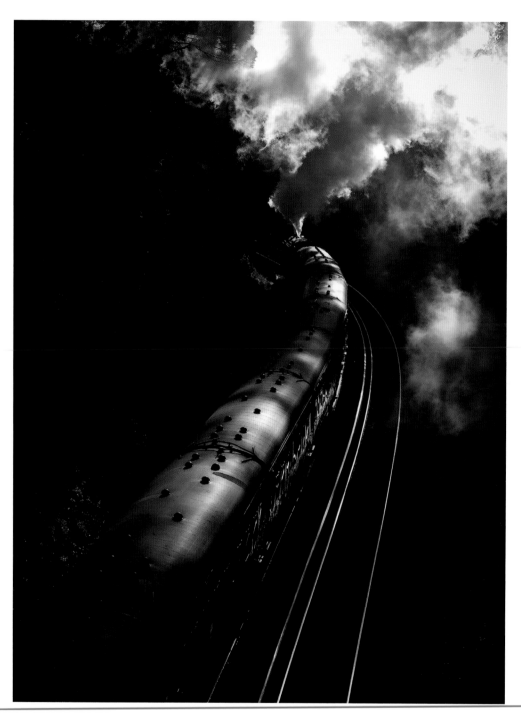

⟨··· ALAN COURTNEY

Early Morning Steam at Parkstone
Dorset, England

A bridge over the railway at Parkstone had always been a great place to see steam engines working up the bank. Nowadays, electric trains glide by effortlessly but, occasionally, you still get the chance to see man and machine battle the 1 in 60 incline. On this day in early September, the Bath Spa Express, headed by a locomotive named *Britannia*, had just passed below me. As the smoke and steam began to dissipate, I managed to get this more unusual 'going away' shot, with the sun's early morning rays penetrating the darkness of the cutting and illuminating the rails and sides of the coaches, giving a retro, yet strangely contemporary, picture.

Network Rail Shortlist

Judge's choice David Watchus

MIKE CURRY ···⟩

Water II
Canary Wharf, London, England

Detail of the reflection of an office building in South Dock at Canary Wharf.

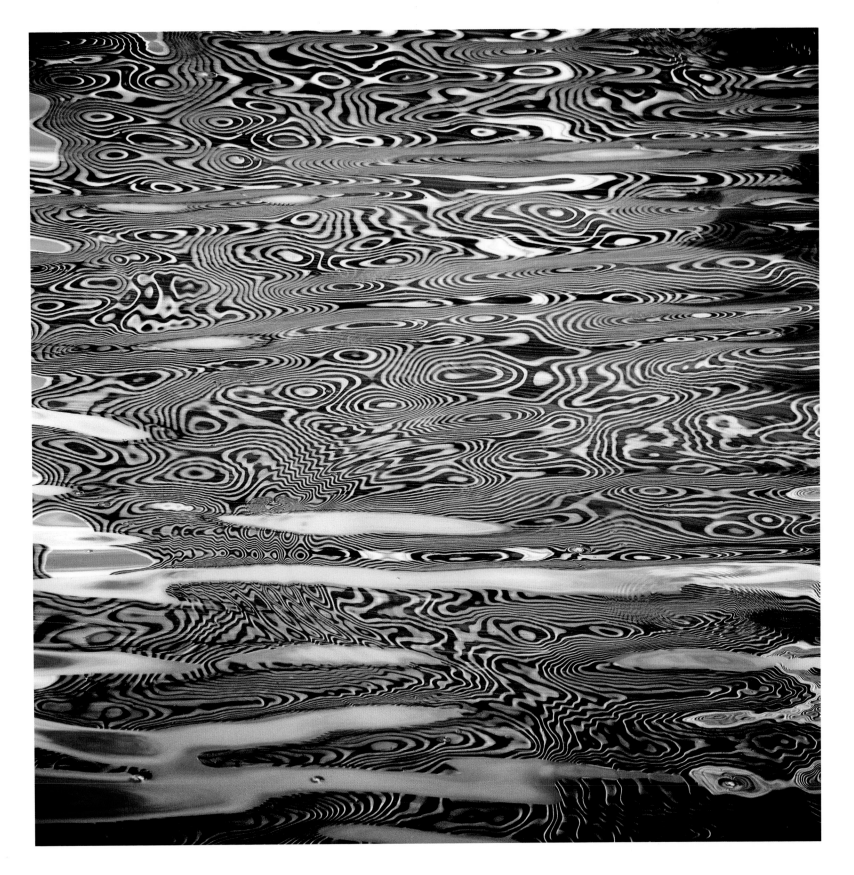

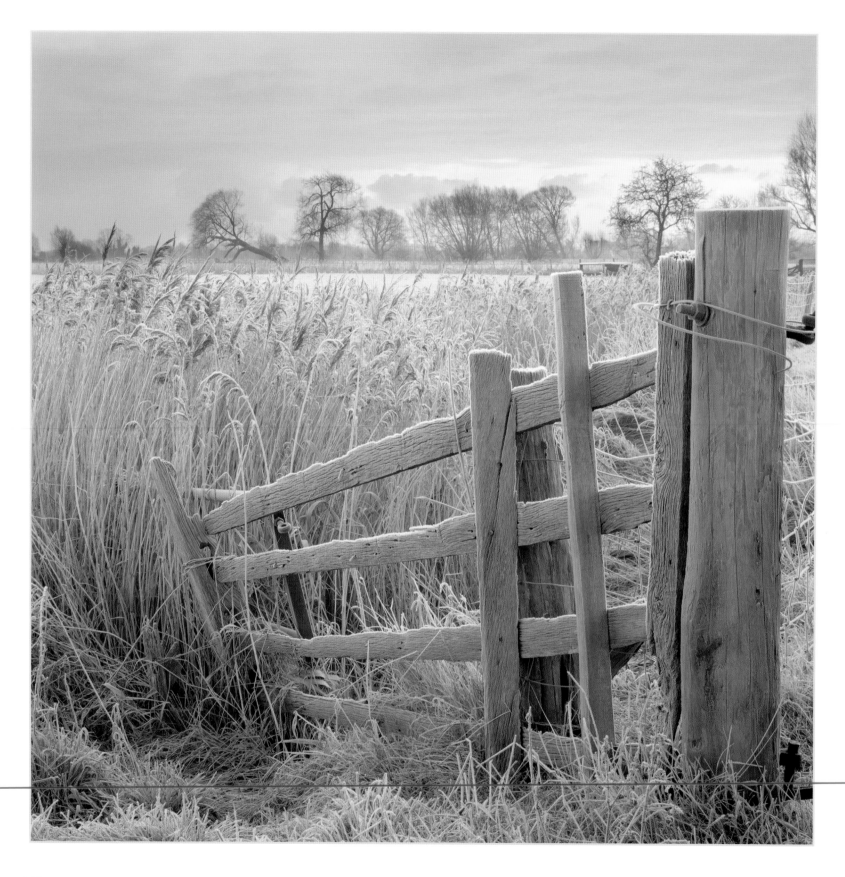

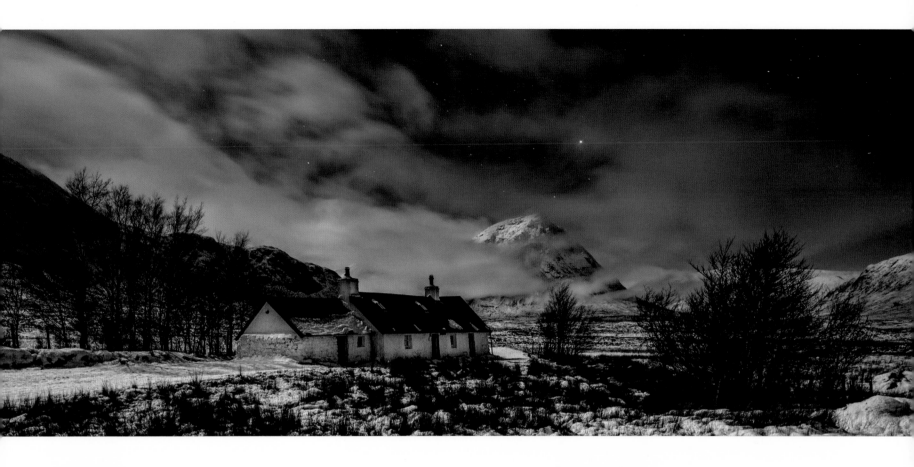

LINDA WEVILL

Frosty Gate
Romney Marsh, Kent, England

This image was taken just after sunrise on an extremely cold January morning when I went to Romney Marsh to photograph Fairfield Church. The gentle colours of the sky at this time of the day, together with the hoar frost covering all the grasses and vegetation on the marshes, gives the scene a soft, magical feel. I noticed the gate and the way it leads the viewer into the scene, through the reeds and towards the fallen tree in the background. I liked the texture of the wood and the hoar frost on the gate and the softness of the wintry scene.

SCOTT WILSON

Black Rock Cottage by Moonlight
Glencoe, Scotland

How do you shoot an icon? I wanted to get an original take on Glencoe's famous Black Rock Cottage. A bitterly cold, starlit December night provided the ideal backdrop.

169

⟨⋯ CHRIS GODDARD

Autumn near Capel Curig
Snowdonia, Wales

I was staying near the small town of Capel Curig in North Wales hoping for some mist to develop along the River Llugwy, which meant an early start. This small patch of wood was a short walk from the river and I happily spent a few hours roaming around looking for shapely trees and the colours of autumn. Woodland can be quite overwhelming so I used a long lens to pick out details and help simplify the scene.

KEITH AGGETT ⋯⟩

Descent
Babbacombe, Devon, England

Descent, taken on a rainy morning in Babbacombe. The weather on this day made for a soft, receding backdrop to increase the focal point on the foreground; filters were used to increase the exposure time and smooth out the water. The location can be found by walking the coastal path to Oddicombe and this composition is only possible with the combining of two images to create a vertorama.

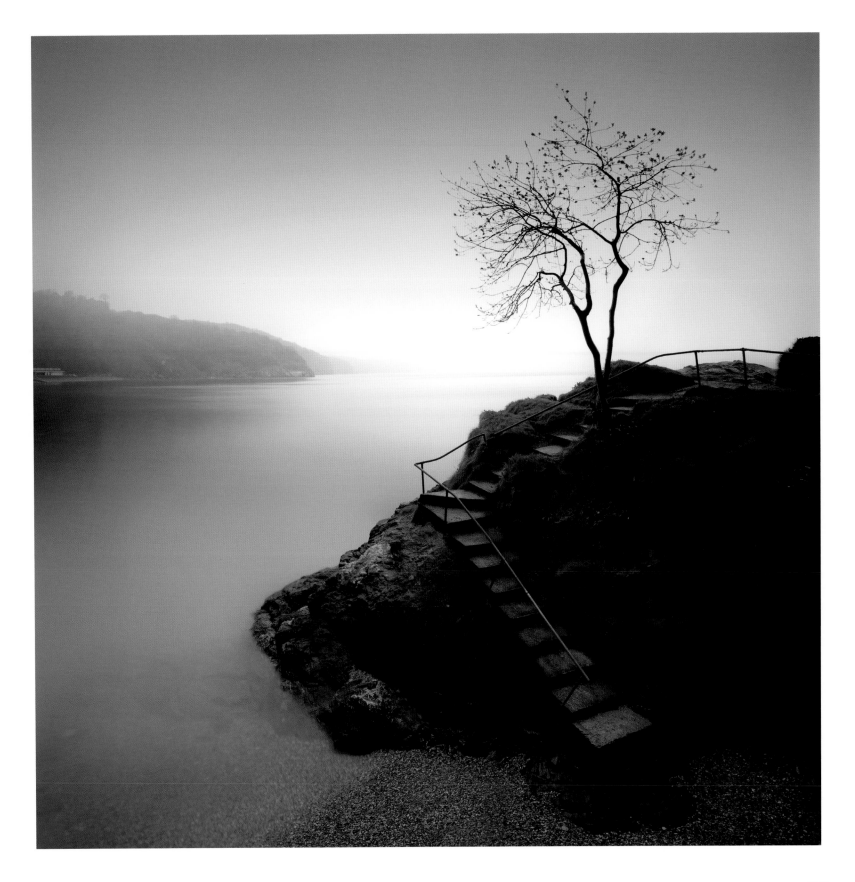

STEVE GRAY

Morning Light in the Poplars
Herefordshire, England

I photographed these trees on a July morning with strong sunlight. I particularly liked the dappled pattern of light on the ground, with the dandelions resplendent in the sun. The rows of trees beyond add a sense of depth and the splash of blue sky in the distance completes the picture and breaks up the predominant green.

Judge's choice Jasmine Teer

DAVID MOULD

Autumn Morning Light
Loch Rusky, Perthshire, Scotland

The beauty of this little loch belies its size. From its infinity view to the south over the Campsie Fells to the seemingly endless ripple-free surface, the early autumn morning light creeps along the far bank ensuring a well-lit scene, welcoming only the most dedicated fishermen and insomniac photographers.

STEVE TUCKER

Parkhouse Hill and Chrome Hill
Peak District, Derbyshire, England

Living in Derbyshire and spending my formative years exploring the caves and dales of the Peak District, this has been one of my all-time favourite places since my early teens. I had planned an early start after a heavy overnight snowfall and hoped for a classic sunrise, but snow-laden cloud put a stop to that and all I could do was set up my camera and wait for a slim chance of some light. For the briefest of moments, the sun cast some light on the scene and added depth and tonality to the image. There was very little natural colour in this image and I think it works well in black and white, which helps to bring out the contrast in the sky.

176

✝ **ESEN TUNAR**

Sastrugi
Snowdonia, North Wales

I found this snowdrift on the way up the Glyders in Snowdonia. Windy conditions created some amazing sculptures at high altitude. On this morning, as the sun rose, small pockets of cloud began rising up the ridge, blocking out some of the sunlight and balancing the exposure.

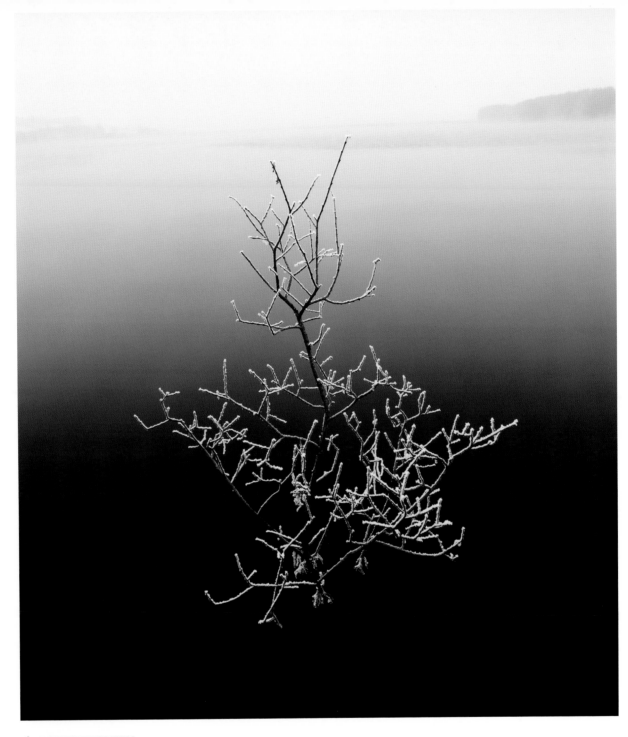

ROBERT BIRKBY

Frosty Morning
Ripponden, West Yorkshire, England

Overnight frost had painted everything white on this bitterly cold morning in the Pennines. On arrival at Baitings Reservoir, I was pleased to see mist rising from the water, creating an eerie, almost monochromatic landscape. I needed something to add foreground interest and after some extensive searching found this small tree at the water's edge. The gradient of black to white formed the perfect background to make the subject really stand out.

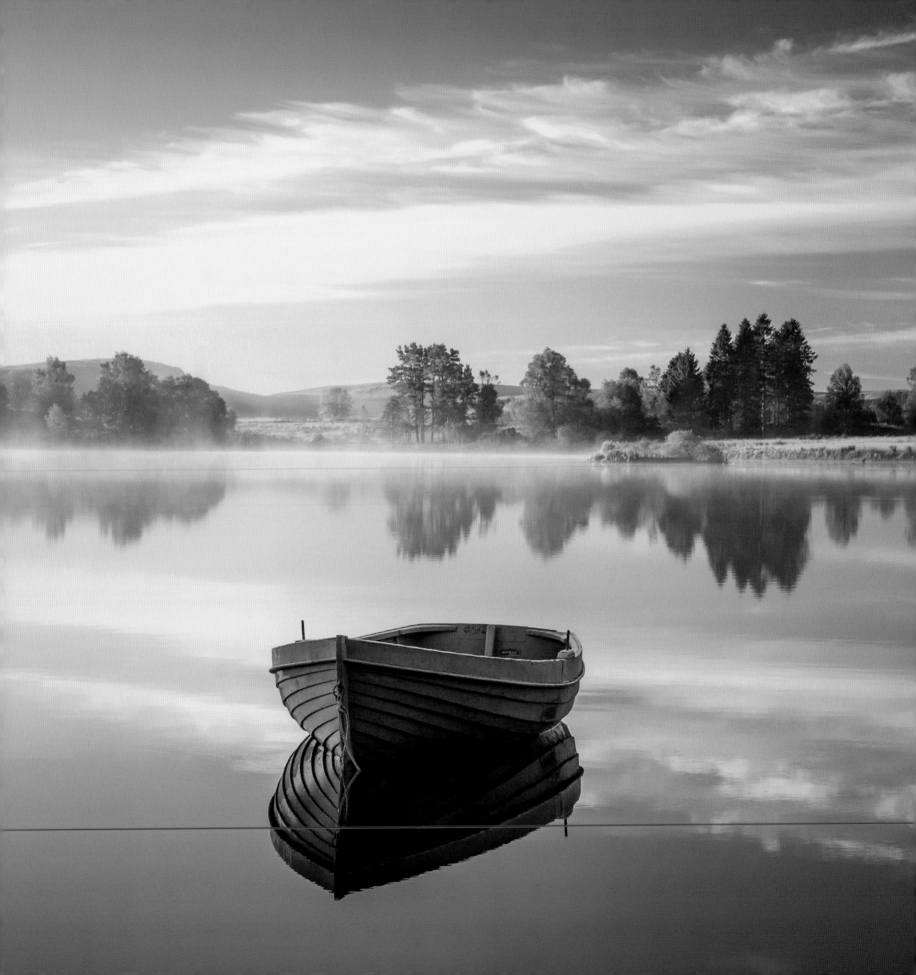

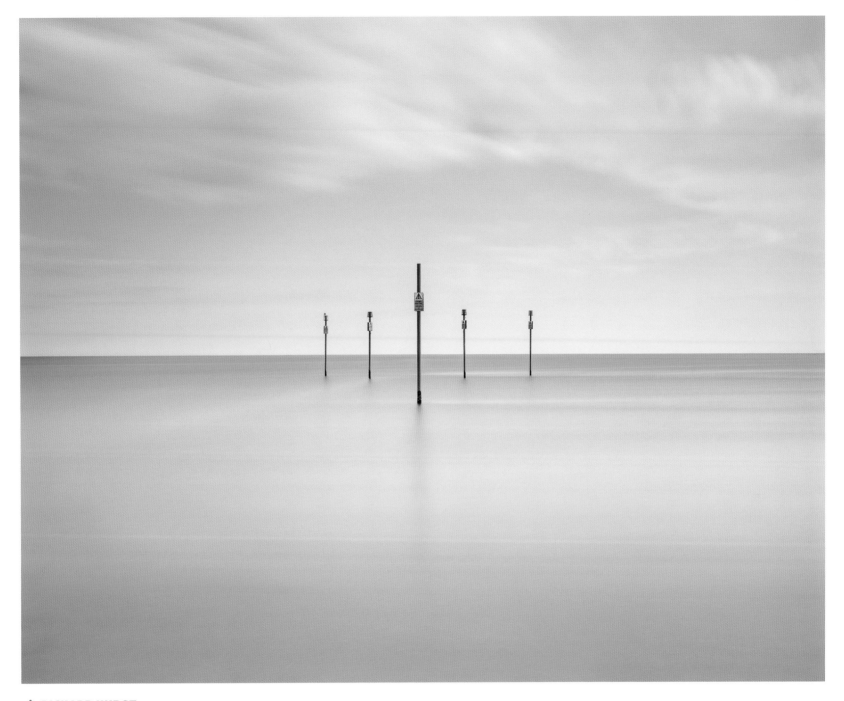

🕆 **RICHARD HURST**

Guardians
Shoreham-by-Sea, West Sussex, England

I planned this shot after a previous trip to this location when the tide was not at the correct height: five solitary markers sitting just off the coast. The long exposure really makes the posts stand out, almost as guardians watching the coastline and keeping it safe.

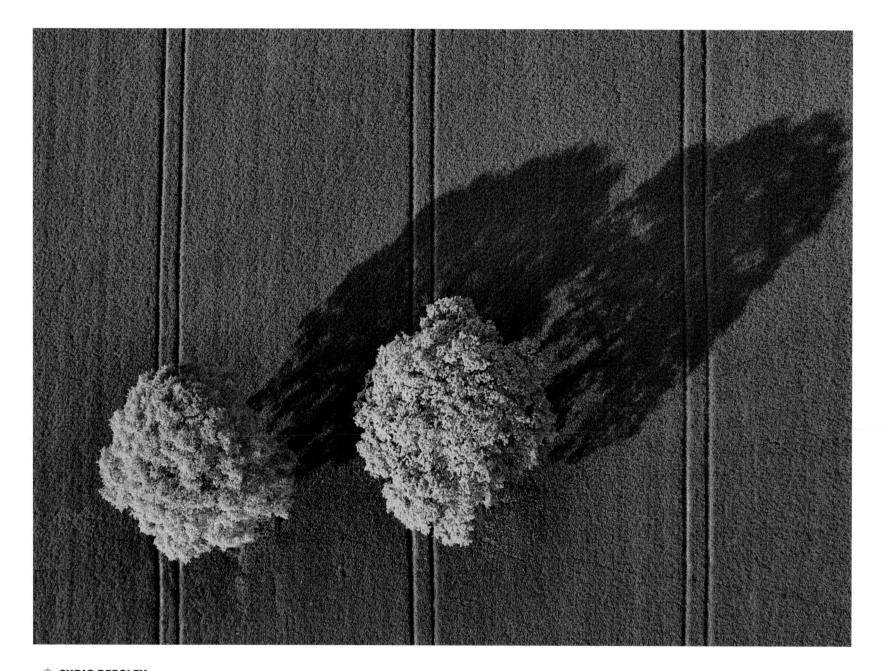

🎈 **CHRIS BEESLEY**

Over Tree Tops
Herefordshire, England

My wife treated me to a hot-air balloon flight for my 50th birthday. This was taken hanging out of the basket whilst drifting over the Herefordshire countryside on a lovely misty but sunny morning. I was taken by the way the shapes of the trees and shadows were in contrast to the tractor lines.

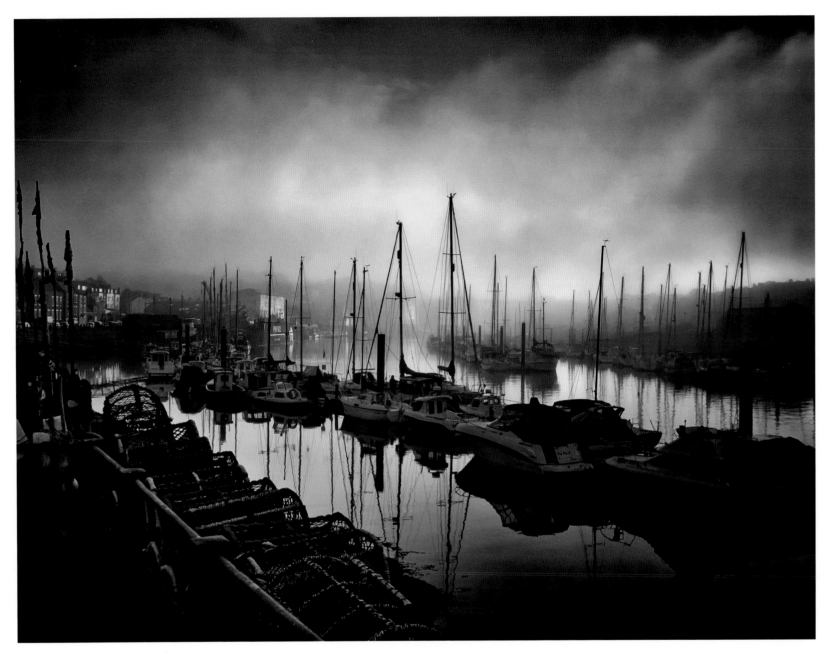

PAUL ANTHONY WILSON

Whitby Harbour in the Fog
Whitby, North Yorkshire, England

The way home from work takes me along the side of Whitby Harbour. On this occasion, a bank of fog was beginning to drift across the water. I imagine this would have been a typical scene confronting Frank Meadow Sutcliffe back in the Victorian era but, instead of modern yachts, the masts of the herring fleet would have faded off into the smog. Within minutes the fog had closed in completely, reducing visibility to a couple of yards. I may never be there at the right moment again but thankfully I had managed to capture the essence of a bygone age.

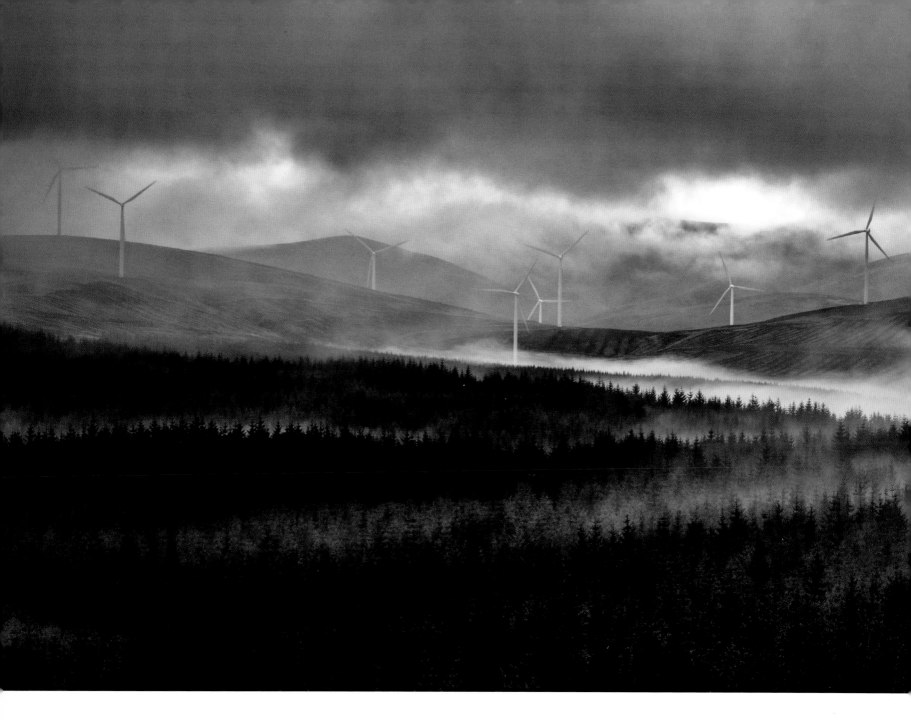

MARK LITTLEJOHN

Sentinels

Clyde Valley Wind Farm, near Moffat, Scotland

I was travelling up to Edinburgh before dawn to visit my father who was ill. As I travelled past the Devil's Beef Tub near Moffat at dawn, I saw the wind turbines appearing through the low cloud. They seemed like guardians, standing over the forest.

180

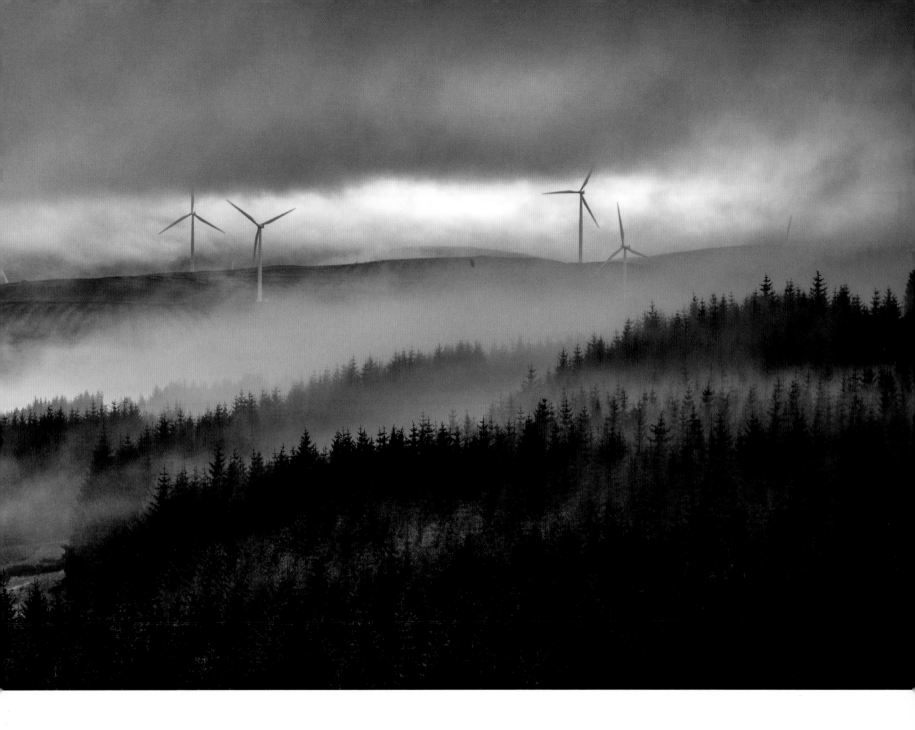

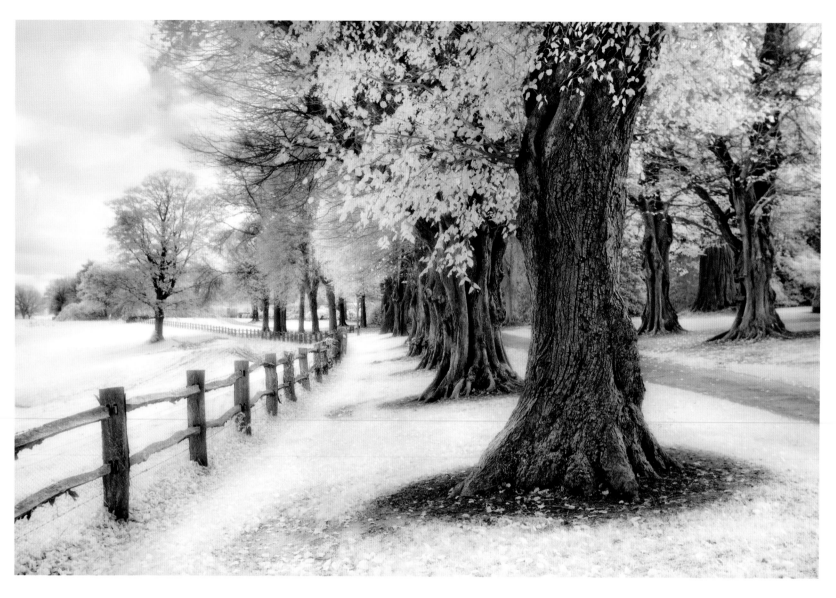

PAUL KNIGHT

Autumn Afternoon
Haywards Heath, West Sussex, England

The avenue of trees looked stunning in the low autumnal sunlight but, as there was so much going on in this image, I felt that it would look better in black and white and in flat light with no heavy shadows. I also chose to shoot on an infra-red, rather than conventional, camera.

MICHAEL SWALLOW ····⟩

Snowstorm I (Nefyn)
Llŷn Peninsula, Northwest Wales

I saw this dramatic snowstorm coming in over the bay at Nefyn on New Year's Day. I only had a few minutes to grab a couple of frames before I was engulfed by the storm and plunged into darkness.

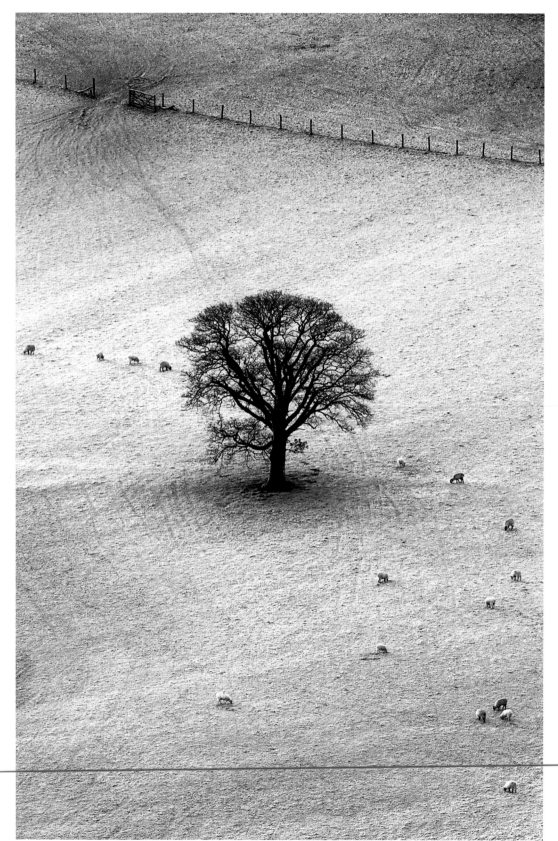

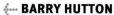 **BARRY HUTTON**

The Field
Lake District, Cumbria, England

I have visited this tree in the Lake District on a few occasions. In the winter months particularly, the natural contours of the land blend beautifully with the lines of the fence. The tracks leading from the gate tell a simple story, whilst the grazing sheep complete the scene. I like the simplicity of the composition that shows the most basic and harmonious interactions between people and the environment. The photograph was taken from a high vantage point, which I think takes the viewer into the scene.

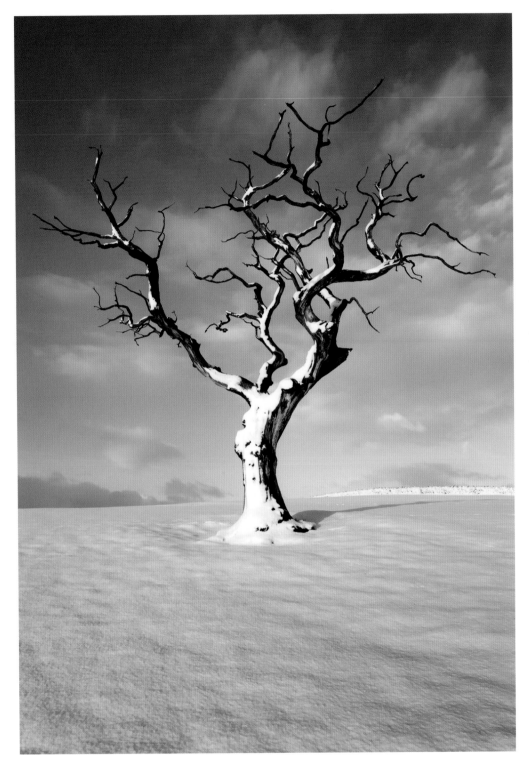

◀··· BRIAN KERR

January
Cumbria, England

A cold January morning near Penrith, a lone dead tree and a fresh falling of snow. The first light of morning hits the snow-covered branches casting their shadow over the fresh, untouched snow. A cold morning...but one of those perfect mornings in Cumbria.

Powering Industry
New Forest, England

A misty morning in April saw me out taking pictures on the edge of the New Forest National Park. The symmetry of this line of pylons interested me, especially in the way that they led to/away from the industrial complex, the structures of which can be seen in the background. Not my normal kind of photograph, but it grabbed my attention enough to try a shot.

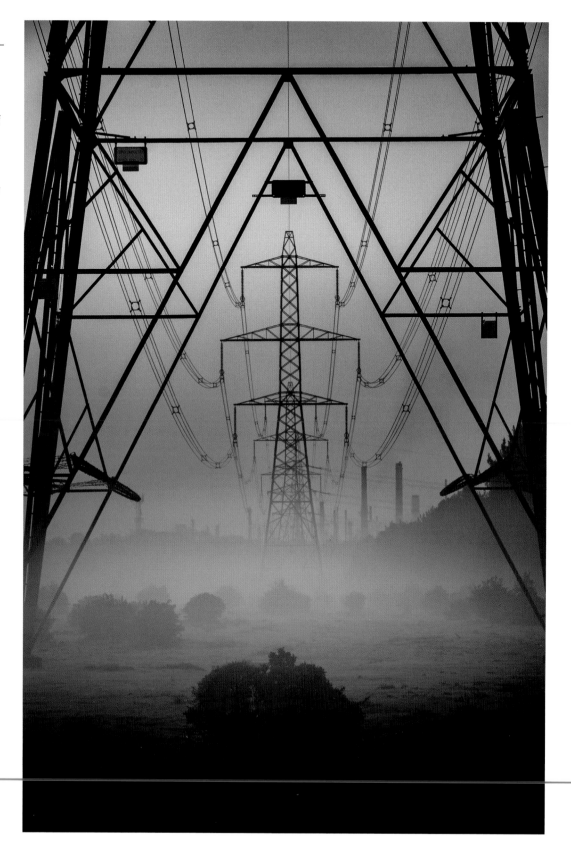

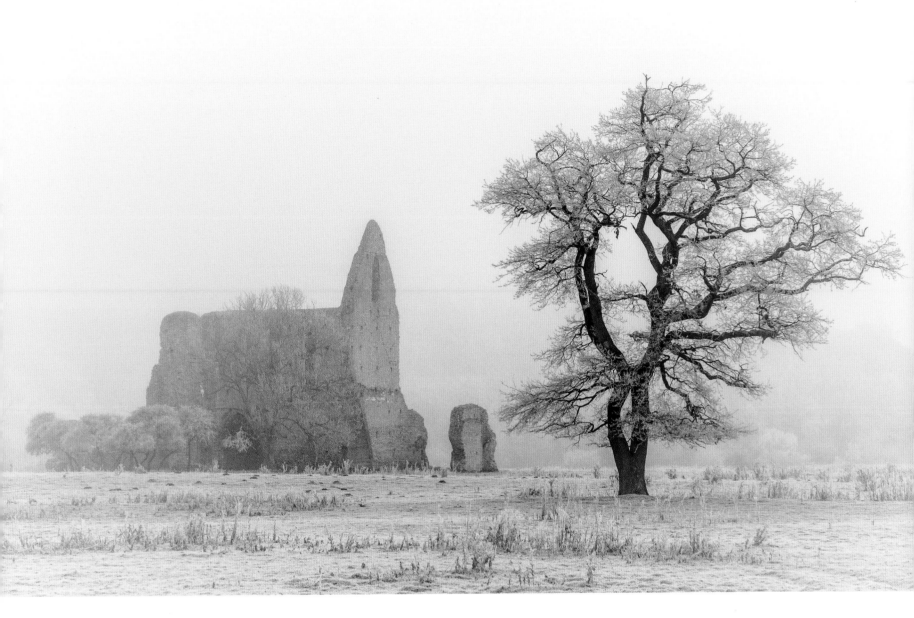

✝ **DOMINIC LESTER**

Winter Tree with Misty Ruin
Pyrford, Surrey, England

This is the ruin of Newark Priory, which I have caught several times on misty mornings but rarely on severely cold, misty days. Usually distant power lines wreck the shot but the mist on that day isolated the two main subjects beautifully. The shot is from the pavement; in the past I have shot the abbey from a more distant location but the tree is a favourite of mine.

186

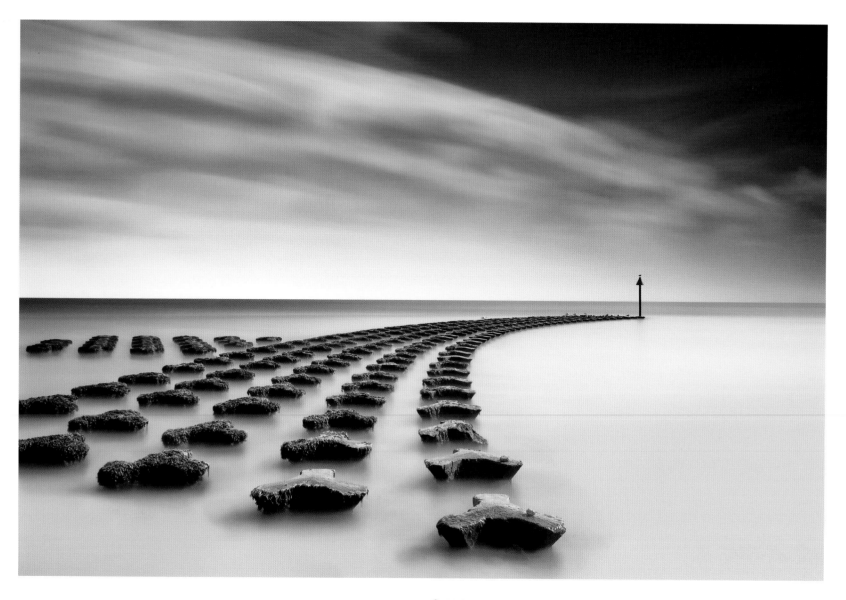

⚜ JUSTIN MINNS

Sweeping Sea Defences
Felixstowe, Suffolk, England

It took four visits to finally get this shot. On the first three carefully planned trips I'd arrived to find either the tide height or the weather all wrong. On the fourth, I just happened to be in the area and drove past to see that the sea level was perfect. Setting up my gear, I just had to wait half an hour or so for the right amount of cloud to streak through the frame.

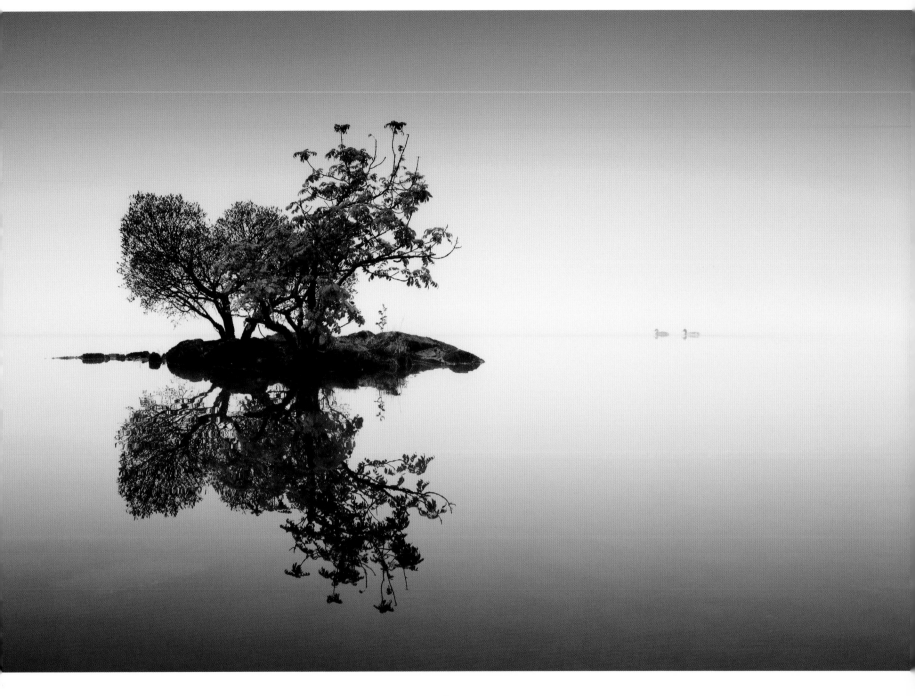

JEFF VYSE

The Butterfly Effect
Windermere, Cumbria, England

A misty Windermere in the silence and stillness after sunrise. It struck me how much the reflection looked like a butterfly. To complete the scene a female duck drifted silently by, dutifully followed by the male.

189

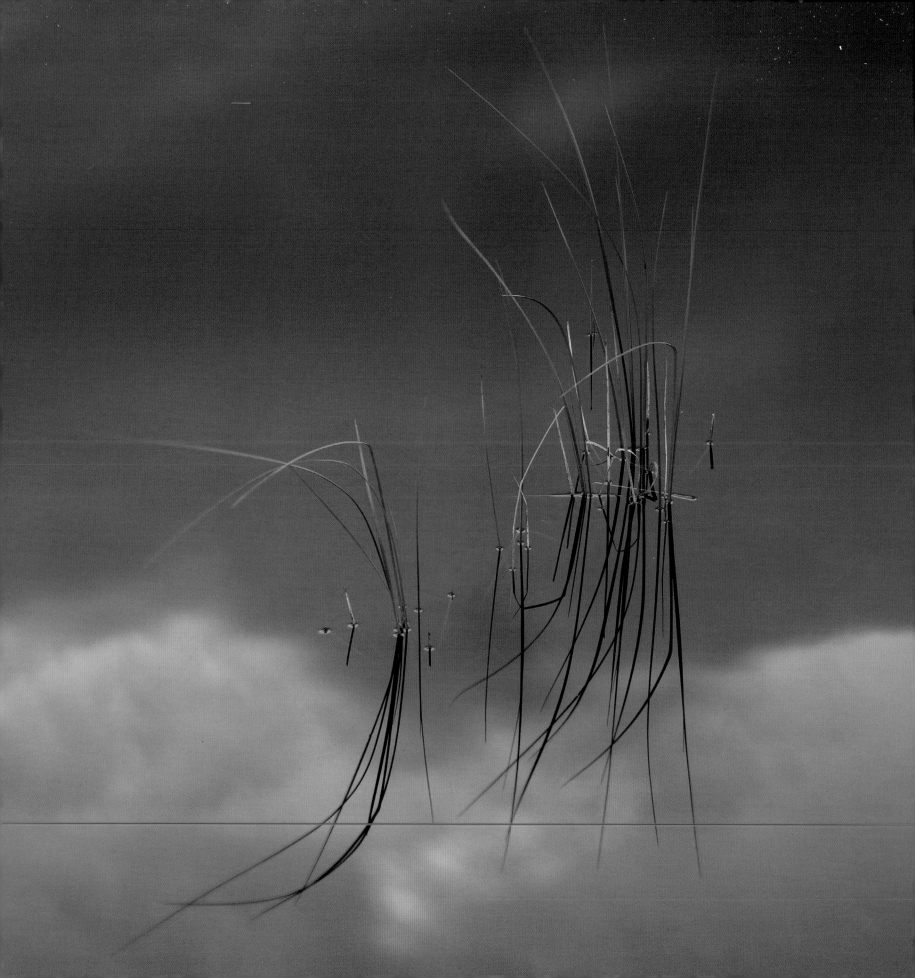

SCOTT MURRAY

Reeds on Loch Ba at Sunrise
Rannoch Moor, Scotland

Taken on an unusually cold and calm September morning on the shores of Loch Ba.
A spectacular sunset was perfectly reflected in the loch, allowing me to frame it with
these reeds protruding through the water. I felt this portrayed the calmness of that day
more than any wide view of the loch.

TINA IND

Unpredictable
Shoreham-by-Sea, West Sussex, England

Taken at Shoreham-by-Sea on one very cold January morning. It was a fierce spring tide
with 10ft waves crashing 30ft high against the sea defence wall. I wanted to try and
capture the emotion and fierceness of the waves and I think the conversion to black and
white creates even more drama. Using a slightly longer exposure kept movement in the
water, as I didn't want a static feel to the image.

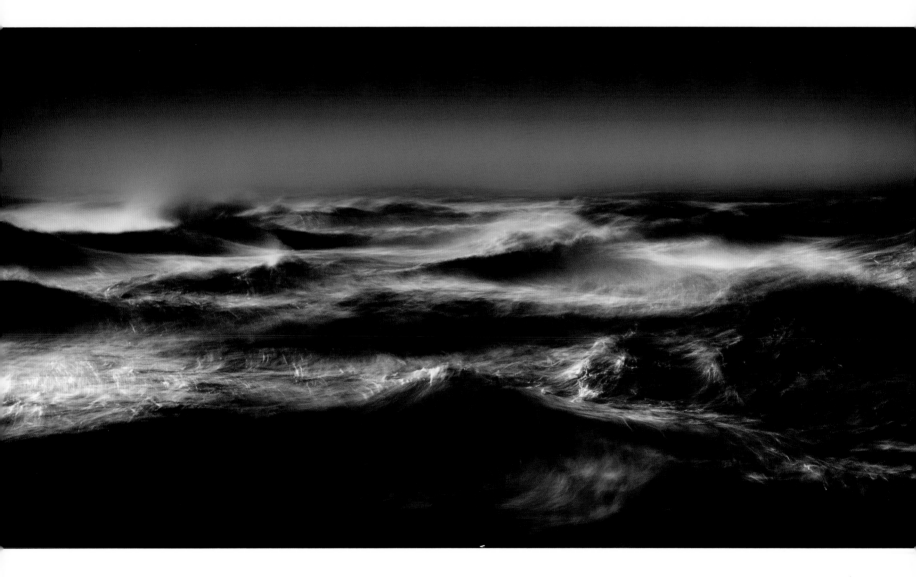

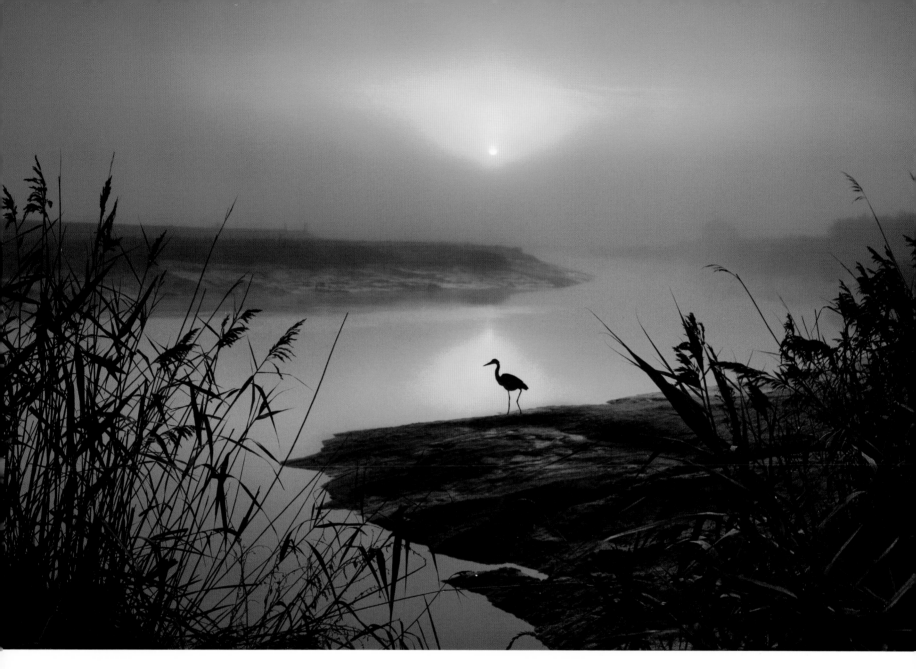

ADRIAN CAMPFIELD

Misty Dawn on the River Darenth
Bexley, Kent, England

This is the River Darenth that flows through the Crayford Marshes, taken on a foggy November morning. I live a short walk away from this location, so I often visit at sunrise around this time of the year because the sun rises over the river. On this particular morning I could see the heron hunting along the riverbank and heading my way so I hid as best I could among the reeds and was lucky enough to get some shots of the bird before it flew off. I liked how the reeds acted as a frame with the heron in the centre and, to round it all off, the sun was just breaking through the fog.

IAN TAYLOR ⋯⋗

Must be an Angel
Gateshead, Tyne & Wear, England

I only live a couple of miles away from the *Angel of the North* and often visit to try and create an image from a different viewpoint. On this February morning, fresh snow was falling and I glimpsed this angel apparition through a copse of silver birch trees.

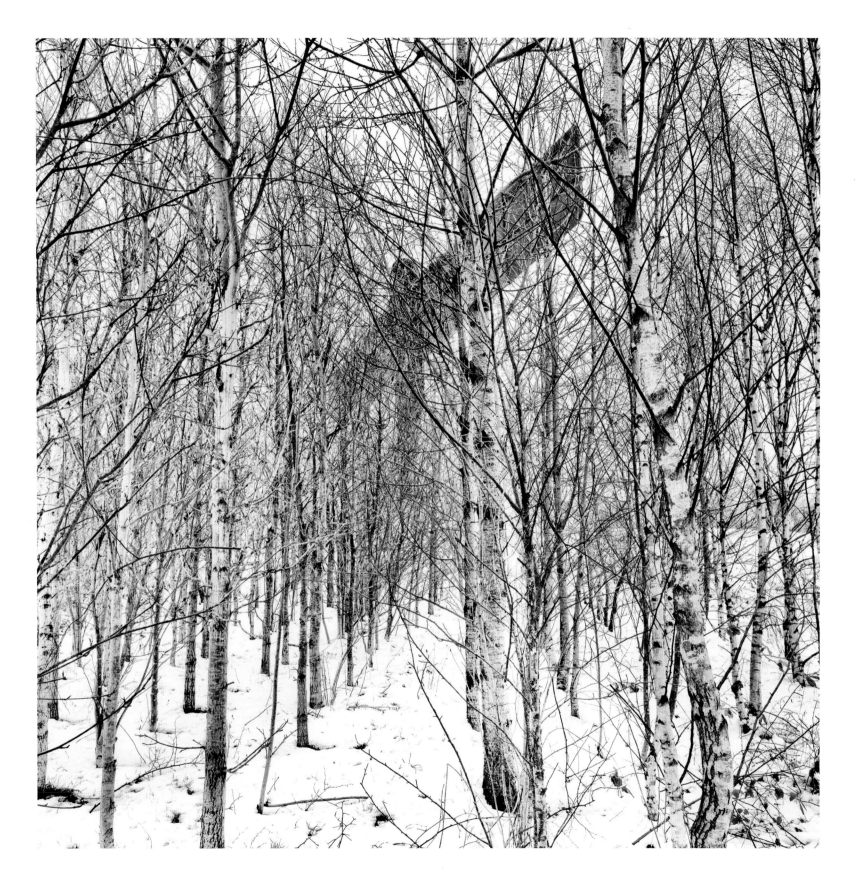

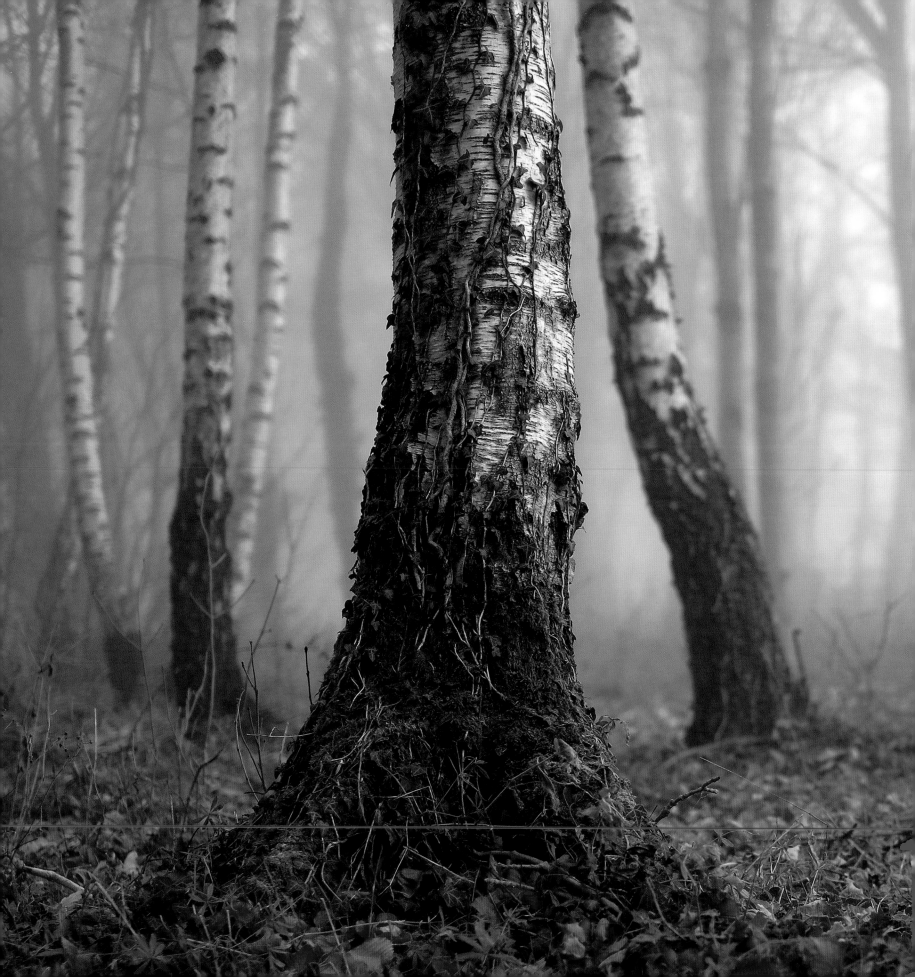

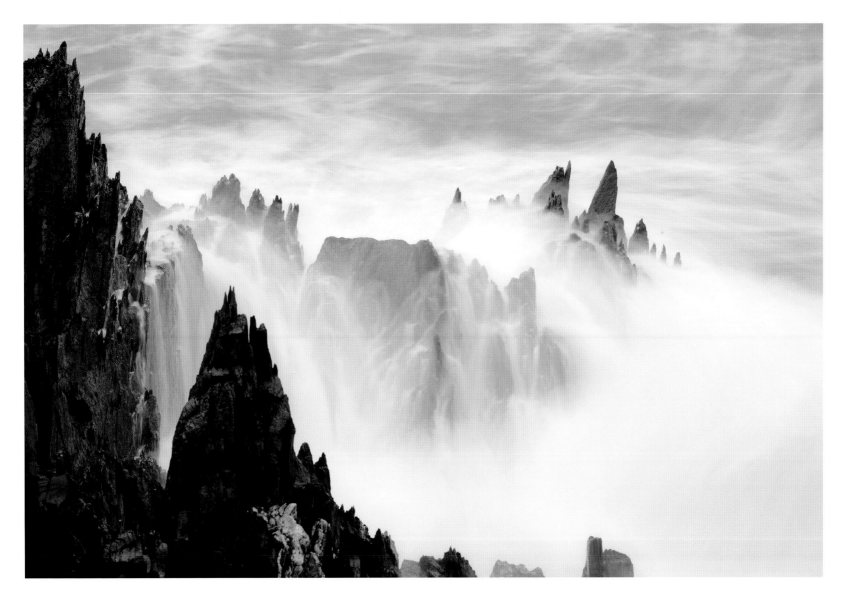

ANDREW LOCKIE

Hobbit Tree
Chipping Campden, Gloucestershire, England

This image was taken on a cold December morning, with isolated pockets of fog hugging the woods and copses along the top of the North Cotswold escarpment just a few miles from where I live. This birch tree was naturally isolated from the background by the magical fog, which gave the image a sense of depth and atmosphere. Shooting the image at the widest aperture also enhanced the almost 3D effect. I crouched down to give the image a low-angle perspective and to capture the wonderful colours and detail of the moss and ivy climbing up the tree trunk.

JERRY YOUNG

The Erosion of Time
Woolacombe Bay, Devon, England

It had been stormy for a couple of days, so the sea was quite heavy. I set a tripod up and thought I would try some time exposures to catch the feeling of movement from the crashing waves. It was before dawn and there was hardly any light, so a long exposure was necessary. I was drawn to the almost monochromatic nature of the scene with the greeny grey sea and the black rocks with bands of white quartzite, though I was shooting in colour.

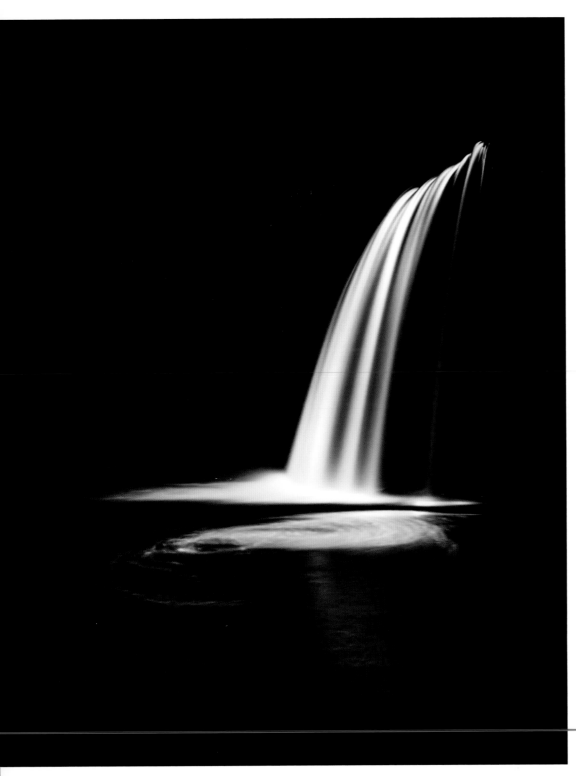

DUNCAN FAWKES

Sgwd Gwladus (The Lady Falls)
Brecon Beacons, Wales

A trip to the Brecon Beacons in November 2012 coincided with exceptionally heavy rainfall that saw much of the country in flood. Upon arrival at Pontneddfechan, I raced along the 35-minute walk to get to the waterfall before darkness fell. It was quite a sight, with the water tumbling 10m from the rocks above into an amphitheatre-like plunge pool. Lacking autumnal colour and in fading light, I was drawn to the white water contrasted against the dark, exposed rock and I enhanced this feeling in post-processing.

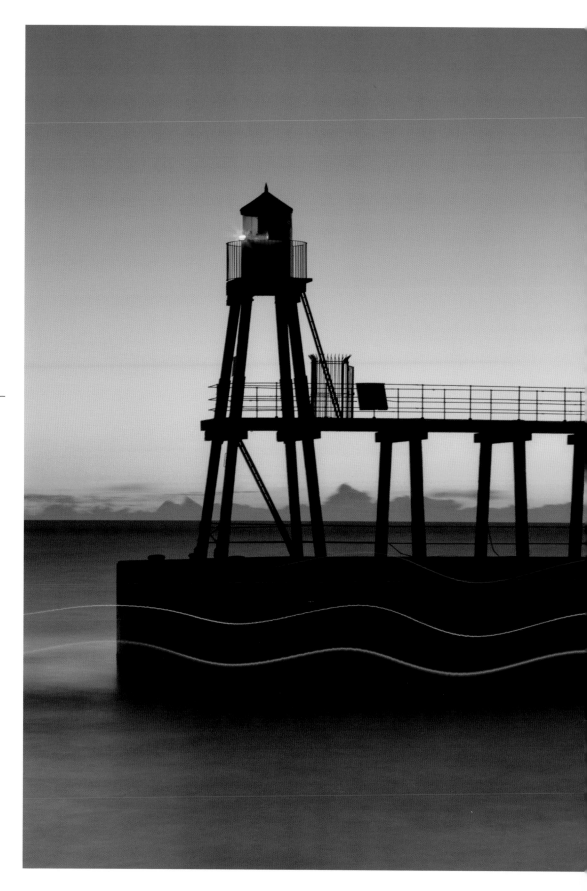

JOHN POTTER ⋯⋗

Gone Fishing
Whitby, North Yorkshire, England

A fishing boat setting off to sea just before an October sunrise created some beautiful wave-shaped light trails as it passed by on the rising swell.

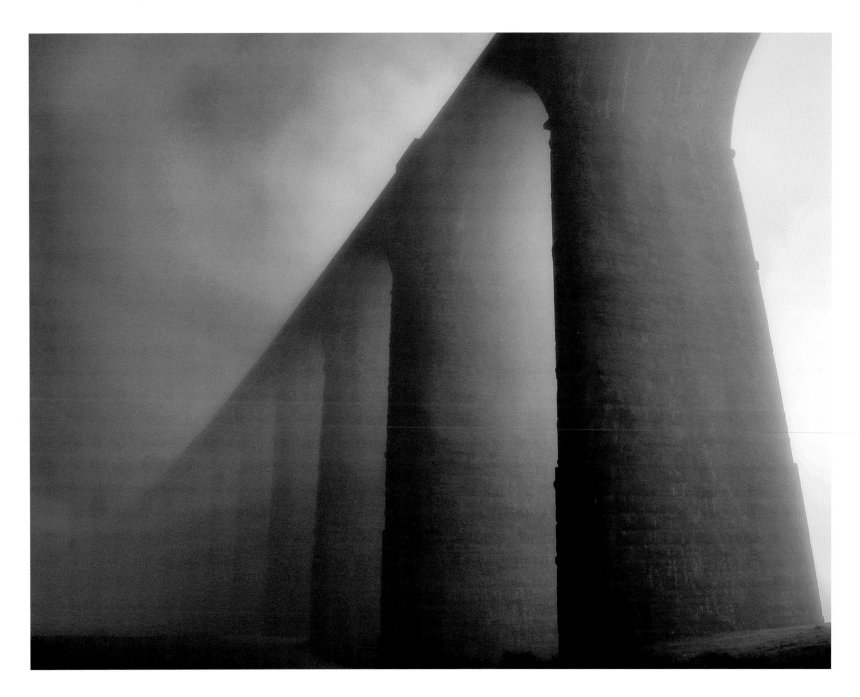

✝ **IAN KENNEDY**

All the Elements
Ribblehead Viaduct, North Yorkshire, England

This was one of the strangest moments I've encountered, as not 10 minutes before the photo was taken the skies were blue and crisp and the eye could see to the end of the bridge lines and beyond. The fog rolled in so quickly that I only had time for the one shot – this was it. Ten seconds later and the sun was obscured completely. Even though I was using a tripod, the settings were not ideal for clarity but had I messed with them, the moment would have gone. A truly amazing spectacle and not one I think I'll ever have the pleasure of photographing again, unfortunately!

A Windy Day
Loch nan Eilean, Isle of Skye, Scotland

Part of the joy of landscape photography is being able to establish a real connection with the beauty that surrounds you. On this day, at Loch nan Eilean just west of Sligachan, I stood sodden-footed courtesy of my boggy surroundings. A vicious crosswind made my eyes water to the point that focusing accurately was proving a real challenge, let alone maintaining one's balance. All of this, whilst patiently waiting for that elusive glimpse of light through a leaden sky that brings the landscape to life before my watery eyes. Click. Absolute heaven...

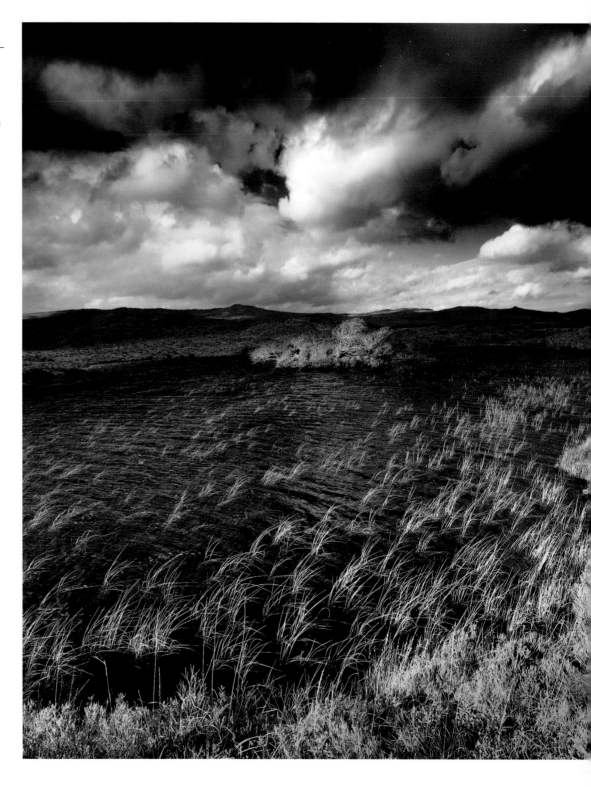

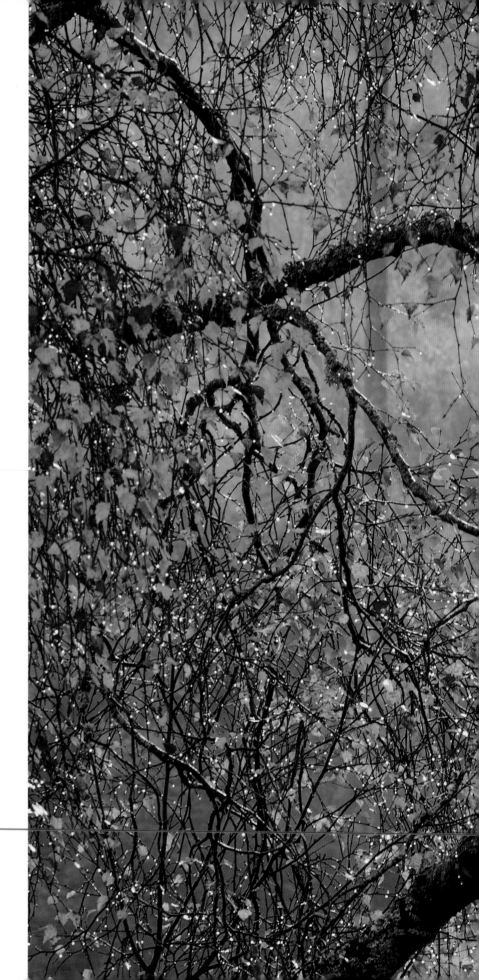

DAVID MOULD ⋯⟩

Autumn Birches
Duke's Pass, Trossachs, Scotland

There is no such thing as bad weather in the Trossachs…only the lack of midge repellent. I was drawn to this scene by the regularity of the distant trunks combined with the misty stillness of the forest after the rain and the light created by the wet leaves and raindrops against the birches' autumn hues. On my tripod, I used the flattening effect of the long lens to compress the distant scene, giving a specific feeling of depth.

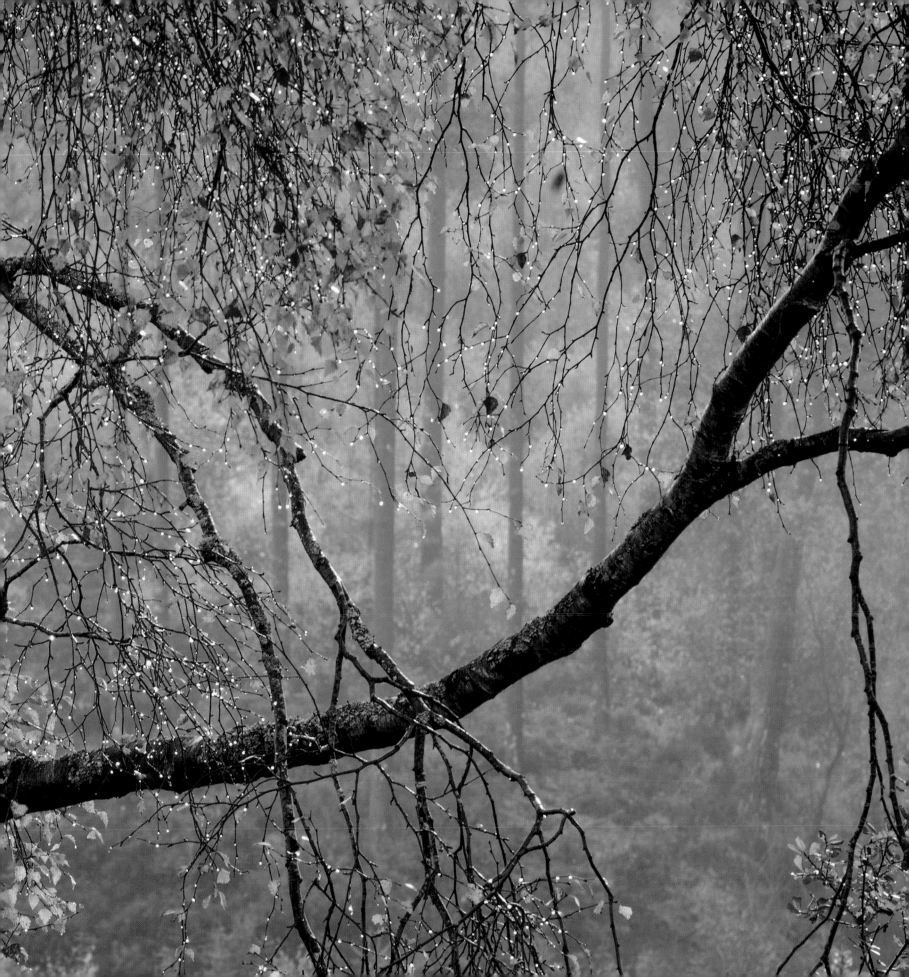

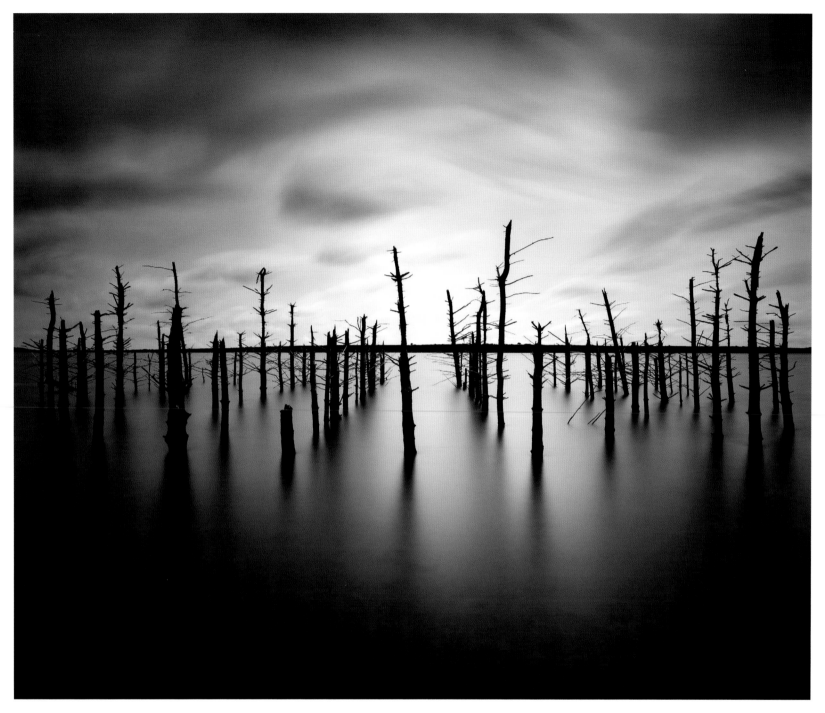

🕆 **KEITH AGGETT**

Drowned Souls

Colliford Lake, Cornwall, England

Colliford Lake is a reservoir managed by the South West Lakes Trust and can be found on Bodmin Moor in Cornwall. After arriving at the main car park, a 20-minute walk is required to reach this area. The camera was set up with a straightforward composition but using a tripod to achieve a long exposure gave me this surreal-looking shot.

Plover Prints
Heswall, Wirral, England

Heswall, on the Dee estuary, is a fantastic place for a landscape photographer. Boats are strewn along the shoreline, listing on the mudbanks and in various states of disrepair. After a rather fruitless sunrise, I made a few exposures of the boats but I was thinking about packing my gear away and heading home for a well-deserved breakfast when I came across these prints in the mud... the only sign that I wasn't the first to visit here that morning.

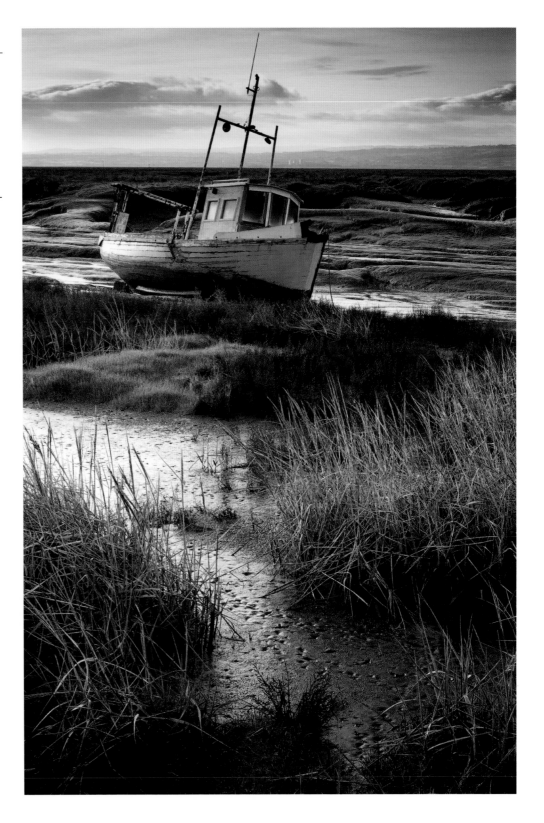

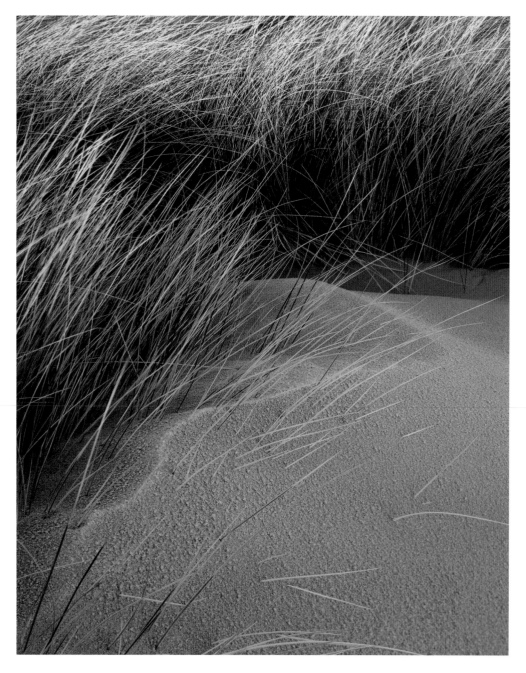

MICHÉLA GRIFFITH ⋯⋗

Ice on Rust
Upper Dove Valley, Staffordshire, England

A series of freezing nights have added their drama to the days' snow showers. Trailing grasses dangle flares of ice down to the stream, snow-covered rocks have crinkled toes and, in places, the water's surface carries a film of ice. Under a grey sky, the stream is rust-stained and vivid, the apparent warmth of the rock at odds with the snow and ice. Small bubbles of air borrow from the shapes in the ice above as the water traces a hasty path between the rocks. One of a series of 'streamscapes' born of 2012's wet summer and featuring two adjoining tributaries to the River Dove. The first, a Staffordshire stream over gritstone. Oxide stained. Of the earth. The second, running clear over Derbyshire limestone. A brighter mood and colours. Of the sky.

⟨ PAUL ARTHUR

Frozen Sand Waves
Budle Bay, Northumberland, England

A late November trip to Budle Bay provided a beautiful dawn and a couple of nice images. On the walk back to the car I spotted this wave frozen in the sand, with ice crystals all over the surface, and had only a couple of minutes to set up and make an image of the blue sky reflected in the sand before the sun rose too far and ruined it all.

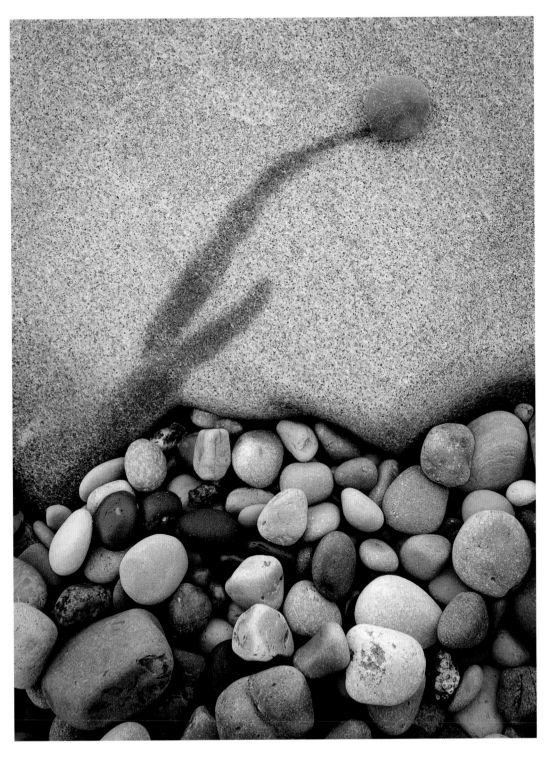

Beach Bloom
Seaton Carew, County Durham, England

Having not owned the camera for very long I was keen to try it out, so took it out to test on the beach at Seaton Carew. It was early afternoon and there was high cloud cover providing diffuse light, ideal for this kind of study. I was looking for interesting rock formations and came across this particular rock, which looked like it had the pattern of a flower stem on it. I had the idea of placing a stone at the top to resemble a budding flower. I found the right stone almost immediately. The whole process of discovery, idea and execution was quick and spontaneous.

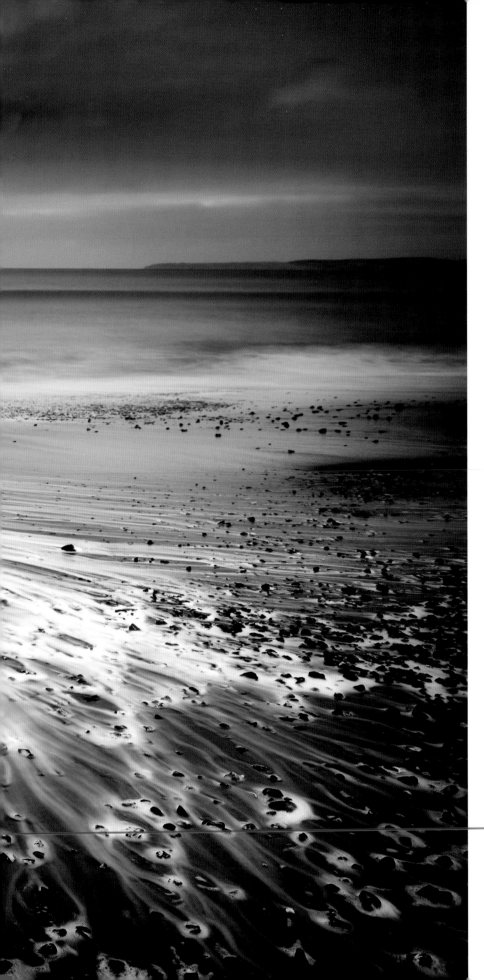

⦉⋯ RUSS BARNES

Rebourne
Southbourne Beach, Dorset, England

Taken on a brisk winter's day at Southbourne Beach, where the special mix of soft, doughy sand and shale deposits make for an interesting combination, as the waves surge through the small gullies carved out by the tide. I love the concept that each pattern is as unique as a snowflake, like a fingerprint on the beach which only lasts a few moments, and a high degree of patience is required to capture the right moment. In deploying a neutral density filter and wide lens aperture, it was possible to capture this four-second wave pattern as it retreated on the shore. The conversion to monochrome accentuates the play on shapes and textures, revealing the final character of the moment in all its glory.

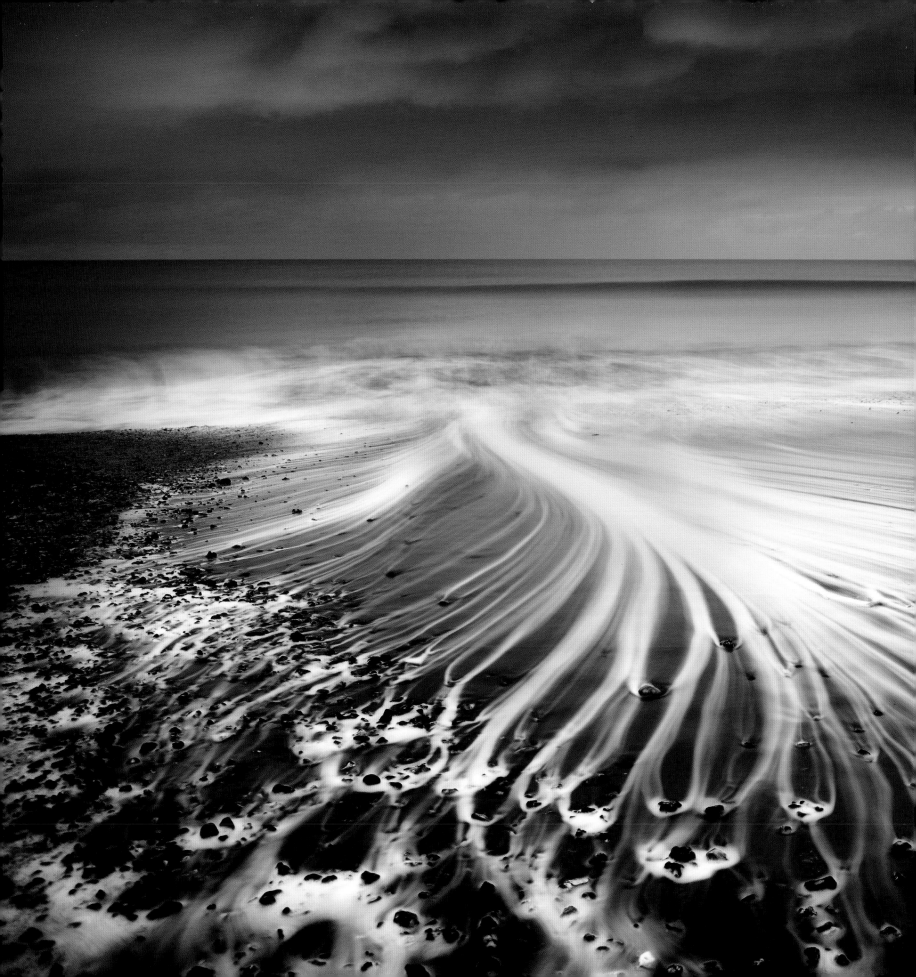

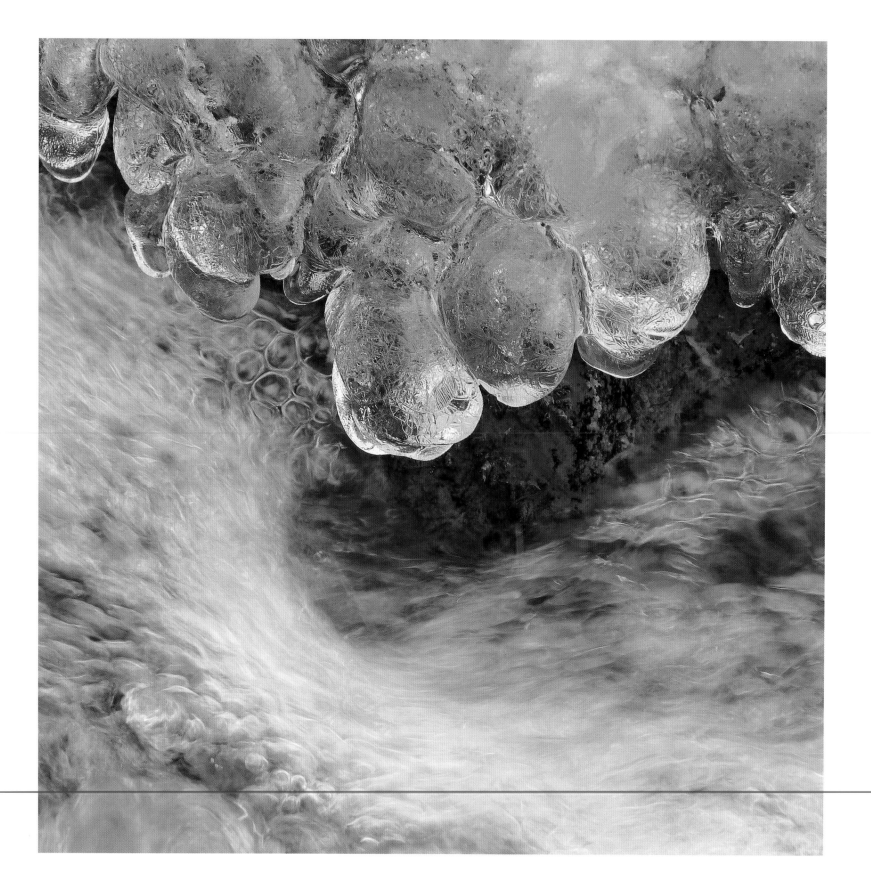

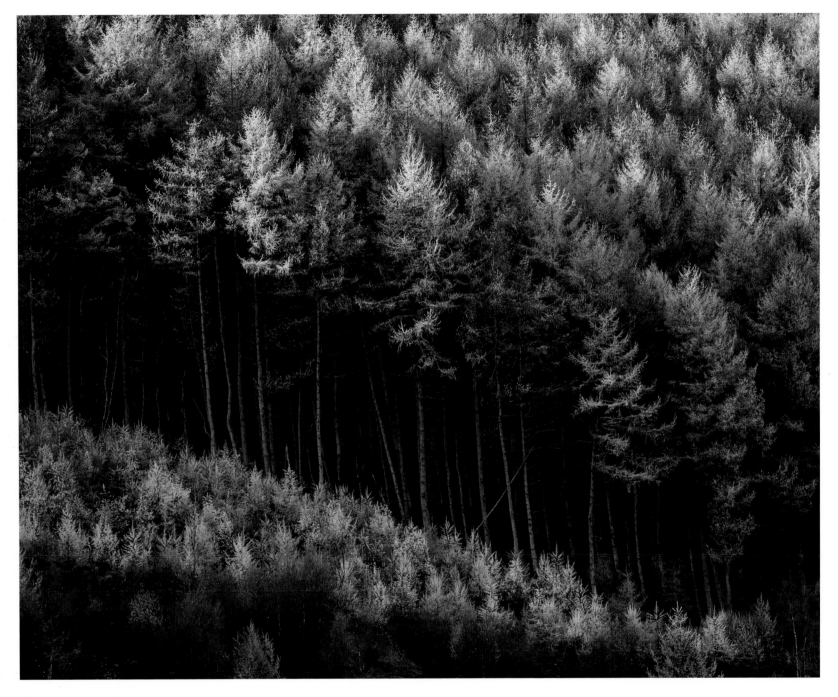

DUNCAN FAWKES

Trees of Gold
Ladybower, Derbyshire, England

As I drove along the Snake Pass I was gifted this wonderful low, raking sunlight striking the autumnal larches. I quickly pulled into a lay-by and climbed a steep, bramble-strewn embankment to get above the roadside wall and trees. I used the longest lens in my bag to get a tight composition of the tops of the trees and the tree trunks which had been exposed by the forestry work. It was a wonderful sight and I think the result is well worth my thorn-inflicted wounds!

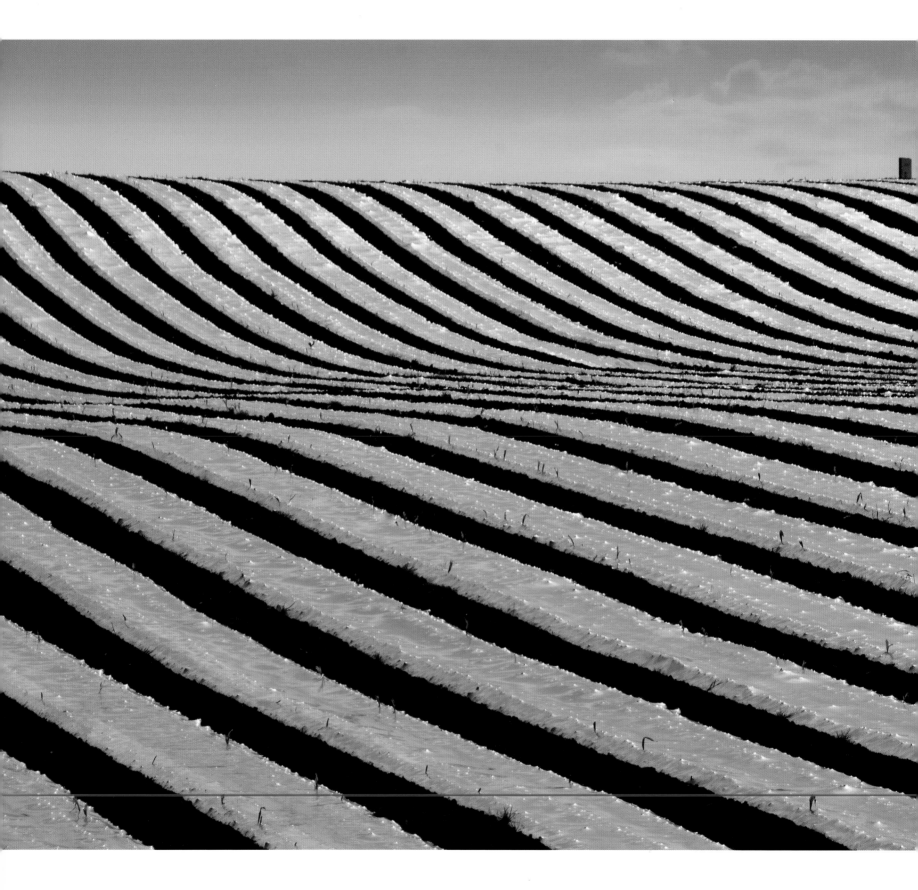

⋯ CAROL CASSELDEN

Polythene Furrows
Borders, Scotland

This graphic image was taken in May whilst travelling through the Borders. The late afternoon sun was shining across the furrows making an almost perfect monochromatic image, with just a hint of blue in the sky.

YOUR VIEW
youth class

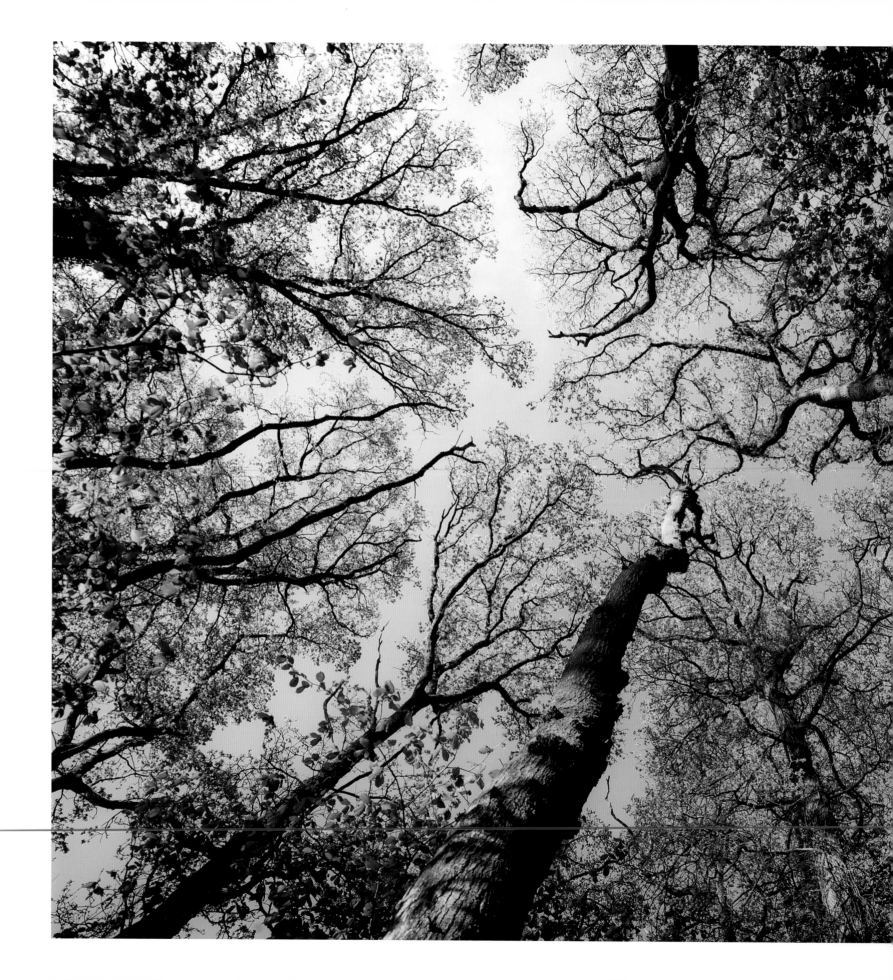

OLIVER CURTIS

Looking up to the Trees
England

I looked up on an evening walk through the woods and loved the early evening/late afternoon light on the trees, with the blue sky in the background.

GRAEME PEACOCK (p.3)
Canon EOS 1Ds Mk III with 17mm TS-E f/4 L. 20 secs, f/22, ISO50. Two overlapping RAW files stitched in Adobe Photoshop CS6, minimal adjustments.

ANDREW MIDGLEY (p.5)
Nikon D700 with 24–70mm f/2.8 lens @ 24mm. 1/80 sec, f/8, ISO400. Gitzo tripod. Adobe Photoshop CS4 to convert to B&W and to adjust contrast, then Silver Efex Pro 2 to add the toning.

IAN CAMERON (p.13)
Pentax 67II, 90–180 zoom, Polariser, backed off 50%, 0.45ND Hard Grad. 2 secs, f/32, Fuji Velvia 50. Adjustments to scan, including hue and contrast and crop to 90% area.

TONY BENNETT (p.16)
Nikon D700 with 70–300 f/4.5–5.6 lens @ 95mm. Raw exposures @ 1/640, 1/320, and 1/160 sec, f/11, ISO400. Processed in Photomatix Pro. Cropping and colour correction in Adobe Lightroom.

CHRISTOPHER PAGE (p.19)
Nikon D5100 @ 34mm. 1/50 sec, f/11, ISO800, +0.3 exposure bias. In-camera basic sharpening enhancement.

DAVID CATION (p.20)
Canon EOS 5D with EF 70–200mm f2.8 L IS USM lens @ 200mm. 1/320 sec, f/5, ISO200. Tripod. Processed in Adobe Photoshop CS5 – colour balance and contrast adjusted.

ROBIN COOMBES (p.22)
Nikon D600 with 28–300mm lens @ 45mm. 1/13 sec, f/4.2, ISO4000.

ROBERT FRANCE (p.22)
Canon EOS 5D Mk II with EF 70-200mm f/4 USM @ 98mm. 1/250 sec, f/4, ISO800.

DAVID LONGSTAFFE (p.23)
Canon EOS 1Ds Mk III with EF 24–70mm f/2.8L USM @ 43mm. f/8, ISO200. Hand held. Processed in Adobe Lightroom and adjusted in Adobe Photoshop CS3.

ROBIN COOMBES (p.24)
Nikon D7000 with 18–300mm lens @ 72mm (35mm equiv = 108mm). 1/500 sec, f/9, ISO400.

RORY TRAPPE (p.25)
Canon EOS 1Ds Mk III with 300mm f2.8 L. 1/320 sec, f/6.3, ISO200. Taken in RAW and processed in Adobe Photoshop CS4 and NIK software.

STUART LOW (p.25)
Canon EOS 5D Mk III with Zeiss Distagon 21mm. 30 secs, f/8, ISO200. Colour corrected in Camera Raw. Selective dodging in grass and rail lines.

NEALE SMITH (p.26)
Canon EOS 1Ds Mk III with TS-E 17 f/4 L (perspective control shift lens). HDR image plus vertical stitch in Adobe Photoshop.

DAFYDD WHYLES (p.27)
Bronica ECTL with 75mm lens. 1/125 sec, f/11 on Fuji Provia slide film, scanned. No digital manipulation other than slight cropping and sharpening of the scanned image.

ROBIN COOMBES (p.27)
Nikon D7000 with 18–300mm lens @ 250mm (35mm equiv = 375mm). 1/640 sec, f/8, ISO2000.

DAVID BREEN (p.31)
Canon EOS 5D Mk II with 24–105 f4.0L lens @ 75mm. 1/5 sec, f/22, ISO100.

ROBERT BIRKBY (p.32)
Canon EOS 5D Mk II with 70–200mm f4 IS lens @ 100mm. Lee graduated ND filter, tripod, mirror lockup, cable release. 1/40 sec, f/9, ISO100. Cropped and curves adjustment of contrast in Adobe Photoshop.

MIREK GALAGUS (p.35)
Nikon D800 with Nikkor 70–300mm f/4.5–5.6 lens @ 70mm. 1/320 sec, f/9, ISO100. Highlights and shadows recovered, contrast adjusted, slightly cropped in Adobe Photoshop.

JAMES HOURD (p.36)
Lee polarising filter & Lee 0.6 neutral density graduated filter, Fuji Velvia 50 120 transparency film. Minor digital adjustments to levels, cropping (retaining original 3:1 aspect ratio) and sharpness.

ROBERT WOLSTENHOLME (p.38)
Nikon D800 with 35mm f2.0 lens. 1/4 sec, f/16, ISO200. Adjustments in Camera Raw to retain highlight and shadow detail. Adjustments to basic levels in Adobe Photoshop & addition of Tony Kuyper's Luminosity Masks. Slight cropping.

ADAM BURTON (p.39)
Nikon D800E with Nikon 24–70mm @ 48mm. 1/4 sec, f/11, ISO100. 0.6 ND Grad and polariser. No manipulation.

MANI PUTHERAN (p.41)
Canon EOS 5D Mk II with TS-E24mm f/3.5L. 1/6 sec, f/11, ISO100.

PAUL MITCHELL (p.42)
Nikon D7000 with 17–55mm lens @ 24mm, no filters. Raw file processed in Adobe Lightroom, then exported into Adobe Photoshop for minor corrections to contrast and colour.

JOHN HODDINOTT (p.43)
Canon EOS 5D Mk II with EF100–400 lens at 275mm. 1/4sec, f/11, ISO100, tripod. Light crop with minor adjustments carried out in ACR to restore some of the detail seen when viewed through the lens. Dust spotting in Adobe Photoshop CS6.

ROBERT BIRKBY (p.44)
Canon EOS 5D Mk II with Canon 70–200mm f4 IS lens at 70mm. 10-stop ND filter, cable release, mirror lock-up. 110 seconds, f/5.6, ISO 200. Colour temperature corrected using Adobe Camera RAW and curves tool in Adobe Photoshop. Image cropped and a little noise reduction applied.

IAN CAMERON (p.45)
Pentax 67II, 45mm lens, 0.3ND Hard Grad. 1/8 sec, f/22, Fuji Velvia 50. Minor contrast and hue adjustments to match existing transparency after the scan and crop 90-95% of frame.

SCOTT ROBERTSON (p.46)
Nikon D600 with 24mm f2.8D lens.1/13 sec, f/10, ISO100. Adjusted in Adobe Lightroom 4.

GRAHAM McPHERSON (p.48)
Canon EOS 5D with 24–105mm lens @ 75mm. 1/60, f/13, ISO100.

ANDY LE GRESLEY (p.49)
Camera Info: Canon EOS 5D Mk II, 32 sec exposure. B&W conversion and slight adjustments in Adobe Photoshop.

SCOTT WILSON (p.51)
Nikon D300 with 50mm prime. 1/2 sec, f/8, ISO200. Cropped and minimal adjustments in Adobe Lightroom.

RUSSELL PIKE (p.52)
Canon EOS 5D Mk II with 24–105mm L @ 105mm. 1.3 sec, f/8, ISO1250.

GRAHAM HOBBS (p.52)
Canon EOS 1DX with EF70–200mm f/2.8L IS II USM lens @ 123mm. 1/2000 sec, f/6.3, ISO800. Adjustments and cropping in Adobe Lightroom 4.

JIM ROBERTSON (p.53)
Nikon D800 with 6–35mm f/4G lens at 16mm. 1/8 sec, f/11, ISO100. ND soft grad filter. Processed in Adobe Lightroom 4 and Photoshop 5.

PAUL HOLLOWAY (p.54)
Canon EOS 5D Mk II with 16–35mm lens @ 24mm. 1/5th sec, f/11, 2 stop ND grad.

ALAN RANGER (p.55)
Sony DSLR A700 with CZF2.8 24–70mm lens @ 24mm. 0.8 sec, f/13. Centre Weighted Metering.

GARY McGHEE (p.56)
Nikon D700 with Nikon 50–135mm AIS lens @ 135mm, tripod mounted. 1/15 sec, f/8, ISO200. Raw file processed in Nikon Capture NX2. No digital manipulation.

BART HEIRWEG (p.57)
Nikon D800E with 14–24mm lens at 21mm. 1/4 sec, f/22, ISO100. Two frames, 3 secs apart. In one of the shots I placed my hand before the sun to remove flare and then manually blended in Adobe Photoshop CS6.

RORY TRAPPE (p.58)
Canon EOS 5D Mk III with Canon 24–70 IS L. Tripod mounted – six frames in Raw merged HDR image. f/8, ISO100.

MIREK GALAGUS (p.59)
Nikon D700 with Nikkor 16–35mm f/4 @16mm. Lee 'big stopper' filter. 13 secs, f/14, ISO200. Lens vignetting removed, contrast adjusted in Adobe Photoshop.

ANGUS CLYNE (p.60)
Canon 5D Mk II with 70–200mm @ 165mm. A blend of two bracketed exposures processed in Adobe Photoshop.

GARY WAIDSON (p.61)
Canon EOS 6D 32mm on an EF 17–40mm f/4 L @ 32mm. 1/60 sec, f/10, ISO100. Spotting and contrast management. No filters.

JOHN FINNEY (p.62)
Nikon D300 with 70–300mm f/4.5–5.6 G AF-S VR IF-ED Lens @ 140mm (35mm equivalent; 210mm). 1/320 sec, f/11, ISO100. Exposure Bias – 1/3 EV. Tripod, Processed from Raw using Adobe Photoshop CS6.

MATTHEW ASPDEN (p.63)
Canon EOS 5D Mk II with 24–105mm lens set @ 28mm. Three exposures blended to cope with the high dynamic range of the scene (1/10s, 1/5s and 0.5s), f/8, ISO100.

ALAN RANGER (p.64)
Sony DSLR A700 with CZF2.8 24–70mm lens @ 70mm. 1.5sec, f/10. Pattern metering.

RAYMOND BRADSHAW (p.65)
Canon 5D Mk III with Zeiss Distagon T* 2.8/21 ZE. 302 secs, f/16, ISO100. Conversion to B&W.

ALAN RANGER (p.66)
Sony DSLR A700 with CZF2.8 24–70mm lens @ 35mm. 1/8 sec, f/16. Pattern metering.

GARY KING (p.67)
Canon EOS 5D Mk II with Canon EF 17–40mm L @ 19mm. 1/6 sec, f/11, ISO100, LEE 0.6 Grad (soft).

ALAN O'RIORDAN (p.68)
Canon EOS 5D Mk II with 85mm f/1.8 lens. 1/100 sec, f/11, ISO100. No cropping or straightening, some tweaks to highlights, contrast, blacks, whites and clarity in Adobe Lightroom 4.

ANDREW JONES (p.69)
Canon EOS 5D Mk II with Canon 17–40mm f/4 L @ 24mm. 5 secs, f/16, ISO 100. ND Graduated Filter, Tripod. Lens corrections, brightness, contrast, and colour adjustments.

ALUN ALLCOCK (p.70)
Nikon D800 with Zeiss 50mm f/1.4 lens. Handheld (due to the wind!), 1/320 sec, f/8 with 2/3rds stop overexposure. Processed and dust spotted in Adobe Lightroom 5.

DAVID TAYLOR (p.71)
Canon EOS 7D with 10–22mm lens at 13mm. 0.3 seconds, f/13, ISO100. Cropped in post-production.

ESEN TUNAR (p.72)
Canon EOS 5D Mk II with Contax 50mm f/1.7 lens. 30 sec, f/1.6, ISO200.

TERRY GIBBINS (p.73)
Canon EOS 5D Mk II with 70–200mm lens @115mm. 1/320 sec, f/8, ISO100. Processed in Adobe Lightroom 5 and Photoshop 6.

JAMES APPLETON (p.74)
Canon EOS 5D Mk II with Canon 16–35mm f/2.8 L @ 16mm. 1/500 sec, f/11, ISO200.

GRAEME KELLY (p.75)
Canon EOS 5D Mk II with Canon 16–35mm II lens @ 16mm. Lee 0.6 Hard ND Filter. f/16, bracketed at 1/20, 1/8, 0.3 sec and blended.

ALEX NAIL (p.76)
Canon EOS 5D Mk II with 16–35mm f2.8L at 16mm. 1/30 sec, f/19, ISO100. 3 vertical frames stitched to form an ultra-wide panorama.

WILLIAM WARD (p.77)
Pentax K20D with 18–55 WR lens @ 18mm (35mm equiv: 27mm). 8 secs, f/22, ISO100. Hoya ND 3 filter, Stacked 2 stop and 3 stop Cokin ND Grads.

MARK LITTLEJOHN (p.78)
Nikon D800 with 24mm f1.4 lens. 1/160 sec, f/5.6, ISO200. Processed in Silver Efex and Adobe Lightroom 4.

MARK SIMPSON (p.79)
Canon EOS 6D with Canon EF 24–105mm f/4.0 L IS USM Lens @ 24mm, Lee Big Stopper + Lee 0.6 Neutral Density Hard Grad, CamRanger & iPad. 120 secs, f/11. Lens & white balance correction in Adobe Lightroom.

JAMES APPLETON (p.80)
Canon EOS 5D Mk III with 16–35mm f/2.8 L @ 32mm. 1/125 sec, f/14, ISO200.

SIMON HARRISON (p.81)
Canon EOS 5D Mk II with 70–200 F4 L USM lens @ 200mm. 1/160 sec, f/14. Minor white balance and contrast adjustments, and removal of dust spots. Composed for and cropped to my preferred 5x4 ratio format.

STEVEN THOMPSON (p.82)
Canon EOS 5D Mk III with 24–105mm L lens @ 28mm. 1/8 sec, f/18, 0.9 ND Grad, polarising filter. Edited from a single RAW file using Adobe Lightroom and Photoshop CS4. General adjustments including levels, contrast and colour balance.

PETER RIBBECK (p.83)
Nikon D300 with Tokina 11–16mm @ 14mm. 0.6 sec & 3 secs, f/22, ISO100. Polariser and Lee 3 stop ND. Two frame vertical panorama blended in Adobe Photoshop CS5 and adjusted in Adobe Lightroom.

TIM WAY (p.84)
Nikon D700 with 21mm Zeiss Distagon T* 2.8/21 ZF.2. 1/8 sec, f/11, ISO200.

ROBIN BOOTHBY (p.85)
Olympus Pen E-PL3 with 60mm lens. 1/15 sec, f/6.3. Three shot panorama stitched together in Adobe Photoshop Elements, with minor adjustments of tone and exposure level in Adobe Lightroom.

JOHN HODDINOTT (p.86)
Canon EOS 5D Mk II with EF24–105 lens @ 55mm. 150 secs, f/11, ISO100, Lee Big Stopper, Tripod. Cropped square, with minor adjustments carried out in ACR and Adobe Photoshop 6.

JOHN PARMINTER (p.87)
Nikon D300 with Sigma 17–70mm @ 17mm. 1/1600 sec, f/11, ISO200.

MARK HARROWSMITH (p.88)
Canon EOS 5D Mk II with 17–40mm lens @ 19mm. 1/80 sec, f/9, ISO200. Exposure Bias +2 EV. Slight adjustments in Adobe Photoshop & Lightroom, including contrast and straightening.

STUART LOW (p.89)
Canon 5D Mk III with Zeiss 21mm Distagon. 10 secs, f/16, ISO500. 3 stop ND filter. Minor adjustments, including colour balance to correct blue cast from filter.

ROBIN GOODLAD (p.90)
Nikon D3 with Nikkor 24–70mm lens @ 50mm. 15 secs, f/20, ISO400.

JACKIE ROBINSON (p.91)
Canon EOS 7D with Tamron 17–50mm lens @ 41mm. f/16, ISO100. A blend of two exposures – 1/15 sec and 1/6 sec – from RAW files in Photoshop and then adjusted with levels and curves.

TIMO LIEBER (p.92)
Canon EOS 5D Mk II with Canon 70–20mm f/2.8L @ 115mm. 1/60 sec, f/11, ISO100.

GRAHAM McPHERSON (p.93)
Canon EOS 5D Mk II with 24–105mm L @ 47mm. 1/10 sec, f/13, ISO100.

JAKE PIKE (p.96–97)
Canon EOS 550D with Sigma 10–20mm lens @ 10mm. f/11, ISO100. Two exposures blended in Adobe Photoshop CS6 (no filters): 1/25 sec & 1/100 sec.

BOB McCALLION (p.100)
Olympus E620 with Leica 140–150mm lens @ 55mm. 1/80 sec, f/14, ISO100. Brightness, contrast and sharpness adjusted in Olympus Master 2 software. Mono conversion in Adobe Photoshop.

ROBIN COOMBES (p.102)
Nikon D7000 with Sigma 24–70mm @ 46mm (35mm equivalent of 69mm). 1/100 sec, f/5, ISO2000. Conversion to B&W.

DAVID HASTINGS (p.104)
Nikon D40X with 18–55mm lens at 48mm. 1/200 sec, f/8, ISO200.

PAUL SANDY (p.105)
Canon EOS 5D Mk II with EF 100–400mm f4.5-5.6L IS USM @ 400mm. 1/15 sec, f/20, ISO100. Minor adjustments and cropping in Adobe Lightroom 4 to restore the full impact of the scene as observed.

ROBERT BIRKBY (p.106)
Canon EOS 5D Mk II with 50mm f1.4 lens. Tripod, 1/15 sec, f/5.6, ISO100. Photograph cropped, colour partially desaturated and toned. Contrast increased using Adobe Photoshop.

MIREK GALAGUS (p.108)
Nikon D800 with Nikkor 70–300mm f/4.5-5.6 lens @ 210mm. 1/80 sec, f/10, ISO160.

MARK LITTLEJOHN (p.110)
Nikon D800 with 105mm f/2 lens. 1/5000 sec, f/5.6, ISO200. Processed in Silver Efex and Adobe Lightroom 4.

DAVID KIRKPATRICK (p.111)
Canon EOS 60D with EF-S15–85mm f/3.5–5.6 IS USM @ 31mm. 1/200, f/14, ISO100, –0.3 EC.

NADIR KHAN (p.112)
Canon EOS 5D Mk III with 24–105mm lens @ 40mm. 1/800 sec, f/16, ISO800, +ve exposure compensation. Edited in Adobe Lightroom 4 and Photoshop CS6.

PAUL WHEELER (p.114)
Nikon D90 with Nikkor AF-S 24–70mm F2.8 @ 70mm. 1/100 sec, f/5.6, ISO200. Mono Conversion and minor mono processing in Adobe Photoshop CS4 and Niksoft Silver Efex Pro 2.

MARK BELL (p.116)
Canon EOS 1Ds Mk II with 70-200mm f2.8L IS @ 72mm. Polariser and 0.6 ND grad. 1/15 sec, f/13, ISO50, tripod and remote release.

GARY TELFORD (p.117)
Sony Alpha A77 with Tamron 70–300mm lens @ 75mm. 1/1500 sec, f/8, ISO100. Small adjustments and cropping in Adobe Lightroom.

STEVE DEER (p.118)
Canon EOS 5D Mk II with 70–200mm f2.8 IS II USM @ 70mm. 1/250 sec, f/5, ISO320.

DAVID MORRIS (p.121)
Canon EOS 5D Mk II with 300mm lens. 1/640 sec, f/11, ISO200. Converted to B&W and minor adjustments.

CHARLOTTE BURTON (p.125)
Canon PowerShot SX240 HS. 1/250 sec, f/5, ISO160. Converted to B&W. Adjustments to levels/curves in Adobe Photoshop CS4.

NIGEL McCALL (p.129)
Canon EOS 1D Mk IV with EF24–105mm lens f/4L IS USM at 65mm. 1/800 sec, f/5.6, ISO250. RAW file converted in Camera RAW 8.1, processed in Adobe Photoshop CS6 using NIK software Viveza 2 plug in.

CHARLOTTE GILLIATT (p.130)
Nikon D700 with 70–200mm f/2.8 @ 116mm. 2.5 sec, f/16, ISO 200. Processed in Adobe Lightroom and Photoshop CS6.

SIMON HARRISON (p.132)
Canon EOS 5D Mk II with 70–200mm f/4 L USM lens @ 98mm. 1/25 sec, f/18, tripod. Two frames to achieve front-to-back sharpness in depth-of-field. Purposely composed and cropped to my preferred 4x5 ratio.

ADRIAN ELSTON (p.133)
Canon EOS 30D with 18–50mm lens at 50mm. 1/13 sec, f10, ISO800.

MIKE CURRY (p.134)
Olympus E3 converted to infra-red capture. 1/250 sec, f/5.6, ISO400, +2.7 exposure compensation.

JOHN IRVINE (p.136)
Canon EOS 5D Mk II with 50mm f1.8 lens. 30 secs, f/10, ISO640. WB alteration, marks cloned out, slight crop.

DAVID BREEN (p.137)
Fujifilm X-Pro1 with 60mm Fujinon lens. Handheld at 1.8secs, f/16, ISO200.

ANDREW HOWE (p.138)
Nikon D5100 with Nikon DX 18–55mm lens @ 24mm. 60 secs using a 10.0 stop ND Filter, f/18, ISO100. RAW and Mono conversion, crop and minor Levels and Curves adjustments in Adobe Lightroom 3.

NEIL MANSFIELD (p.140)
Canon EOS 5D Mk II with 17-40 lens @ 40mm. 1/40 sec, f/13, ISO200. Processed in Adobe Lightroom 4 and Photoshop 4 with minor exposure, sharpening and contrast adjustments. Image cropped to square format.

TOBY SMITH (p.141)
Canon EOS 5D Mk II with 50mm f/1.2 lens. 8 secs, f/16, ISO400. Elinchrom Octa Softbox using Tungsten Modelling Light as the Main light source alongside a large array of smaller sources.

COLIN WESTGATE (p.142)
Sony Alpha A900 DSLR with 70–300mm G Series zoom @ 150mm. 1/160 sec, f/5.6 (plus one stop compensation for the snow), ISO400.

CHARLOTTE GILLIATT (p.144)
Nikon D700 with 16–35 mm f/4 lens @ 28mm. 205 secs, f/16, ISO100. Lee Big Stopper. Processed in Adobe Lightroom, Photoshiop CS6 and Siver Efex Pro. Converted to mono and cropped square.

KAUSHIKLAL KORIA (p.145)
Nikon D200 with 17–55mm f/2.8 @ 26mm. 1/8 sec, f/3.5, ISO320. Minor adjustments of exposure, levels, sharpening, noise reduction, cropping in Adobe Lightroom

NIGEL MORTON (p.147)
Canon EOS 450D with 70–200mm f4 L at 84mm. 2 secs, f/18, ISO100. Lee 0.6 neutral density filter, Lee 0.9 neutral density filter, tripod, cable release.

ROBERT BACK (p.148)
Leica D-Lux 5, 1/400 sec, f/3.3 ISO80. Original image converted to B&W with minor adjustments, including levels and contrast.

WARREN CHRISMAS (p.149)
Canon EOS 7D and an EF-S 17–55mm @ 55mm. 1/6 sec, f/2.8. ISO640. Rubber lens hood to avoid window reflection. 'Matt's HDR Pre-sets' applied in Adobe Lightroom, image cropped and vignette added.

JAMES WALLACE (p.150)
Canon EOS 5D Mk II with EF 70–200mm IS lens. 4 portrait shots taken and stitched in Adobe Photoshop. Slight adjustments made to RAW files in Adobe Lightroom prior to stitching, with further tweak to contrast in Adobe Photoshop.

KAUSHIKLAL KORIA (p152)
Nikon D200 with 17–55mm f/2.8 @ 20mm. 1/6 sec, f/3.5, ISO320. Minor adjustments to exposure, levels, sharpening, noise reduction, cropping and converted to B&W in Adobe Lightroom.

IAN MOUNTFORD (p.153)
Canon EOS 5D Mk II with EF24–105mm f/4L IS USM @ 85mm. 49 secs, f/8, ISO00, tripod, Lee Big Stopper ND filter. Cropped in Adobe Lightroom, B&W conversion in Silver Efex Pro and adjustments in Photoshop 5.

CHARLOTTE BURTON (p.156–157)
Canon PowerShot SX240 HS, 1/200 sec, f/6.3, ISO100.

DAVID LYON (p.160–161)
Canon 5D Mk II with 100–400mm @ 275mm. 1/2000 sec, f/11, ISO320, tripod. RAW file converted in CaptureOne to three images -1ev 0 and +1ev, then combined to HDR image and converted to mono.

DAVID BAKER (p.162)
Canon EOS 5D Mk II with 70–200 lens @ 200mm. 1.3 secs, f/16, ISO50. Lee filters.

ROBERT BIRKBY (p.163)
Canon EOS 5D Mk II with 100mm macro lens. Tripod, mirror lockup, cable release.

0.6 sec, f/16, ISO100. Image cropped and brightened a little in Adobe Photoshop.

NIGEL MORTON (p.164)
Canon EOS 450D with 50mm f/1.4 lens. 0.3 sec, f/14, ISO100, tripod, cable release.

ALAN COURTNEY (p.166)
Panasonic Lumix DMC-G2 with 14–140mm lens @ 48mm. 1/250 sec, ISO100. Processed from Raw to Jpeg and cropped in Adobe Lightroom, with some slight adjustments to levels.

MIKE CURRY (p.167)
Nikon D700 with 24–120mm lens @ 120mm. 1/400 sec, f/7.1, ISO800. Cropped square.

LINDA WEVILL (p.168)
Canon EOS 5D Mk II with EF24–105mm f/4L IS USM @ 40mm 1/8 sec, f/18, ISO100. Cropped square.

SCOTT WILSON (p.169)
Nikon D700 with 14–24mm f/2.8 lens at 24mm. 20 secs, f/3.5, ISO400. Minimal post-processing in Adobe Lightroom.

CHRIS GODDARD (p.170)
Nikon D800E with Sigma 100-300mm f/4 @ 120mm. 0.8 sec, f/13, ISO50.

KEITH AGGETT (p.171)
Canon EOS 5D Mk II with 17–40mm L @ 17mm x 2 B&W ND106 & Cokin 0.9 SE grad. 22 secs, f/11, ISO100. Two frames (top & bottom), stitched together and adjusted in Adobe Photoshop and cropped square. Converted to B&W in Silver Efex Pro.

STEVE GRAY (p.172)
Panasonic Lumix DMC-LX5. 1/80 sec, f/8 ISO80. Unfiltered.

DAVID MOULD (p.173)
Pentax K5 with Sigma 17–70mm f2.8-4.5 @ 45mm. 1/15 sec, f/16, ISO200. Lee 105 circular polariser / ND 0.3 soft grad. Tripod. Cropped, curves, levels and saturation in Adobe Camera Raw and Adobe Photoshop CS6.

ROBERT BIRKBY (p.174)
Canon EOS 5D Mk II with Zeiss 21mm lens. 1/60 sec, f/5.6, ISO100. Tripod. Image cropped and a slight boost to contrast using Adobe Photoshop.

ESEN TUNAR (p.175)
Canon EOS 5D Mk II & TS-E 24mm f/3.5L II. ¼ sec, f/11, ISO100.

STEVE TUCKER (p.176)
Nikon D800 with 24–70mm f/2.8 lens @ 62mm. 1/160 sec, f/11, ISO100. Farmer's quad bike tracks and foreground barbed wire fence removed.

RICHARD HURST (p.177)
Canon EOS 1DX with 35mm Zeiss Lens. 166 secs, f/16, ISO100. Square crop and some slight exposure and colour alterations.

CHRIS BEESLE (p.178)
Pentax K100D Super with DA 55–300mm lens @ 55mm. 1/160th sec, f/6, ISO200. Adjustments made to contrast, plus some straightening of the tractor lines to give a more visually appealing image.

PAUL ANTHONY WILSON (p.179)
Fujifilm X10 with 10mm lens. 1/180 sec, f/5.6, ISO100. Converted to Sepia using Adobe Photoshop to convey nostalgia.

MARK LITTLEJOHN (p.180)
Nikon D800 with 105mm f/2 lens. 1/20 sec, f/8, ISO100. Processed in Silver Efex.

PAUL KNIGHT (p.182)
Canon EOS 5D converted to Infra-red. Changed to black and white with minor editing in Adobe Photoshop.

MICHAEL SWALLOW (p.183)
Canon EOS 5D with 70–200mm f/2.8 lens @ 98mm. 1/125 sec, f/11.

BARRY HUTTON (p.184)
Canon EOS 5D Mk II with 17–200mm f/4L @ 200mm. 1/8 sec, f/8, ISO100.

JUSTIN MINNS (p.185)
Canon EOS 5D Mk II with EF 17–40mm f/4L USM lens @ 29mm. 203 secs, f/11, ISO50.

DOMINIC LESTER (p.186)
Nikon D7000 with 16–85mm f/3.5-5.6 lens @ 78mm (35mm equivalent = 117mm). 1/350 sec, f/8, ISO800. Hand held.

MIK DOGHERTY (p.187)
Nikon D800 with Nikkor 18–105 lens @ 85mm. 1/10 sec, f/11, ISO100. Originally processed in Adobe Lightroom and converted to B&W using Silver Efex Pro 2.

BRIAN KERR (p.188)
Canon 5D Mk II with EF 17–40mm f/4 USM @ 21mm. 1/8 sec, f/16, ISO80. Lee Soft Grad 0.75 filter. Raw file processed in Adobe Lightroom, final edit and crop done in Photoshop CS5.

JEFF VYSE (p.189)
Nikon D90 with 30mm lens (35mm equivalent = 45mm) 1/50 sec, f/11, ISO200. Processed in Capture NX2 and Silver Efex Pro.

SCOTT MURRAY (p.190)
Canon EOS 5D Mk II with EF 24–105mm f/4L IS USM @ 80mm. 4 secs, f/16, ISO100.

TINA IND (p.191)
Canon EOS 5D Mk II with 24–105mm lens @ 58mm. 1.3 secs, f/8, ISO100. Adjusted in post-production.

ADRIAN CAMPFIELD (p.192)
Sony Alpha 550 with 18–55mm lens. 1/000 sec, f/6.3, ISO400. Exposure comp -0.7. In-camera HD range set on level 1.

IAN TAYLOR (p.193)
Nikon D800 with 24–70mm @ 24mm. 1/80 sec, f/14, ISO200 & tripod. Raw image processed in Adobe Camera Raw with square crop. B&W conversion in Silver Efex Pro 2.

ANDREW LOCKIE (p.194)
Fuji X-E1 with 35mm f/1.4 lens. Small adjustments to levels, saturation and sharpness in Adobe Photoshop and cropped square.

JERRY YOUNG (p.195)
Nikon D800 with 180mm f/2.8 ED manual lens. 1.6 sec, f/8, ISO100. Minimal post production.

DUNCAN FAWKES (p.196)
Canon EOS 5D Mk II with Zeiss Distagon T*2.8/21mm ZE. 30 secs, f/13, ISO100. Processed using Adobe Lightroom 4, Adobe Photoshop CC, Nik Silver Efex 2.

JOHN POTTER (p.197)
Canon EOS 5D Mk II with EF 24–105mm f/4L IS USM @ 105mm. 56 secs, f/13, ISO100.

IAN KENNEDY (p.198)
Canon EOS 50D with 18–200mm lens at 18mm. 1/8 sec, f/22 ISO100. Improved contrast and softened noise in sky a little.

ANDY DENTTEN (p.199)
Nikon D700 with 20mm AIS f3 lens. 1/160 sec, f/8, ISO800, Exposure Bias -1/3. Handheld with polarising filter and a 3 stop ND grad. No image manipulation apart from B&W conversion and basic levels adjustment.

DAVID MOULD (p.200–201)
Pentax K5 with Sigma 120–400mm, f4.5–5.6 @ 200mm. 1 sec, f/16, ISO100. Tripod. Curves, levels and saturation in Adobe Camera Raw and Photoshop CS6.

KEITH AGGETT (p.202)
Nikon D7000 with Sigma 10–20mm @ 13mm. 192 secs, f/18. B&W ND110 & Cokin 0.9 SE grad filters. Converted to B&W Silver Efex. Curves and levels adjusted in Adobe Photoshop. Slight colour tone added.

PAUL SUTTON (p.203)
Canon EOS 7D with Sigma 24–70mm EX @ 42mm. 1/15 sec, f/16, + 0.6 ND grad.

PAUL ARTHUR (p.204)
Ebony SV45TE, Schneider Super Angulon 180mm f/5.6, Fuji Velvia.

MICHÉLA GRIFFITH (p205)
Panasonic DMC LX5 @ 17.10mm (35mm equivalent = 94mm). 1/60 sec, f/5.6, ISO80. White balance = cloudy. Minor adjustments to midtones and highlights plus output sharpening.

RUSS BARNES (p.206)
Nikon D800 with 24mm PC-e. 4 secs, f/4, ISO100, 10 stop ND filter, 2 stop hard grad. Converted to B&W.

CHRIS PATTISON (p.208)
Nikon 1 V1 with 1 NIKKOR VR 10–30mm f/3.5-5.6 @ 12.7mm (35mm equiv = 34mm). 1/80 sec, f/5.6, ISO100. Handheld.

DUNCAN FAWKES (p.209)
Canon EOS 5D Mk II with EF135mm f/2L USM. 1/13 sec, f/11, ISO100. Processed using Adobe Lightroom 4 and Nik Color Efex 4

CAROL CASSELDEN (p.210)
Nikon D80 with 18–200mm f/3.5-5.6 lens @ 135mm (35mm equiv = 202mm). 1/320 sec, f/10, ISO100. Minor adjustments to levels and a touch of sharpening.

OLIVER CURTIS (p.214)
Canon EOS 1D Mk II N with Samyang 14mm f/2.8 lens, 1/80 sec, ISO100.

PHOTOGRAPHERS' WEBSITES

Keith Aggett	www.keithaggettphotography.com
Alun Allcock	www.alunallcock.com
James Appleton	www.jamesappleton.co.uk
Paul Arthur	www.paularthur.net
Matthew Aspden	www.mattlandscape.com
Robert Back	www.robertmbackphotography.com
David Baker	www.milouvision.com
Russ Barnes	www.russbarnes.co.uk
Chris Beesley	www.flickr.com/fancithat
Mark Bell	www.markbellphotography.com
Robert Birkby	www.robertbirkbyphotography.co.uk
Raymond Bradshaw	raymondbradshawphotography.co.uk
David Breen	www.triplekitephotography.co.uk
Adam Burton	www.adamburtonphotography.com
Ian Cameron	www.transientlight.co.uk
Adrian Campfield	www.flickr.com/photos/adrians_art
Carol Casselden	www.carolcasselden.co.uk
David Cation	www.davidcation.com
Warren Chrismas	www.flickr.com/photos/warrenchrismas
Angus Clyne	www.angusclyne.co.uk
Robin Coombes	www.flickr.com/photos/robinandtaliesin
Alan Courtney	www.flickr.com/photos/77565025@N02
Mike Curry	www.mikecurryphotography.com
Steve Deer	www.stevedeer.co.uk
Andy Dentten	www.pbase.com/andyd
Mik Dogherty	www.mikdoghertyimages.com
Duncan Fawkes	www.duncanfawkes.com
John Finney	www.johnfinneyphotography.com
Robert France	www.flickr.com/photos/rf100

Mirek Galagus	maglightscapes.com
Terry Gibbins	www.terrygibbins.com
Charlotte Gilliatt	www.charlottegilliatt.com
Chris Goddard	www.cjgoddard.co.uk
Robin Goodlad	www.naturallightphotography.co.uk
Steve Gray	www.flickr.com/photos/ lightweightlandscapes
Michéla Griffith	www.longnorlandscapes.co.uk
Simon Harrison	www.simonharrisonphotography.com
Mark Harrowsmith	www.flickr.com/photos/markharrowsmith
Bart Heirweg	www.bartheirweg.com
Paul Holloway	paulhollowayphotography.co.uk
James Hourd	www.jameshourd.com
Andrew Howe	andrewhowe.4ormat.com
Richard Hurst	www.richardhurstphotography.co.uk
Barry Hutton	www.lakescape.co.uk
Tina Ind	www.tinaind.co.uk
John Irvine	www.johnirvineimages.com
Andrew Jones	www.AndrewJonesPhotography.com
Graeme Kelly	www.graemekellyphotography.com
Ian Kennedy	www.iankennedyphotography.com
Brian Kerr	www.briankerrphotography.com
Nadir Khan	www.nadirkhanphotography.co.uk
Gary King	www.garykingphotography.com
David Kirkpatrick	www.kirkpatrickphotos.co.uk
Paul Knight	www.paulknight.org
Andy Le Gresley	www.andylegresley.com
Dominic Lester	DominicLester.com
Timo Lieber	www.timolieber.com

Mark Littlejohn	www.facebook.com/markljphotography	Mark Simpson	www.electriclemonade.co.uk
Andrew Lockie	www.andrewlockie.com	Neale Smith	www.nealesmith.com
David Longstaffe	www.davidlongstaffe.com	Toby Smith	www.shootunit.com
Stuart Low	www.stuartlowphotography.co.uk	Paul Sutton	www.postscriptphoto.co.uk
David Lyon	www.davelyonphotography.com	Michael Swallow	www.michaelswallow.com
Neil Mansfield	www.landscapesuncovered.com	David Taylor	www.davidtaylorphotography.co.uk
Gary McGhee	www.garymcgheephotography.co.uk	Gary Telford	www.garytelfordimages.co.uk
Graham McPherson	www.grahammcpherson.com	Steven Thompson	sunstormphotography.com
Andrew Midgley	www.andrewmidgleyphotography.com	Rory Trappe	www.caeclyd.com
Justin Minns	www.justinminns.co.uk	Steve Tucker	www.stevetuckerphotography.com
Paul Mitchell	www.paulmitchellphotography.co.uk	Esen Tunar	www.esentunar.com
David Morris	www.davidmorrisphotographer.com	Jeff Vyse	www.jeffvyse.co.uk
Nigel Morton	www.nigelmorton.com	Gary Waidson	www.waylandscape.co.uk
David Mould	www.davidmould.co.uk	James Wallace	500px.com/wames_jallace
Ian Mountford	ianmountfordphotography.com	William Ward	www.thingsthatihaveseen.com
Scott Murray	www.scottamurray.com	Tim Way	www.timwayphotography.co.uk
Alex Nail	www.alexnail.com	Colin Westgate	www.questphoto.co.uk
John Parminter	www.viewlakeland.com	Linda Wevill	www.lindawevillphotography.com
Chris Pattison	www.chrispattison.co.uk	Paul Wheeler	www.pswheeler.com
Graeme Peacock	www.graeme-peacock.com	Scott Wilson	www.flickr.com/photos/wilsonaxpe
Jake Pike	www.flickr.com/photos/jakepike	Paul Anthony Wilson	www.paulanthonywilson.co.uk
Russell Pike	www.russellpike.co.uk	Robert Wolstenholme	www.robwolstenholme.co.uk
John Potter	www.jpotter-landscape-photographer.com	Jerry Young	jerryyoung.co.uk
Mani Puthuran	www.maniputhuran.com		
Alan Ranger	www.alanranger.com		
Peter Ribbeck	www.facebook.com/PribbeckPhotography		
Jim Robertson	www.jimrobertson.co.uk		
Jackie Robinson	44photography.co.uk		
Paul Sandy	paulsandy.co.uk		